Luxury
Goods
from
India

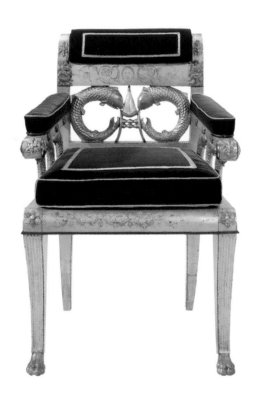

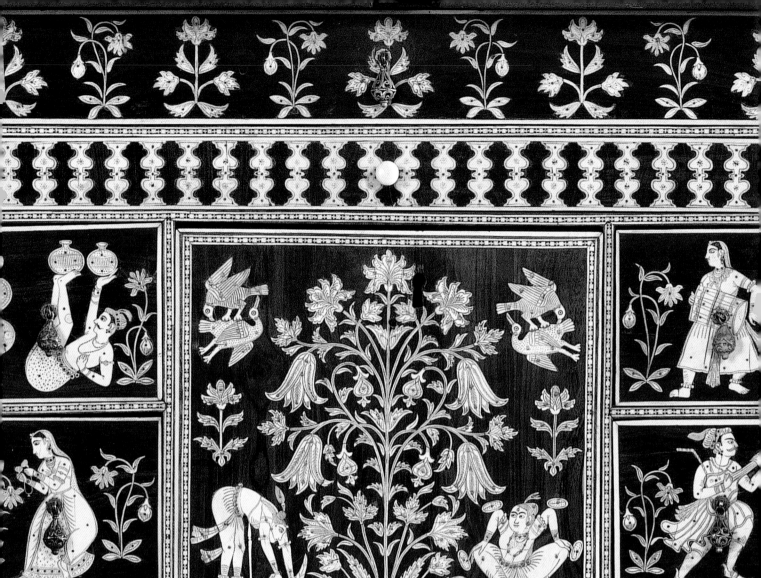

Luxury Goods *from* India

THE ART OF THE INDIAN CABINET-MAKER

Amin Jaffer

V&A Publications

PUBLISHED WITH THE CONTRIBUTION
OF THE CALOUSTE GULBENKIAN
FOUNDATION – LISBON

First published by V&A Publications, 2002

V&A Publications
160 Brompton Road
London SW3 1HW
© The Board of Trustees of the Victoria and Albert Museum 2002

Amin Jaffer asserts his moral right to be identified as the author of this book

Designed by Andrew Shoolbred
V&A photography by Mike Kitcatt, V&A Photo Studio

ISBN 1 85177 381 9

A catalogue record for this book is available from the British Library

Front jacket illustration: Detail from cabinet on table-stand (cat. 8)
Back jacket illustration: Mother-of-pearl basin (cat. 11)
Frontispiece: Detail from fall-front cabinet (cat. 24)

Printed in Hong Kong

V&A Publications
160 Brompton Road
London SW3 1HW
www.vam.ac.uk

Contents

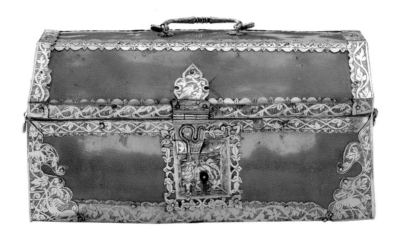

For Shahina and Shamira

Acknowledgements

This volume would not have been possible without the support and encouragement of members of staff of the Research Department and the Department of Asian Art of the Victoria and Albert Museum. The idea behind the book belongs to John Guy, and it was supported from the start by Deborah Swallow, to whom I owe many thanks for her help and encouragement during the writing and publication process. Rosemary Crill has answered endless questions and always in the most helpful way. Nick Barnard, Ben Curran, John Clarke, John Guy, Graham Parlett, Divia Patel and Susan Stronge have all been extremely helpful, both with academic questions and practical issues that needed to be resolved for this publication. Within the Museum Nigel Bamforth, Neil Carleton, Richard Edgcumbe, Wendy Monckhouse, Susan North and Tony North have all assisted in answering questions posed by some of the objects discussed. Stephanie Durante and Laurie Lindey both volunteered their time to help with difficult bits of the research, and Naomi Pears assisted greatly by double-checking footnotes, undertaking picture research and reading the text. I would also like to thank Dr Gauvin Alexander Bailey, Dr Anna Dallapiccola, Dr Jyotindra Jain and Simon Digby for help with research. Two of the entries are based on research and writing undertaken in a joint effort with other scholars: cat. 1 with Melanie Schwabe, and cat. 44 with Irving Finkel.

Finally, I would like to offer my thanks to those who have been responsible for transforming my text into a published work. At V&A Publications, I am very grateful to Mary Butler, Ariane Bankes, Monica Woods and Clare Davis. Michael Bird copy-edited the volume, and Andrew Shoolbred is responsible for its attractive design. All of the new photography is the work of Mike Kitcatt, to whom I owe many thanks.

The publication of the volume has been generously supported by the Calouste Gulbenkian Foundation, and I am grateful both to the Foundation and to Nuno Vassallo e Silva, Deputy Director of the Calouste Gulbenkian Museum.

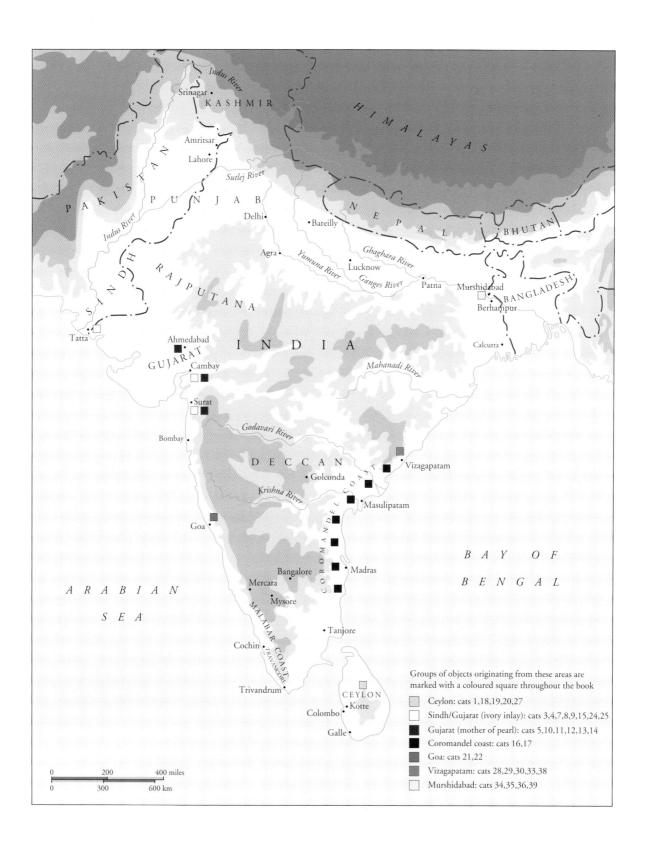

Srinagar
Indus River
KASHMIR
HIMALAYAS
Amritsar
Lahore
PAKISTAN
PUNJAB
Sutlej River
Delhi
NEPAL
BHUTAN
Indus River
Bareilly
SINDH
Agra
Yumuna River
Lucknow
Ghaghara River
RAJPUTANA
Ganges River
Patna
Murshidabad
BANGLADESH
Berhampur
Tatta
INDIA
Ahmedabad
Mahanadi River
Calcutta
GUJARAT
Cambay
Surat
Godavari River
Bombay
DECCAN
Vizagapatam
Golconda
Krishna River
Masulipatam
Goa
CORMANDEL COAST
Bangalore
Madras
BAY OF BENGAL
Mercara
ARABIAN
Mysore
SEA
MALABAR COAST
TRAVANCORE
Tanjore
Cochin
Trivandrum
CEYLON
Kotte
Colombo
Galle

Groups of objects originating from these areas are
marked with a coloured square throughout the book

Ceylon: cats 1,18,19,20,27

Sindh/Gujarat (ivory inlay): cats 3,4,7,8,9,15,24,25

Gujarat (mother of pearl): cats 5,10,11,12,13,14

Coromandel coast: cats 16,17

Goa: cats 21,22

Vizagapatam: cats 28,29,30,33,38

Murshidabad: cats 34,35,36,39

0	200	400 miles
0	300	600 km

Introduction

In the chapter on interior decoration in his book *The Arts of India* (1880), Sir George Birdwood concluded that 'the great art in furniture is to do without it.'[1] Indeed, prior to the arrival of Europeans in India in the late fifteenth century, people principally sat cross-legged on textiles placed on the floor. This posture, in which they socialized and ate, determined their needs and the design of the objects that surrounded them. Writing from the Mughal court in the early seventeenth century, Edward Terry observed that Indian interiors 'have no chairs, stools, couches, tables, nor beds enclosed with canopies or curtains'.[2] Visiting India later in the century, Thomas Bowrey similarly found that when people 'hold any Conversation it must be sittinge, and not Upon Chairs, Stools, or Benches, but Upon Carpets or Matts Spread Upon the ground, and on them they Sit crosse legged'.[3] Floors were rendered comfortable with lightweight textiles or carpets held down with carpet weights, as well as with cushions and bolsters, which frequently constituted the bulk of the furnishings in a room. Articles such as lamps and hookahs were placed directly on the floor, although very low tables were also sometimes used, and walls were equipped with niches for storage purposes. Clothing, textiles and books were wrapped in sheets and kept in storage chests.

To say that there was no tradition of elevated furniture in India would be incorrect. Low-strung beds (*charpai*) and couches have been in use in the subcontinent since ancient times, as have thrones, which in their very design aimed to raise the ruler above those around him. Ancient texts suggest that courtly furniture was extremely richly embellished. For example, in the *Ramayana*, Ravana, King of Lanka, is described as having a bed decorated with ivory, and in the *Mahabharata*, rulers of the ancient kingdoms of Magadha, Bengal and Orissa, present Yudisthira, leader of the Pandavas, with chairs (*asanani maharhani*), sedan chairs (*yanani*) and beds (*sayanani*) of ivory inlaid with precious stones and gold.[4] Lavishly decorated furniture of this type was not confined to epic tales. Portuguese traveller P.A. Cabral was astonished to find that at Calicut the ruler sat in a throne 'the arms and back of which were of gold and full of stones, that is, jewels',[5] and Francisco Pelsaert observed that, although Western-style furniture was not known in India, the few pieces of furniture that Indian elites used 'were lavishly made with gold or silver'.[6] Accounts such as these confirm that, although India's furniture and woodwork are less well known than its sculpture, painting and

textiles, it has enjoyed a very rich tradition in these arts, as is illustrated by the fifty objects in this volume.

Many of the objects discussed here were made in India under European patronage. Chairs and tables are essential tools for Western living and were amongst the first requirements of Europeans settling in India. However, as the Portuguese discovered when they reached the subcontinent in the late fifteenth century, there was no local furniture that suited their manner of living. In some instances early European merchants in India adopted the Indian manner of sitting. On his journey to Gujarat in 1689 John Ovington noticed that East India Company officials, 'when they eat at Home, do it after the *English* manner', but outside 'they imitate the Customs of the *East* in lying round the Banquet upon the *Persian* Carpets which are spread upon the Ground.'[7]

There were several ways of acquiring Western-style furniture in India. Pieces that had been used in the cabin on the voyage out could, of course, be used on land, but such items generally consisted of no more than cabin beds, chests and portable writing boxes. The pressing demand for furniture, particularly larger pieces, led to commissioning it from native carpenters, who applied their talents to Western furniture forms. Apart from local carpenters who produced elementary furniture for daily use, however, there existed artisans skilled in working with precious materials such as ivory, tortoiseshell and mother-of-pearl for Asian luxury markets, who began to apply their traditional decorative techniques to Western furniture forms. The articles they produced were clearly prized in Europe, for both their quality of craftsmanship and the materials used, and they swiftly found a place in royal *Kunstkammern*, ecclesiastical treasuries and stately houses.[8]

The fusion of Western forms and Indian materials and techniques occurred in many different parts of India, but particularly in areas of concentrated European trade and settlement such as Gujarat, the Malabar and Coromandel coasts, and Bengal. The development of schools of Western-style furniture-making seems to have taken place first in the textile-producing region of Gujarat, whose international ports were natural magnets for Europeans. The degree to which the Portuguese – the first of the European nations to arrive in Asia – were involved in directing workshops to produce Western-style goods is difficult to ascertain. It is apparent, both from contemporary accounts and from the objects themselves, however, that in the sixteenth century Gujarati artisans had access

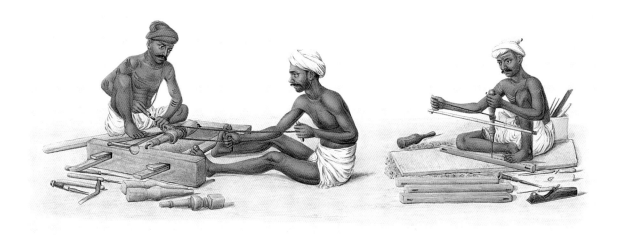

Indian carpenters working; gouache and watercolour on paper. Tanjore, c.1840–50. V&A: IS.4-1990.

to Western prototypes as well as Western-style objects made in other parts of Asia, and that they were familiar with European ornament. Many such articles are worked with coats of arms, insignia belonging to Holy Orders, or Western inscriptions that suggest that they were made for specific patrons who communicated their requirements in design and decoration. Naturally, as European presence in the subcontinent grew, so did the exposure of native craftsmen to Western goods. In British India, craftsmen's familiarity with furniture imported from Europe was supplemented with more practical understanding of the furniture-making trade acquired from the growing numbers of European tradesmen, among them cabinet-makers, who arrived in India from Europe in the hope of making a fortune by supplying the burgeoning settlements at Madras, Calcutta and Bombay. A more structured transfer of technology existed at Dutch settlements on the Coromandel coast and in Ceylon, each of which had an '*Ambachtskwartier*' or 'craftsmen's quarter' where European and local furniture makers worked together under the direction of Dutch foremen.[9]

Accounts by travellers to India reeling with delight at the luxury goods to be found there provide some idea of the circumstances in which things were purchased. Sir Thomas Herbert visited Gujarat in the 1620s, by which time a mechanism for the production of Western-style goods was firmly established. He described how Indian merchants 'all along the sea side pitch Booths or Tents and Straw Houses in great numbers, where they sell Callicoes,

Chena satten, Purcellan ware, Scutores or Cabbinets of mother of pearle, of ebony, of ivory, agats, turquoises, heliotropes, cornelians'.[10] Large trading centres in Gujarat, the Malabar and Coromandel coasts, and Bengal were inhabited not only by Indians and European traders, but also by different Asian merchant communities selling the commodities of their own countries. John Ovington, for example, wrote of Surat in 1689 that it was 'reckon'd the most fam'd Emporium of the *Indian* Empire, where all Commodities are vendible, though they never were there seen before . . . And not only from *Europe*, but from *China*, *Persia*, *Arabia*, and other remote parts of *India*, Ships unload abundance of all kinds of Goods, for the Ornament of the City, as well as inriching the Port.'[11] At ports such as Surat the convergence of diverse goods and patrons who brought with them their own decorative traditions created an atmosphere highly conducive to artistic and technical exchange, as is evident from articles from these centres produced at skilled workshops.

If India had virtually no pre-existing tradition of case furniture and little experience of elevated furniture in the Western sense, then the question immediately arises of how her craftsmen acquired expertise to produce these foreign forms. Aside from practical ways of transferring the necessary technology, an answer is partly found in the aptitude, evident throughout history, that Indian craftsmen possessed for copying goods for foreign markets. During his embassy to the Mughal court from 1615 to 1619, Sir Thomas Roe noted that Indians were able to

'imitate euerything we bring'.[12] Travelling in the late seventeenth century, John Ovington similarly wrote that 'The Indians are in many things of matchless Ingenuity in their several Imployments, and admirable Mimicks of whatever they affect to copy after',[13] a view echoed by the mid-eighteenth-century traveller Edward Ives, who found it 'astonishing how exactly they will copy any thing you give them'.[14]

At cosmopolitan trading centres with a strong European presence, such as Surat, Cambay, Goa, and later Vizagapatam, it was possible to purchase furniture ready-made. However, when commissioning a piece it was customary to equip the carpenter with materials needed for the work or to provide the cash equivalent, and to negotiate a fee, at least half of which was given in advance. Edward Ives explained the procedure:

> Whenever therefore you employ them, you are always obliged first to give them in hand, by way of expedition money, commonly half of what your bargain comes to: and besides this, if the tradesman you employ be in want of the necessary materials, (which is too often the case) you are then under a necessity of supplying him with three parts, if not the whole money beforehand.[15]

It was also necessary to furnish native carpenters with some sort of pattern, known as a *muster* (from the Portuguese *mostrar*, to show). Edward Ives noted that, in accepting an order, Indian craftsmen only ask for a *muster*, 'that is, for a pattern, and they will be sure to keep exactly to it'.[16] References to *musters* abound in contemporary travellers' accounts. However, few writers elaborate on the actual medium used to give Indian carpenters an idea of what they were required to produce. The fact that in India there did not exist a specific design vocabulary for the manufacture of furniture, such as had evolved among tradesmen in Europe, reinforced the dependence on visual design sources and actual models, from which it was also possible to form an understanding of joinery and methods of construction.

In India, carpenters (known as *sutar*, *barhi* or *mistri* in the north, and *asari* or *vadrangi* in the south) who produced furniture were also responsible for making a variety of other goods and for performing a wide range of services.[17] In smaller communities they were expected to construct articles as disparate as farm implements, boats and storage chests, while also undertaking wood-carving and decoration in domestic and temple architecture. The parameters of their work were defined not by object type, but by medium: in an interview taken in 1970 one villager described a carpenter as 'the craftsman who knows how to use wood'.[18] As with tradesmen such as barbers and potters, village carpenters were required to provide fellow villagers with certain fundamental services, among them constructing or repairing agricultural implements and vehicles, in exchange for which they were paid in kind, usually in the form of grain (known as the *jamjani* system). Trade skills were traditionally passed from father to son, as observed by John Ovington on his voyage to India in 1689:

'Auction held every morning in the Rua Direita in the city of Goa'; coloured engraving in Jan Huygen van Linschoten, *Histoire de la navigation aux Indes orientales*, Amsterdam, 1638, p. 44. Courtesy of the Museum Calouste Gulbenkian Photographic Archive.

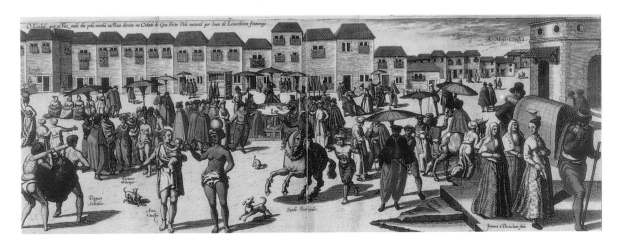

Fremjee Pestonjee Bhumgara's Stall, Exposition Universelle, Paris 1889; from the *Journal of Indian Art*, Vol. III, No. 28, October 1889; V&A: ISEAC Dept Library

their Arts are Hereditary, and their Employments confin'd to their own Families. The Son is engag'd in the Father's Trade, and to maintain the Profession of it in his Posterity, it is transmitted always to the succeeding Generation, which is obliged to preserve it in a lineal Descent, uncommunicated to any Stranger.[19]

Many of the articles discussed in this volume were made at leading centres of commerce where there existed a population that was able support specialist workshops producing luxury goods. Unlike those in villages, Indian craftsmen operating in this type of urban environment traditionally belonged to guilds (*sreni*), autonomous corporate bodies that set rules for work, standardized prices and administered justice among members. Craftsmen employed at royal and imperial workshops similarly operated outside the symbiotic network of the village, dedicating their talents to the production of courtly articles for use by their sovereign, who decided how they were paid and supported.

The fifty objects discussed in this volume span five centuries. They are made of different materials, represent diverse decorative traditions, and serve different functions. Some of them were made expressly for a royal setting, a church, or an exhibition hall, while others were fashioned as luxury goods, either for Indians or for the

Portuguese, Dutch or British, whose tastes they reflect. In spite of these differences, the pieces illustrated here all share a common identity in belonging to the Indian and South-East Asian collection at the Victoria and Albert Museum. The Museum's holdings of this class of material are rooted in two different institutions: the India Museum (1801–79) and the South Kensington Museum (established 1857 and renamed the Victoria and Albert Museum in 1899), into which the furniture collections of the former were merged in 1879. The India Museum was created by the East India Company as a repository for its manuscripts and assorted Indian treasures, some of which had been acquired as booty following victorious campaigns against various Indian princes. Furniture did not figure particularly strongly in the collections, with the exception of rare objects with important historical associations, such as Ranjit Singh's throne (see cat. 43), which was taken at the British annexation of the Punjab in 1849. These few pieces were bolstered with major purchases made at the Paris Expositions Universelles of 1855 and 1867, at which outstanding examples of Indian furniture were acquired along with boxes and cabinetwork representative of leading Indian centres of woodwork. The South Kensington Museum's early purchases of this type of material were almost all confined to richly

worked objects of some antiquity that conformed closely to Western prototypes – some examples so much so that they were thought to be European at the time of acquisition. Pieces from this phase of collecting include a seventeenth-century cabinet from Ceylon carved with scenes of Adam and Eve in the Garden of Eden (cat. 20); a pair of seventeenth-century Gujarati mother-of-pearl ewers and basins (bought as Italian) (cat. 11); a sixteenth-century western Indian fall-front cabinet (bought as Italian) (cat. 3) and an early seventeenth-century communion table (cat. 9) and Gujarati mother-of-pearl casket (cat. 5). Precious articles of this type, almost all made under Portuguese patronage, were supplemented by a group of Indo-Portuguese tables and cabinets on stands purchased in 1865 through the Museum's Lisbon agent, Senhor Blumberg.

A more considered approach towards collecting this type of material developed after the combination of some of the India Museum's collections with those of the South Kensington Museum in 1879. Acquisitions now started to focus on high quality furniture and woodwork for indigenous use, including a seventeenth-century painted box (cat. 23); a mid-nineteenth-century painted Jamnagari box (cat. 46); a late eighteenth-century ivory-veneered games table from the Malabar coast (cat. 37); an early nineteenth-century throne chair reputedly belonging to the last Mughal emperor (cat. 40); and a Mughal mother-of-pearl ceremonial mace (cat. 10). The early twentieth century also witnessed a great contribution to the collection in the form of two groups of important Anglo-Indian furniture worked with ivory. The first was bequeathed to the Museum by John Jones in 1882, but not transferred to the Indian Department until 1936; and the second was placed on loan at the Museum in 1929 by the 1st Earl of Amherst, whose descendant the 5th Earl gave it outright in 1991. Both groups included furniture of art historical and cultural importance, such as solid ivory chairs from a suite given by Mani Begum of Murshidabad to Warren Hastings (cat. 34), the first governor-general of India; and a set of ivory-inlaid chairs and a daybed made at Vizagapatam, which are amongst the earliest identifiable examples of furniture made in India under British patronage (cat. 28). The Amherst collection also included a rare example of documented Indian palace furniture, a gilt-wood throne belonging to Ghazi-ud-din Haidar, Nawab and (after 1819) King of Oudh, and probably designed for him by Scottish artist Robert Home, whom he employed as his court designer (cat. 42).

The last fifty years has been marked by a strengthening of the holdings of furniture made in British India, particularly from Vizagapatam, a port along the Coromandel coast where articles based on English designs were skilfully worked with ivory. This phase has also witnessed the acquisition of rare and precious articles across periods, including the Robinson Casket (cat. 1), one of a small group of sixteenth-century ivory caskets sent from Ceylon to Portugal as diplomatic presents; a seventeenth-century Ceylonese ivory-veneered cabinet formerly belonging to the Pre-Raphaelite artist William Holman Hunt (1827–1910) (cat. 27); an eighteenth-century staff from Lucknow painted with chinoiserie designs (cat. 31); an early seventeenth-century cabinet painted with European themes (cat. 6); and an outstanding Ceylonese ebony cabinet reputedly shown at the Empire of India Exhibition of 1895 (cat. 49). Another important acquisition was a pair of splendid solid ivory candelabra (cat. 39), bought as English in 1960 by the Department of Furniture and Woodwork, and later identified as having been made in Murshidabad, the former capital of Bengal, where artisans who made ivory articles for the court, such as combs and fly-whisk handles, began to produce candlesticks, figurines based on European porcelain, and pieces of furniture. Some of the articles in this volume that were undoubtedly made by furniture-makers but which are not, strictly speaking, furniture, belong to the Museum's Metalwork Department, which acquired them for their fine mounts. These include a rare sixteenth or early seventeenth-century Gujarati tortoiseshell casket (cat. 2), and an important group of seventeenth-century Gujarati mother-of-pearl articles (cat. 10–13).

Gifts, bequests and timely acquisitions have meant that the Victoria and Albert Museum today holds the most comprehensive and sizeable collection of furniture and woodwork made in the Indian subcontinent, largely under European patronage. The purpose of this volume is to provide readers with some idea of the breadth of this collection and the huge diversity of influence it represents. It is this amalgamation of influences from within and outside India that renders the objects under discussion both visually stimulating and culturally important. However, it is perhaps because of its hybridity that past scholars overlooked this genre of object. The purpose of this volume, then, is to convey a sense of the richness and variety of India's cabinet-making traditions and to provide these rare and curious articles with the attention they deserve.

1

Robinson Casket

This casket was acquired in Lisbon before 1888 by Sir Charles Robinson, Superintendent of Art Collections of the South Kensington Museum, renamed the Victoria and Albert Museum in 1899.[20] It belongs to a group consisting of at least nine caskets probably made in Kotte, Ceylon and sent by that kingdom's rulers to Portugal as diplomatic gifts of the finest quality, in some cases marking specific historical and religious events.[21] The caskets are best understood in the context of Sinhalo-Portuguese relations. Bhuvaneka Bahu (r.1521–51), King of Kotte and nominal Emperor of Ceylon, sought Portuguese support in his attempts to subordinate his neighbouring rivals, particularly his brother and nominal heir, Mayadunne Pandar, ruler of Sitavaka, and establish his grandson Dharmapala as his heir.[22] The Portuguese endorsed Bhuvaneka Bahu's claims, and in 1542–43 an embassy was sent from Kotte to Lisbon, and Dharmapala was crowned in effigy by Dom João III (r.1521–57).

Through this gesture Bhuvaneka Bahu managed to secure the succession to his throne and bolstered his position as overlord of the island.

This casket is the first in the group to depict Christian motifs. Bhuvaneka Bahu, keen to secure military support from the Portuguese, bargained with continuous promises to convert to Christianity.[23] This he failed to do, chiefly since he felt it would lose him the support of his people, who were largely Buddhist. The situation had changed by the time of his grandson Dharmapala's accession in 1551, princes from Kandy and Sitavaka having

☐ **Ivory, carved, with silver gilt hinges, the lock and handle of gold filigree set with sapphires**
Kotte, Ceylon, *c.*1557
Height: 13.7 cm Width: 22.8 cm Depth: 12.7 cm
IS 41-1980

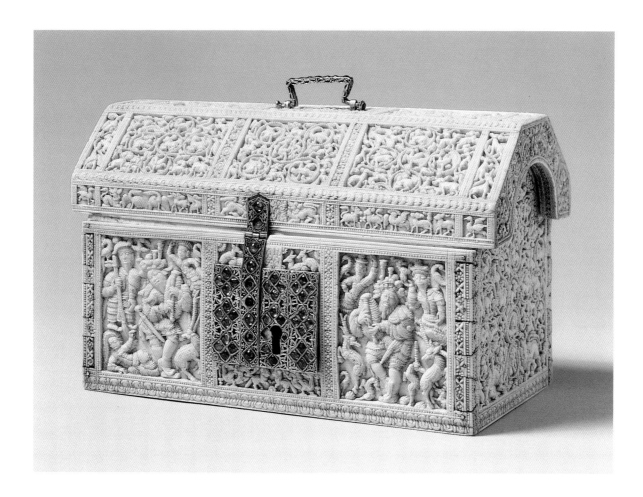

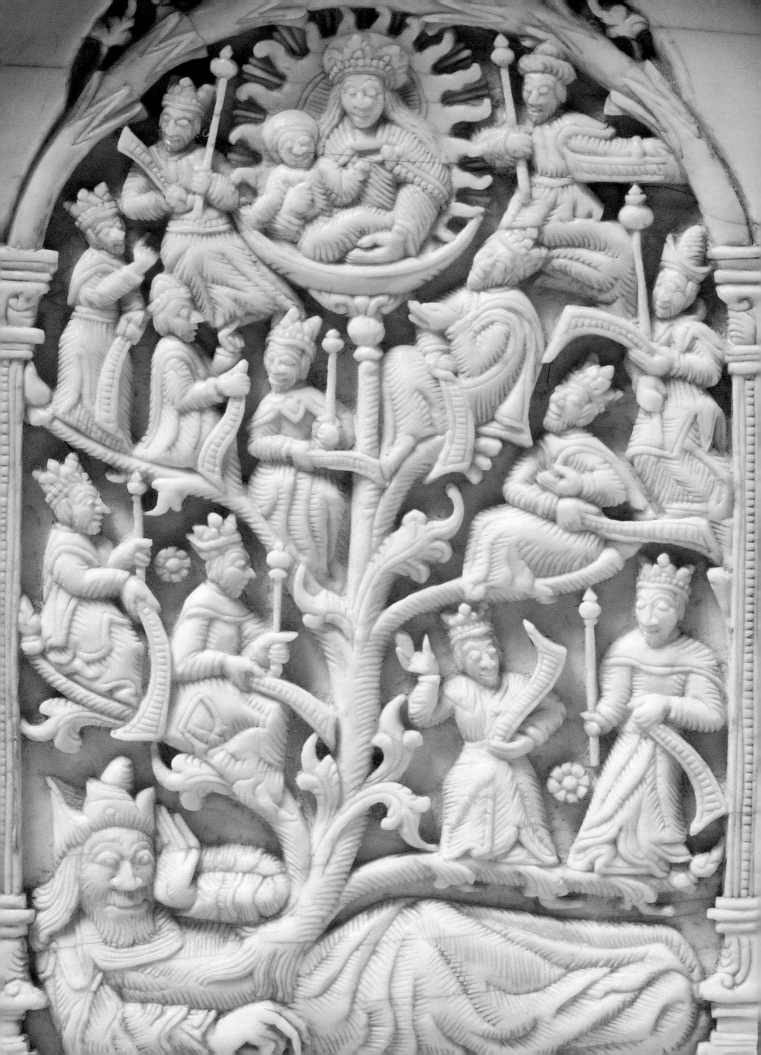

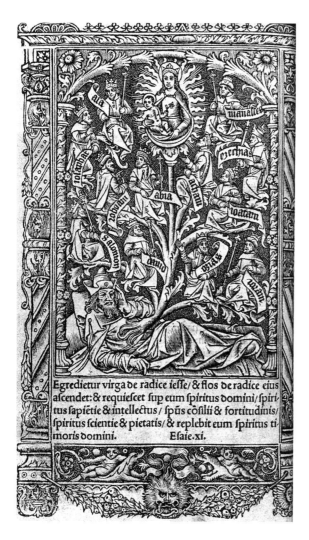

The Tree of Jesse, woodcut by Thielman Kerver in *Horae beatae Mariae Virginis*, 1499; V&A Picture Library

casket was sent to Portugal via Franciscan monks accompanying this announcement.[24]

In the same year the Portuguese succession was secured with the long-awaited birth of Sebastião – known as 'O Desejado' or the desired one – grandson and heir to Dom João III. Hitherto it had been feared that Portugal would be absorbed into the Spanish empire, the strongest claimant to the throne being Philip II of Spain.[25] In Sebastião the gradually declining Portuguese empire saw its opportunity for revitalization, and the decoration of the casket refers to this event in its expression of joy at the conversion of Dharmapala. This interpretation is certainly supported by its iconography, which develops the themes of birth and rebirth with both Christian and Sinhalese motifs.

The left panel of the back of the casket shows the Betrothal of the Virgin, the first event immediately connected with the birth of Christ. Mary and Joseph are portrayed standing on dragons representing the power of Christianity over the forces of evil. The right panel of the back shows the Rest on the Flight into Egypt, which is an integral element in depictions of the cycle of the infancy of Christ. The Tree of Jesse, on the right end of the casket (see p. 15), is an interpretation of the dream of Jesse, which prophesied that the Messiah would descend from twelve kings of Israel of his own family. The depiction on the casket would appear to have been copied from a Book of Hours printed by Thielman Kerver as early as 1499, and reprinted at least until 1546 (left).[26] Apart from the inscriptions on the scrolls held by each of the kings, the Tree of Jesse on the casket very clearly follows the printed source down to subtle elements such as the positioning of figures and gestures. Printed religious images were employed in Portuguese spheres of influence from Africa to East Asia, originally as tools for conversion but ultimately inspiring the decoration of a range of locally-made secular and religious objects.[27] A print by Albrecht Dürer (1471–1528) of 1514 was clearly the source for the modelling of the central bagpiping shepherd on the front right and left panels of the casket, although liberties have been taken with aspects of his dress.

already embraced Christianity. Dharmapala was himself invested on the throne by the Portuguese, and, after six years as king, he and his court adopted Christianity. In 1557 Dharmapala dispatched a letter to Dom João III informing him of the conversion; it is very likely that the

Tortoiseshell casket

The translucent panels lend an unreal quality to this casket, which is constructed entirely of tortoiseshell secured with elaborate silver mounts. In Portugal caskets of this type have been highly prized, particularly in churches, where they have been used as reliquaries and ciboria.[28] Their shape follows a typical Portuguese form that was executed in India in various materials including gold, ivory and mother-of-pearl. The mounts, which are incised with vegetal and animal motifs, are also found on Gujarati mother-of-pearl articles made under Portuguese patronage, suggesting that local silversmiths were supplying the makers of tortoiseshell and mother-of-pearl goods.[29]

Until recently this casket and examples of its type were thought to be seventeenth-century Spanish or Portuguese. Their new Indian attribution is based on recent Portuguese scholarship, which has drawn on documentary sources and an in-depth study of the properties of the caskets themselves. Contemporary travel accounts confirm that tortoiseshell articles were made in India under Portuguese patronage and that they were highly valued in Europe. The early seventeenth-century French traveller François Pyrard de Laval, for example, revealed that the centre of the tortoiseshell market was Cambay,

where the material was worked into women's bracelets, and 'very beautiful caskets and boxes decorated with silver'.[30] He likewise observed, at Cambay and Surat, 'small cabinets, caskets and boxes in tortoiseshell that they make so clear and polished that there is nothing more beautiful'. Tortoiseshell caskets mounted with silver also appear in contemporary Portuguese documents, both in India and in Portugal. For example, the inventory of a customs official in Diu dated 1546 included a money chest of 'tortoiseshell and silver',[31] while the gifts presented by Cardinal-King Henry of Portugal (1512–80) to the Sultan of Morocco from 1577 to 1580 included 'a small casket in tortoiseshell, decorated in silver' and 'another flat chest in tortoiseshell . . . all decorated in silver'.[32]

The casket was acquired in San Sebastián in 1919 by W.L. Hildburgh, an American collector of Spanish metalwork, who gave it to the Museum in 1955.

Tortoiseshell, with silver mounts

India, 16th or early 17th century

Height: 13 cm Width: 28 cm Depth: 14 cm

M. 10-1945

Gift of W.L. Hildburgh

Fall-front cabinet

Portable fall-front cabinets of this type were designed for holding personal effects and were a basic requirement of European merchants and traders living and travelling in Asia. This piece belongs to one of the earliest identifiable groups of furniture made in India under Portuguese patronage in the sixteenth and early seventeenth centuries. The production of such furniture was based in western India, a long-standing centre of luxury goods where there were firmly established merchant communities from the Middle East, South-East Asia and Europe.[33] Contemporary accounts differ as to the precise place of manufacture of such articles, suggesting perhaps that there were several centres in the region working in related styles and sharing methods of production. Francisco Pelsaert noted in 1626 that in Tatta, Sindh, 'Ornamental desks, draught-boards, writing cases, and similar goods are manufactured locally in large quantities; they are very prettily inlaid with ivory and ebony, and used to be exported in large quantities to Goa and the coast-towns.'[34] Writing at the close of the seventeenth century, Captain Cope confirmed that at Tatta, 'They make fine Cabinets, both lack'd and inlaid with ivory.'[35] By contrast, the early seventeenth-century English traveller William Finch cited Gujarat as a leading centre of fine inlay work.[36] Another English traveller, Sir Thomas Herbert, wrote in around 1626 that at Swally (where ships for Surat usually anchored, and discharged or took in cargo), 'scrutores or cabbinets' of ebony, ivory and mother-of-pearl were available for purchase,[37] while James Ovington noted in the late 1680s that Surat was a source of 'Desks, Scutores, and Boxes neatly polisht and embellisht'.[38]

Whatever their place of manufacture, it is clear that portable fall-front cabinets of this type were made in large numbers and traded both locally and to Europe, where their exotic materials and decoration would have ensured that they were highly esteemed. As with other goods bound for Europe, such cabinets were frequently traded through Goa. Pyrard de Laval wrote around 1610 that, among the goods handled there,

> I should mention a great number of cabinets of all patterns, in the fashion of those of Germany. This is an article the most perfect and of the finest workmanship to be seen anywhere; for they are all of choice woods, and inlaid with ivory, mother-of-pearl, and precious stones; in place of iron they are mounted with gold. The Portuguese call them, *Escritorios de la Chine.*[39]

Although known as 'German' cabinets, due to the renowned luxury examples made at Augsburg and Nuremberg, this form seems to have originated in Spain, where it was known as a *scritorio* or *escritorio*, from which derived the English scriptor or scrutore (Spanish cabinets of this type were known as *varguenos* only after the mid-nineteenth century).[40] These cabinets were used for storing private papers and personal effects. Although of Western form, fall-front cabinets also came into use by Indians, as is evident from the margin (*hashiya*) decoration on a Shah Jahan period miniature in the Chester Beatty Library, Dublin, in which it is possible to see such a cabinet being used to store jewellery (below).

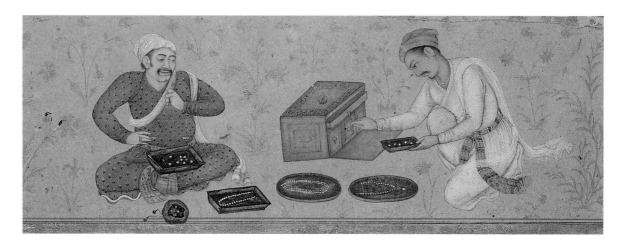

Detail from a portrait of Rustam Khan; gouache on paper; Mughal, *c.*1650; reproduced by kind permission of the Chester Beatty Library, Dublin

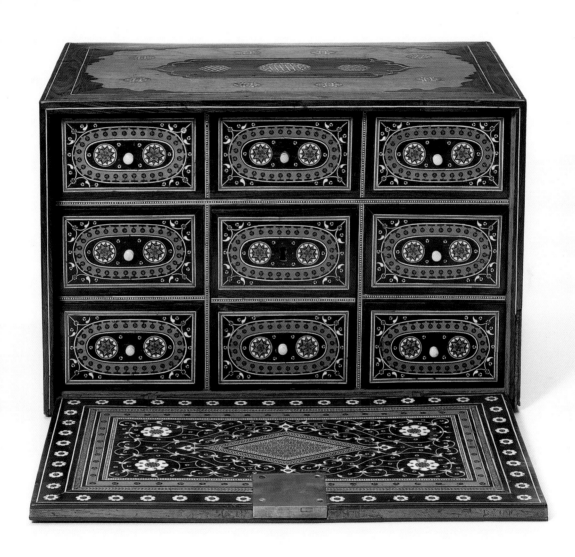

☐ **Wood, veneered with rosewood, inlaid with exotic woods, ivory, brass and** *sadeli*

Gujarat or Sindh, 16th century

Height: 35.5 cm Width: 45 cm Depth: 30 cm

317-1866

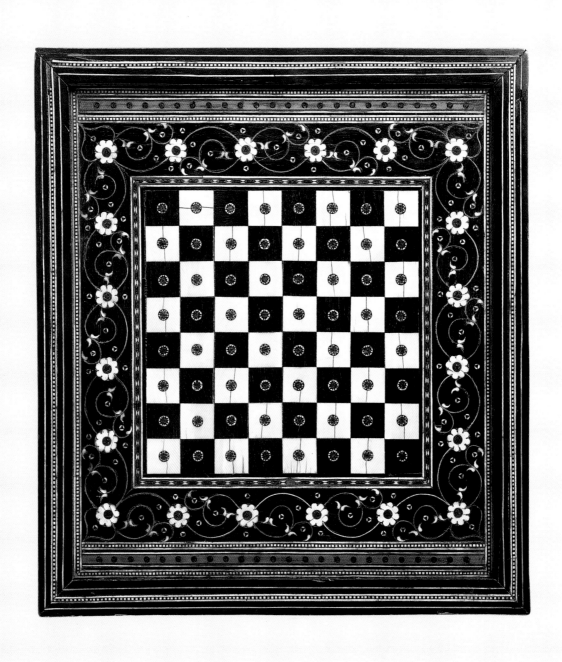

Reversible games board

Were it not for the use of tropical woods in its manufacture, this games board might well have been made in sixteenth-century Italy, so closely does its aesthetic conform with examples of woodwork produced there in the 'Veneto-Saracenic' style.[41] This board is configured on one side with alternating squares of ebony and ivory for chess (see p. 20); and on the other with divisions for tric-trac, an ancestor of modern-day backgammon (below). Both sides are veneered with ebony inlaid with ivory, and with *sadeli*, a micro-mosaic of woods and metals arranged in geometric patterns. This technique has been in use since Antiquity, but is particularly associated with the Near and Middle East, whence it spread, both west to Italy and east to Persia and India. The Italian variety of this work was known as *alla certosina*, after the Certosa (Charterhouse) of Pavia, one of many places where such work was executed.

Common to both East and West, games boards were among the first articles encountered by Europeans in India which they themselves could use. Duarte Barbosa recorded among the articles he saw in India around 1516 'bracelets, sword-hilts, dice, chessmen and chessboards'.[42] Huygen van Linschoten observed at Cambay around 1585 'fine playing tables, and Chessebordes of Ivory',[43] and Francesco Pelsaert saw that in Sindh in about 1626 'draught-boards, writing cases, and similar goods are manufactured locally in large quantities; they are very prettily inlaid with ivory and ebony, and used to be exported in large quantities to Goa and the coast-towns.'[44]

A sixteenth-century Gujarati reversible games board decorated with mother-of-pearl is in the Bavarian National Museum, Munich (R 1099).

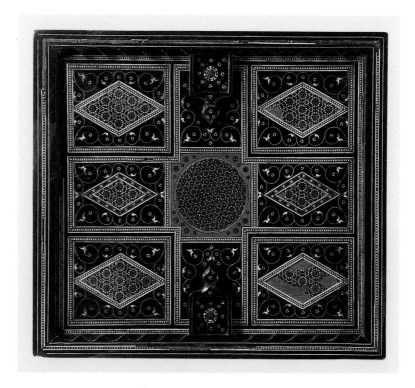

☐ **Teak, veneered with ebony, citronwood, ivory and *sadeli***
Gujarat or Sindh, 16th century
Length: 32.5 cm Width: 29.2 cm
1961–1899

5

Casket

In the sixteenth and seventeenth centuries, Gujarat, in western India, was the centre of production of a range of articles decorated with or fashioned out of mother-of-pearl.[45] The principal appeal of mother-of-pearl, a substance found in thin layers on the inside of certain shells (most particularly *Turbo marmoratus*), lay in its lustrous and iridescent surface. Articles made from the material reflected light and glowed in pretty shades of pink and green. The material was also versatile; it was sufficiently strong and stable as to be applied in pieces over a wooden carcass as a veneer, or could be used alone in the construction of smaller articles such as bowls and cups.

Gujarat is first mentioned as the centre of mother-of-pearl work in 1502, in which year the King of Melinde, on the East Coast of Africa, presented Vasco da Gama with 'a bedstead of Cambay, wrought with gold and mother of pearl, a very beautiful thing'.[46] In the European context, Indian mother-of-pearl first makes its appearance in Portuguese royal collections. A list of Manuel I's (1469–1521) wardrobe made in 1522 included, among other things, 'a casket from India inlaid with mother-of-pearl with eighteen sheets of silver', while in 1529 Francis I of France (1494–1547) purchased a chair and bed made in India, which were 'marqueté a feillage de nacle de perle . . . vernissée de noir et enrichie de feuillages et figures dor'.[47]

Gujarati mother-of-pearl can be classified into two groups. The first, to which this casket belongs, consists of articles made of wood and covered with a dark mastic inset with pieces of mother-of-pearl in vegetal, geometric and, less frequently, figurative designs. The second group consists of objects which are either constructed entirely from pieces of mother-of-pearl; or constructed of wood, entirely overlaid with pieces of mother-of-pearl (see cat. 11, 12, 13 and 14). A physical examination of the objects themselves suggests that the two groups were influenced by one another and possibly even made in the same place; similarities are evident not only in the forms that were manufactured, but also in design and methods of construction. That there exists a small group of objects that has both mastic-inset *and* overlaid mother-of-pearl

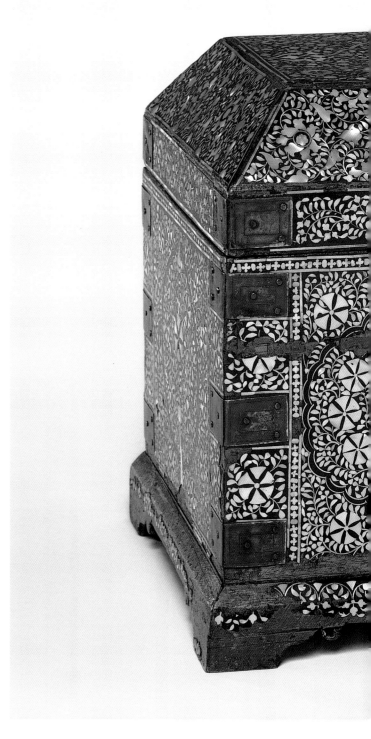

■ Teak, overlaid with mother-of-pearl set in black lac, with engraved brass mounts

Gujarat, *c.*1600

Height: 35 cm Width: 51 cm Depth: 28.5 cm

155-1866

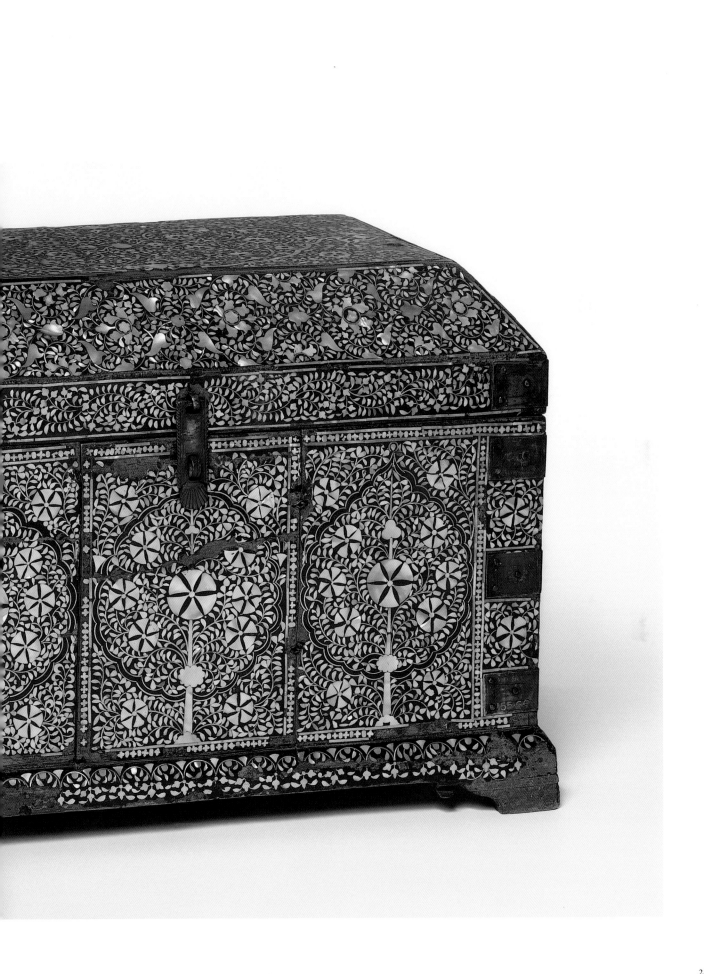

decoration also suggests that craftsmen working in the two techniques collaborated or deliberately worked in each other's style.

The Dutch traveller Jan Huygen van Linschoten described how shells were worked in India in the last quarter of the sixteenth century:

> they make divers things of them, as deskes, tables, cubbards, tables to play on, boxes, staves for women to beare in their hands and a thousand such fine devises, which are all inlaid and covered with this Chanco or Mother of Pearle, very faire to beholde, & very workmanlike made, and are in India so common that there is almost no place in those countries but they have of them. It is likewise much carried abroad, both into Portingale, and elsewhere.[48]

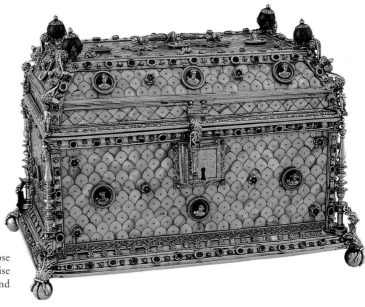

Casket; teak, overlaid with mother-of-pearl; Gujarat, early 16th century, mounts by Pierre Mangot, 1532–33; Musée du Louvre, Paris; © Photo RMN - Michèle Bellot

In spite of numerous contemporary references to the production of mother-of-pearl articles in Gujarat, little can actually be established about the place or conditions of their manufacture. It is generally thought that mastic-inset mother-of-pearl work was a speciality of Ahmedabad. This is based partly on Abu'l Fazl's *Ain-i Akbari* (1595), in which *sarkar* Ahmedabad (or the province of Ahmedabad, i.e. Gujarat) is described as the centre of production of a range of exports, including articles worked with mother-of-pearl: 'Designers, wood-inlayers and countless other craftsmen so set mother-of-pearl that it appears a fine line, and make pen-boxes and coffers and the like of these.'[49] Further evidence comes from the survival of mastic-inset mother-of-pearl decoration on the tomb canopies of Shah Alam at Rasulabad and Shaykh Ahmad Khattu at Sarkhej, both in the vicinity of Ahmedabad and erected between 1605 and 1608. European travellers, including Gaspar Correa (1502), Pyrard de Laval (1608) and Sir Thomas Herbert (1627–29), indicate that mother-of-pearl articles were available at Surat and Cambay, although it is not certain whether such goods were actually made at these cosmopolitan ports or produced in Ahmedabad or elsewhere in the hinterland and transported to the ports for export. Linschoten singles out Tatta in Sindh as a centre of manufacture. According to him, in Sindh, 'They make also all sorts of Desks, Cupboards, Coffers, Boxes and a thousand such like Devises in Leade [inlaid] and wrought with mother of

pearle, which are carried throughout India, especially to Goa and Cochin, against the time that the Portuguese ships come thither to take in their lading.'[50]

This casket, with its pitched lid and bracket feet, is of a standard form made at mother-of-pearl workshops. Caskets of similar shape and ornament in the Green Vaults, Dresden and the Bavarian National Museum, Munich, are recorded in documents of 1602 and 1637 respectively.[51] The same form, but overlaid with mother-of-pearl plaques, was mounted by French court goldsmith Pierre Mangot and hallmarked 1532–33 (above).[52] A piece of related form, but larger, has been used as a reliquary in Lisbon Cathedral, and is dated by scholars to the first half of the sixteenth century.[53] A reliquary in the Treasury of the Capuchin Monastery, Vienna is yet another example, and is documented in the *Kunstkammer* inventory of Kaiser Rudolf II of 1607–11,[54] while a final example existed in the collection of Ferdinand II of Tyrol, documented in 1596 and now at Schloss Ambras.[55] Whether inset or overlaid with mother-of-pearl, most of these caskets are constructed and treated in the same manner, the interior and underside painted red.

6

Painted fall-front cabinet

This cabinet, which has lost its fall-front and drop handles, is based on a sixteenth-century continental European form that was much reproduced in Asia under European patronage.[56] Its painted surface, however, is in a provincial Mughal style and exemplifies the tradition of Mughal painters applying their talents to different media.[57] The European form and subject matter point to

Wood, painted and varnished

Western India, early 17th century, the gold paint on the top later

Height: 15.5 cm Width: 17.6 cm Length: 26 cm

IS 142-1984

Gujarat as a probable place of manufacture. The region was celebrated both for its production of Western-style furniture, especially portable cabinets of this type (see cat. 3 and 7), and for the skill of its craftsmen in painting and varnishing wood. Edward Terry, chaplain to Sir Thomas Roe, ambassador of James I (r.1603–25) to the court of the Mughal emperor Jahangir (r.1606–27), observed how this technique was practised in 1616:

> They paint staves, or bedsteads, chests of boxes, fruit dishes, or large chargers, extremely neatly, which when they be not inlaid, (as before) they cover the wood (first being handsomly turn'd) with a thick gum, then put their paint on, most artificially made of liquid silver, or gold, or other lively colours, which they use; and after make it much more beautiful with a very clear varnish put upon it.[58]

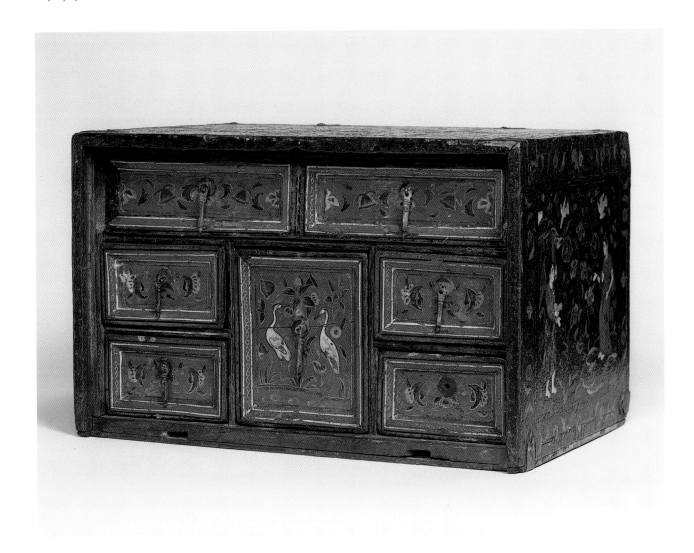

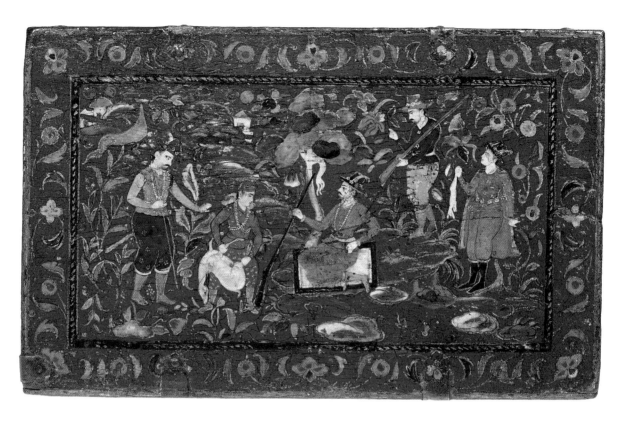

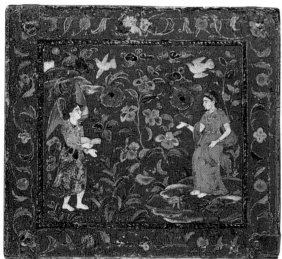

The right side of the casket (left) depicts a woman in conversation with an angel. Scholars are agreed that this represents the Annunciation. The choice of subject was doubtless inspired by Christian paintings and printed works introduced to the Mughal court during the Jesuit missions of the 1580s and 1590s.[59] However, Mary (Maryam) also figures prominently in the Koran, in which she is revered for her purity. The announcement by Gabriel (Jibril) is described in the nineteenth chapter of the Koran, *Surat Maryam*:

> He said: I am only a messenger of your Lord: That I will give you a pure boy.
>
> She said: When shall I have a boy and no mortal has yet touched me, nor have I been unchaste?
>
> He said: Even so; your Lord says: It is easy to Me: and that We may make him a sign to men and a mercy from Us, and it is a matter which has been decreed.
>
> So she conceived him; then withdrew herself with him to a remote place.

In Western painting the Virgin is usually shown indoors in a contemplative attitude, typically with book in hand. The Angel Gabriel stands proclaiming his message, while

a dove symbolizing the Holy Ghost descends in her direction (see opposite below). The depiction of the Virgin Mary on the box is somewhat unconventional. Apart from the inclusion of two doves, rather than one, we find that the Virgin is not the modest Madonna of Western art who is draped from head to foot and bears a demure, submissive expression. Instead, she gesticulates with bare arms, her head uncovered, and adorned with rich necklaces, with flowers strewn in her hair. The probable model for the Virgin on the box is not a traditional representation of Mary, but an allegorical figure of the type found in engravings circulated by Europeans at the Mughal court, which court artists copied, reworked and conflated with other religious and courtly scenes.[60]

The back (see top image, p. 26) and left side of the box depict a hunting party, a popular subject in Mughal painting.[61] However, these scenes are not of Mughal princes, but of Europeans. The figures on the left side are engaged in hunting a pair of fowl, while those on the back are celebrating their catch, the central figure sitting on a carpet in the Indian style, while an Indian servant parades before him the game that they have shot. The Europeans are dressed in an early seventeenth-century style, but their garments are more than usually colourful and depart from contemporary Western conventions of male dress. It is known that Europeans in India had their own fashions copied in local textiles, and this may account for the curious mixture of colours on the doublet, breeches and cloak. Some of the figures are wearing necklaces and strings of flowers in their hats. The former, although worn as prerogatives of rank or station at home, would not ordinarily have been donned for hunting. Judging by the long barrel and slender stock, the Europeans are using *toradars*, Indian matchlock muskets.[62] Firearms were introduced to India by the Portuguese, as well by the Mughal emperor Babur (r.1526–30), whose success at the Battle of Panipat (1526) was apparently due to his troops being armed with imported guns.

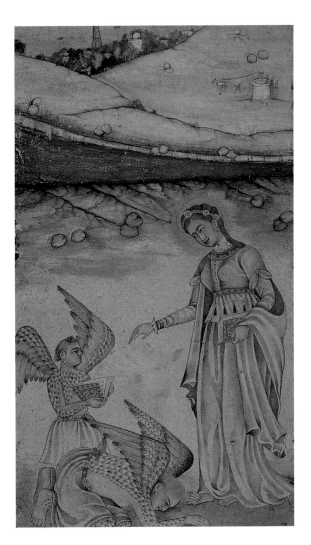

The Annunciation; album leaf on paper; Mughal; 17th century; © The British Museum

Fall-front cabinet

Fall-front cabinets and boxes made in Gujarat and Sindh in the sixteenth century and early seventeenth are typically decorated with inlay of one sort or another, ranging from micro-mosaic work (*sadeli*) to geometric, floral and figurative marquetry in wood and ivory (see cat. 3 and 6). This example is representative of a group characterized by the inlay of ivory (either white or stained green), a variety of woods, and brass or copper. A range of decorative motifs is found, including animals positioned symmetrically or chasing one another, courtiers, and armed hunters – both Indian and Portuguese – on foot, or mounted on horses or elephants. Such figures are usually portrayed around mounds from which spring trees with multiple branches and abundant foliage. Similar motifs are found on Gujarati mastic-inset mother-of-pearl cabinet-ware.[63]

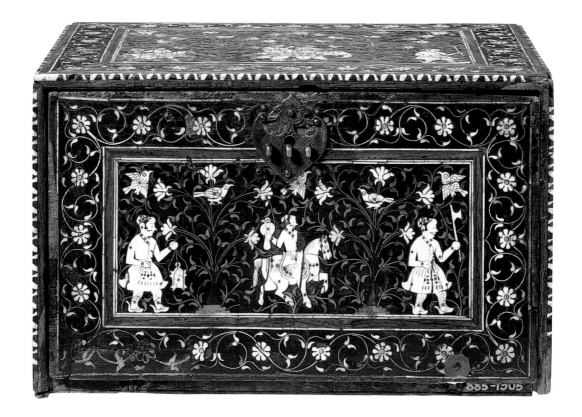

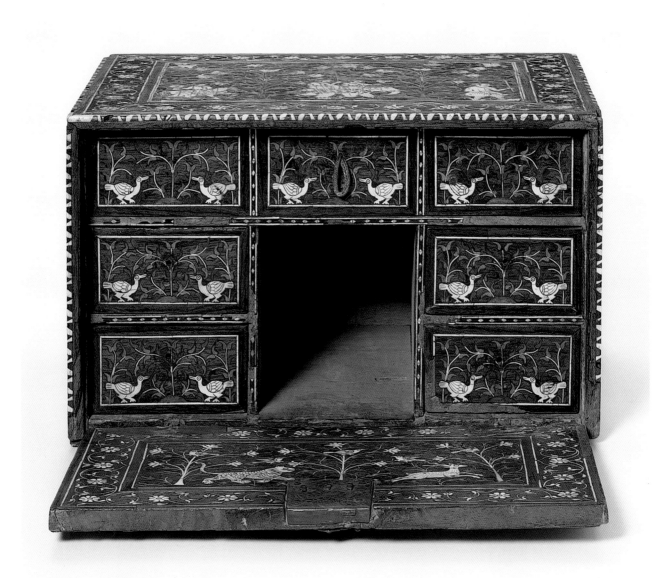

☐ Teak, veneered with rosewood and inlaid with
tropical woods, ivory and brass, with silver
escutcheon and iron mounts

Gujarat or Sindh, early 17th century

Height: 16.5 cm Width: 27.5 cm Depth: 20 cm

885-1905

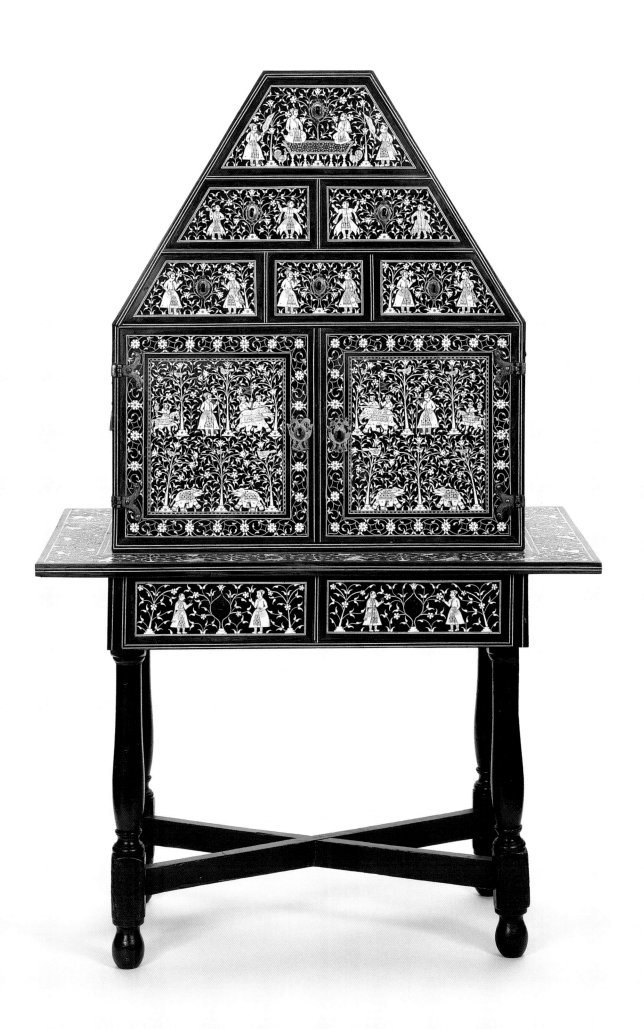

Cabinet on table-stand

This cabinet on table stand is a *tour de force* of Indian furniture-making. The exterior is richly inlaid in ivory, with pairs of courtly figures engaged in activities including conversing while seated on a platform throne (*takht*), dancing, falconry, and hunting on elephant back. The figures flank centrally positioned trees with spreading branches and split leaves. In contrast to the figures and profuse foliage of the exterior, the interior of the cabinet (below) is geometric in character; the drawer fronts and inner face of the doors are inset with a micromosaic (*sadeli*) of stars and circles composed of transversely cut sections of woods and materials arranged in repeating patterns.

The decoration of the piece is typical of a large group of furniture that scholars believe originated in western India, specifically the coastal regions of Gujarat and Sindh. This attribution is based on a number of factors – principally the numerous contemporary documentary sources that confirm that this region was a centre of production for fine ivory-inlaid articles specifically aimed at Western markets (see cat. 3). Supporting evidence is found in the character of the ornament. For example, the treatment of the figures, with their pointed noses and wide eyes, and the curly moustaches worn by men, conforms to Gujarati and Rajasthani painting traditions.[64] *Sadeli* decoration (see cat. 4) is found in northern

Italy and Islamic lands, including Moorish Spain, Syria and Persia, and is also characteristic of western India, particularly Sindh, to which it was allegedly carried from Shiraz by Parsee artisans.[65] Although the *sadeli* work on this cabinet is Eastern in character, its use is probably more inspired by Mudéjar geometric inlay and Italian *alla certosina* work on cabinets brought to India by the Portuguese than by any local decorative traditions.[66]

The handling of the ivory and the manner in which the figures are depicted suggest that this cabinet on table stand was made in the late sixteenth or early seventeenth century. The dancing figures on the second tier of drawers, for example, wear a distinctive type of robe with a pointed hemline (*chakdar jama*) fashionable at the Mughal court during the reigns of the emperor Akbar (r.1556–1605) and his successor Jahangir (r.1605–27) (see p. 32).[67] The sashes (*patka*) tied around the waists of the figures are decorated with geometric patterns resembling those in fashion at Jahangir's court, and some of the male figures wear turbans of a variety also popular in that period.[68] As may be seen from the figures on the cabinet, *jamas* are fastened to one side of the chest, near the armpit. Under the direction of Akbar, Muslims were invited to tie their *jamas* to the right and Hindus to the left, making it easy to identify members of the different faiths.[69] Figures depicted on this cabinet are shown with

☐ **Wood, veneered with ebony, inlaid with ivory, with gilt copper mounts and brass carrying handles**

Gujarat or Sindh, late 16th or early 17th century, with later legs

Height: 73.5 cm Width: 65 cm
Depth: 36.5 cm

IM 16-1931

Gift of Mrs Beachcroft

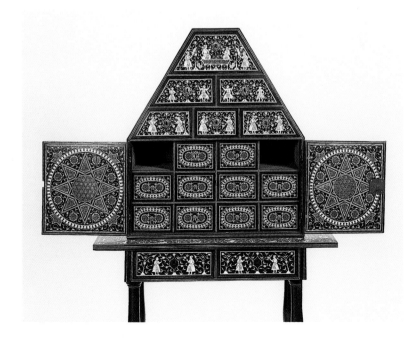

Ragini; gouache on paper by Pandit Virji; Pali, Marwar, dated VS 1680 (AD 1623); private collection

jamas tied to the right and left, although it is difficult to know whether this was in accordance with religious distinctions or simply more convenient in terms of design.

The border around the table top is inlaid with scenes of men hunting (*shikar*) tigers and gazelles. Hunting themes permeate Mughal design and may be seen not only in miniature painting, but also adorning a range of articles including carpets, clothing and metalwork.[70] The presence of hunting scenes on this and many related cabinets has traditionally been viewed as a Mughal influence. However, it is important to remember that such themes were equally in vogue on high-quality European cabinets of the period, which were increasingly given to narrative decoration. These were executed in a variety of techniques, from inlaying materials into wood to etching on ivory, the latter permitting a fluidity of design that made it possible to replicate images directly from printed works, such as Gaston Phébus's *Livre de la chasse* (1563).[71] Hunting motifs are also in evidence on contemporary textiles made in Bengal under Portuguese patronage, suggesting that this subject was a particular favourite among the Portuguese in the period.[72]

Although the basic form of the cabinet confirms that it was intended for European use, the unconventional trapezoidal upper section with drawers is atypical of Western furniture forms. Numerous cabinets with pyramidal tops were certainly made under Portuguese patronage in India. Related examples may be seen in the David Collection, Copenhagen, and in a private Portuguese collection.[73]

Communion table

This table, with its decoration of Christian and Indo-Persian elements, is a rare surviving example of liturgical furniture made in India under Portuguese patronage in the early seventeenth century. The style of the ivory inlay and the character of much of the ornament conforms to a large group of cabinets made to European designs in western India from the mid-sixteenth century onwards. However, this is at present the only known table from this school, and one of a very few pieces of furniture with direct Christian imagery.

At the centre of the table is an ornate monstrance surrounded by cherubs and four angels, the upper two carrying censers and the lower two candles. These are encircled by an inscription, *Lovvado seia Osantissimo Sacramento* (Portuguese for 'Blessed is the Holy Sacrament').[74] At the centre of the composition is the Host, the consecrated wafer taken as the body of Christ in the Holy Sacrament of the Eucharist. This ritual was established by Jesus at the Last Supper, when he offered his Apostles bread and wine as tokens of his own flesh and blood.

Around the end of the fourteenth century, monstrances (vessels for displaying the Host) became a standard component of church furniture and were placed visibly on altars or carried in procession.[75]

The Eucharist is of central importance in Christian ritual; just as Jesus instituted this sacrament over a table, so has a table featured centrally in its celebration ever since. Accordingly, an altar or communion table is part of the furniture of every Catholic church, so placed that communicants can approach it and receive the Host from their priest. With the spread of Christianity in Asia under the proselytizing missions of the Jesuits and other religious orders, there developed a need for devotional works of art and liturgical articles, such as communion tables, in order to furnish newly built churches. This demand was met in various ways that included sending such articles from Europe and having local artists copy them.[76] This convergence of cultures flourished in a particularly positive way in late sixteenth- and early seventeenth-century India, where, in Portuguese-controlled regions such as

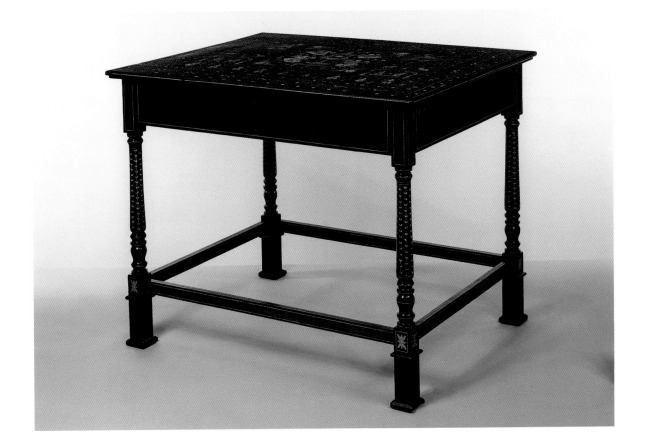

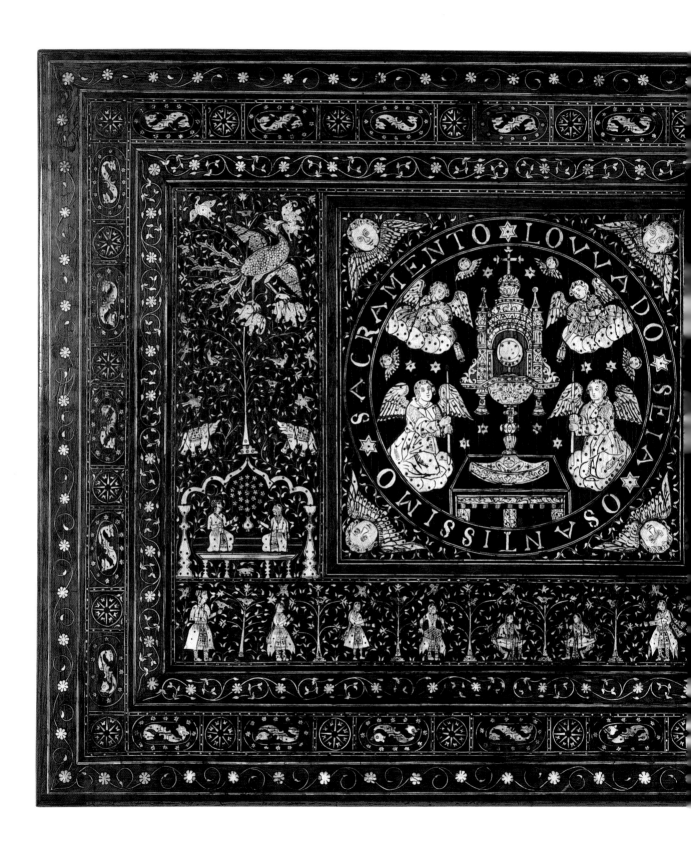

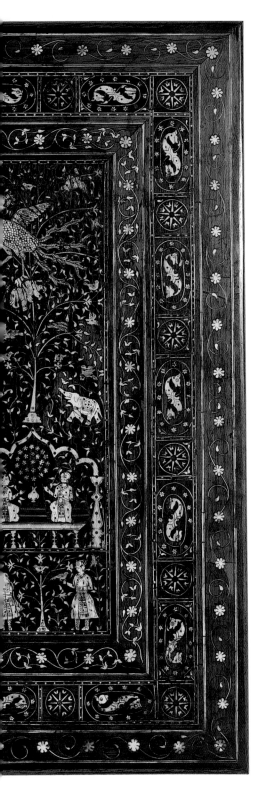

Goa, impressive churches were erected that proclaimed the glory of Christianity. The predilection of the Mughal emperors Akbar and Jahangir for Western representations of biblical subjects led to the incorporation of such images into both imperial miniature painting and murals at palace complexes at Agra and Lahore.

The hybrid style of Mughal painting of this period is reflected in the decoration of this table, whose central Christian panel is surrounded by Indo-Persian motifs. At the top is a pair of *simurghs*, fantastically-plumed mythic birds of Persian inspiration believed to nest in the Tree of Knowledge (left). As on this table, the *simurgh* is sometimes shown with elephants in her clutches, characteristic behaviour of the mythic roc (*rukh*) of the Arabian Nights. Further down the table there is a couple seated in conversation leaning against bolsters on a platform throne (*takht*) and below them is a row of courtly figures, the women dancing and clapping their hands, and the two men each holding a bird. As on a cabinet with related inlay also in the Museum, these figures are dressed in a style fashionable in the late sixteenth century and early seventeenth (see cat. 8). A cabinet with related *simurghs* and courtly figures is in the Museu Nacional de Arte Antiga, Lisbon (inv. 1312).[77]

According to tradition, this table was commissioned for the Jesuit chapel at Lahore.[78] A table inlaid with ivory was indeed ordered for that chapel in 1616; however, there is nothing to suggest that this is the same piece.[79]

☐ **Blackwood, inlaid with ivory**

Gujarat or Sindh, 1600–10;
elements of the base later

Height: 84 cm Width: 106 cm
Depth: 102.5 cm

IS 15-1882

The mythical bird simurgh grasping elephants in its claws, line drawing with coloured wash; Mughal, *c*.1600–20; V&A: IM 155-1914

Ceremonial mace (*chob*)

In India, as in Europe, the mace was both an instrument of war and, in a ceremonial context, a symbol of authority. Mace-bearers or stick-bearers (*chobdars*; see also cat. 31.) appear in depictions of Mughal court scenes, usually standing outside the inner railings that surround the ruler (see p. 37). Their function appears to have been that of regulating entry to the immediate precincts of the throne; in the *Padshanamah* manuscript, for example, they appear only in presentation scenes in which objects of value are in evidence or where some level of security is needed.[80] Mughal arms were often highly decorated and made of precious materials; the Emperor Jahangir (r.1605–27) himself refers in his memoirs to a six-flanged mace (*shashpar*) made out of solid gold.[81] Maces such as these are unlikely to have been made for any other purpose than to be used in court ceremony.

Mother-of-pearl was certainly a favoured material at the Mughal court. In 1616 Sir Thomas Roe observed at the emperor's camp near Agra, 'a throwne of mother of pearle borne on two pilla[r]s raysd on earth',[82] and at celebrations for New Year (*Nowruz*), he saw among the decorations a square 'pavilion' (possibly a canopy throne) of 'wood, inlayd with mother of pearle'.[83] Such articles were probably the work of artisans from Gujarat, where mother-of-pearl was worked into the decoration of luxury goods for consumption within India and for export to markets in the Middle East and Europe (see cat. 5).

The decoration of this mace relates closely to that of the tomb canopy erected in the mausoleum of Shaykh Salim Chishti at Fatehpur Sikri (1571–81), near the Mughal capital at Agra.[84] It is difficult to know whether the canopy was made in Gujarat and simply constructed at Fatehpur Sikri, or built by Gujarati craftsmen working *in situ*. What is clear, however, is that it was installed at some point before 1610, in which year English traveller Ralph Finch noted 'the faire and sumptuous tombe, artificially inlaied with mother of pearle and inclosed with a grating of stone curiously carvd'.[85]

The *Padshahnama* manuscript: *Shah Jahan receives his three eldest sons and Asef Khan during his accession ceremonies*; attributed to Ram Das; Mughal, *c.*1640; The Royal Collection © 2001, Her Majesty Queen Elizabeth II

■ **Wood, overlaid with mother-of-pearl secured with brass pins, with copper handle and finial**

Mughal, *c.*1600

Height: 30 cm Width: 13 cm

IM 228-1927

Bequeathed by the Marquess Curzon of Kedleston

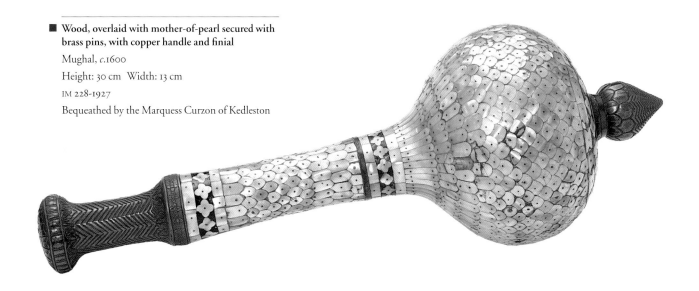

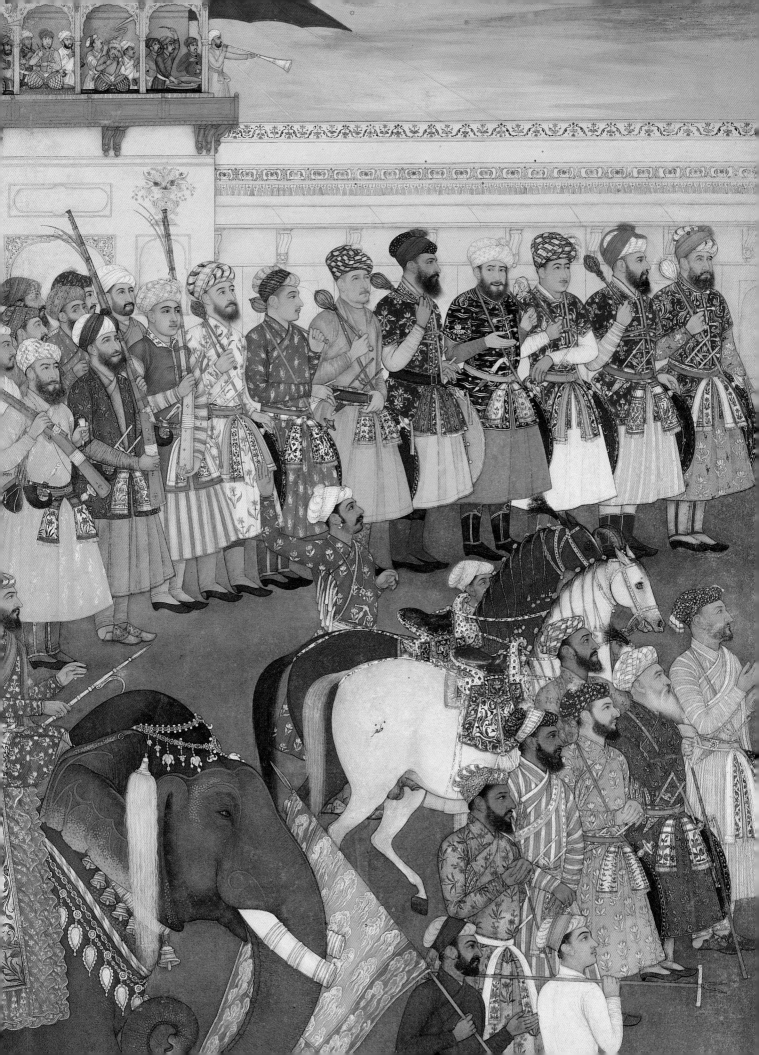

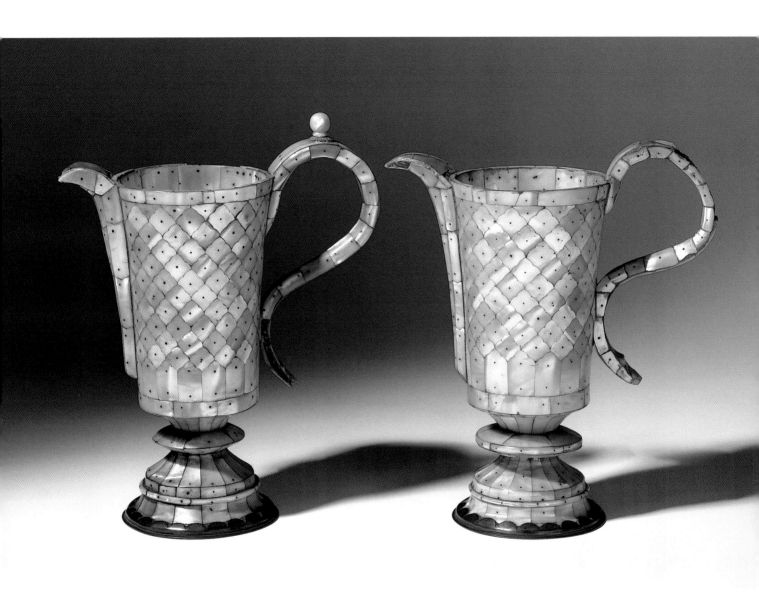

■ Wood overlaid with mother-of-pearl secured with
iron pins; the rim of the basins and base of the
ewers mounted with a brass fillet

Gujarat, early 17th century

Basins (4282-1857 and 4283-1857)
Height: 4 cm Diameter: 22–23 cm

Ewers (4257-1857 and 4258-1857)
Height: 25.5–27 cm Width: 22–22.2 cm

Pair of ewers and basins

When acquired by the Museum in 1857, these pieces were thought to be Italian.[86] The conviction that such articles were European was motivated not only by their Western shape, but also by the fact that seventeenth- and eighteenth-century continental goldsmiths consciously copied Gujarati mother-of-pearl work, translating its effects into familiar and new forms, thus creating problems of attribution for future scholars that still exist today.[87]

Judging from a documented example in the Green Vaults, Dresden, Gujarati basins of this design were being imported to Europe from as early as the second quarter of the sixteenth century.[88] At present there are no comparable ewers that can be firmly dated, although a closely related example in the Kunsthistorisches Museum, Vienna is believed to have descended from the Habsburg Royal *Kunstkammer*, formed in the late sixteenth century.[89] In some cases, the vessels that accompanied such basins are typically Islamic, based on the *surahi*, a type of flask with a bulbous body and long neck.[90] The marriage of Islamic and Western forms in such sets is not uncommon. Garnitures of Gujarati mother-of-pearl articles frequently include candlesticks that are firmly derived from Safavid metal examples, but sit along-side tankards of seventeenth-century European shape.[91]

The commissioning of Gujarati mother-of-pearl wares is associated particularly with the Portuguese. It is tempting to conclude that articles of this type did not arrive in Britain until the nineteenth century, when richly worked goods made from exotic materials were highly prized and avidly collected. It is probable, however, that such novelties were brought to Britain by merchants in the sixteenth and seventeenth centuries, both as high-value presents and as luxury imports. Gujarati pieces were also being imported from other European centres, such as Paris, where the Scotsman John Clerk of Penicuik is recorded buying plates and dishes of mother-of-pearl in the 1640s.[92] Mother-of-pearl articles are listed in sixteenth-century English royal inventories, although it is difficult to know whether such pieces were of Indian manufacture and, if so, how they arrived in the country. For instance, a mother-of-pearl fountain and basin set with precious stones is listed in the contents of the Tudor Jewel House in 1550.[93] In 1534 Thomas Cromwell presented Henry VIII (r.1509–47) with a mother-of-pearl ewer set in gold as a New Year's present,[94] while in 1585 Lord Burghley gave Queen Elizabeth I (r.1558–1603) a ewer and basin of mother-of-pearl richly mounted in gold.[95]

Powder flask (*barud-dan*)

Prior to the development of bullets the principal form of ammunition for firearms was gunpowder, which needed to be loaded into the barrel in order to fire a shot. Flasks for carrying gunpowder were thus essential accessories of warfare. Early examples were formed out of natural materials such as animal horns, gourds and shells, all of which could be transformed into sealed containers impervious to the climate and easy to carry. This rare flask, constructed of two layers of mother-of-pearl secured with brass pins, follows a conventional continental form that enjoyed particular popularity in late sixteenth- and seventeenth-century Italy.[96] The flask would have been secured to a belt with a suspension cord that ran through the silver eyelets, positioning the flat side against the user's hip or flank (see below). The nozzle is fitted with a spring-operated cap that is released with pressure from the thumb and ensures a tight seal, making it possible for the user to dispense exact amounts of powder. The nozzle retracts and is held in place with a small silver screw.

As with arms, powder flasks, particularly those used for hunting, were sometimes richly ornamented according to the fashions of the day. Numerous styles of powder flask would have been made in India, where firearms came into circulation from the sixteenth century onwards. However, to date no other Indian example of this shape is known. The same form was being made in ivory in Ceylon and in lacquer in Japan, indicating that it was current and popular in Asia in the seventeenth and early eighteenth century.[97]

The influence of Gujarati mother-of-pearl work is evident on a Mughal powder flask in the National Museum, Delhi, which is veneered with ivory that is engraved to simulate mother-of-pearl shell plaques.[98]

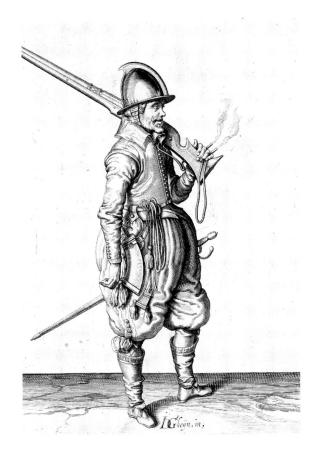

Soldier; engraving from Jacob de Gheyn, *The Excercise of Armes for Calivres, Mvskettes, and Pikes*, plate 1; printed at The Hague, 1607; V&A: CLE.56

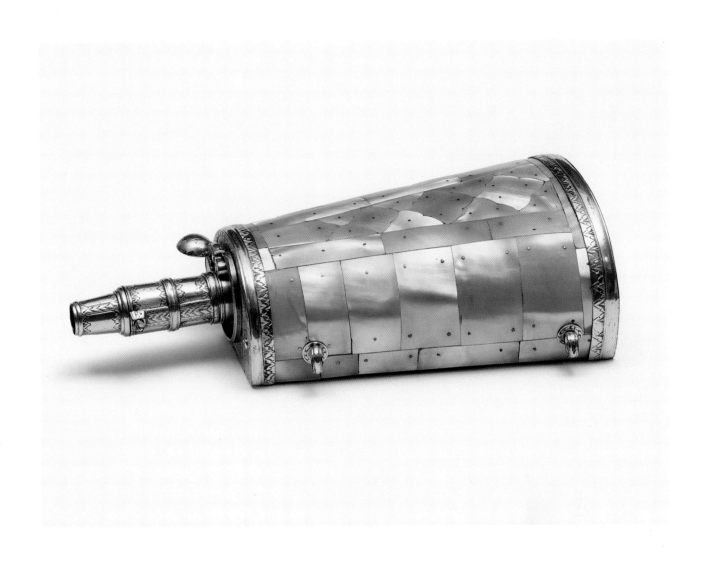

■ Mother-of-pearl secured with brass pins, with
silver mounts

Gujarat, early 17th century; the mounts English,
1675–1700

Height: 20 cm Width: 11.7 cm Depth: 5.8 cm

M. 22-1964

Basin

The hallmark on the English silver gilt mounts that embellish this basin has rendered it the only example of Gujarati mother-of-pearl work in the Victoria and Albert Museum's collection where a *terminus ante quem* can be established for its manufacture.[99] Dishes and basins are among the Gujarati mother-of-pearl articles most commonly found in European collections. These vary in size from ordinary dinner plates to, more rarely, expansive platters, but are most often composed of a thin teak carcass covered on both sides with shaped plaques of mother-of-pearl, usually secured with pins. On the main body the plaques are typically laid down in radial patterns representing a flower head, most probably inspired by the lotus, a central motif in Hindu and Buddhist iconography, and possibly by Yuan and Ming period porcelain dishes of similar shape that feature flowers in the same way.[100]

Basins were in some cases accompanied by ewers, and were designed for washing hands at table following a meal. As such articles qualified as plate, they were displayed ceremonially on sideboards and sometimes finished in a manner that suggests they were made more for show than use. It is into this category that Gujarati examples fall. In addition to their already luxurious and lustrous appearance, in European princely collections Gujarati mother-of-pearl ewers and basins were sometimes richly mounted, reflecting the high esteem in which they were held. The earliest documented basin, accompanied by a ewer, is in the Green Vaults, Dresden and bears silver gilt mounts by a Nuremberg goldsmith datable to 1530–40;[101] while the latest, that in the Victoria and Albert Museum, is without a ewer and is mounted with a silver, partly gilt, rim ascribed to a London maker and dated 1621–22. Several related examples are known.[102]

Little can be firmly established about the goldsmith responsible for the rim and foot ring mounted on this basin. His mark, a trefoil within a shaped shield,[103] is also found on two other pieces in the Museum. The first, the Dyneley Casket (24-1865), is made of alabaster; the second, a tankard (M. 52-1912) left to the Museum as part of the Bryan Bequest, is made of serpentine, indicating that this goldsmith specialized in mounting articles made of precious materials.[104] The style of his work shows the influence of the Low Countries, and it has been suggested that he was Dutch, working under the influence of German designers. The mounting of the basin reflects the Renaissance princely tradition of enhancing rarities and curiosities with rich settings, transforming them into objects worthy of display and representative of majesty. Mounted articles included manmade objects of such materials as crystal, mother-of-pearl and horn, as well as creations of nature, such as ostrich eggs, pieces of coral and coconuts. These were kept in *Kunstkammern* and *Wunderkammern* alongside other *artificialia* and *naturalia* admired for their inimitable qualities. Although produced in Gujarat in functional Western shapes, mother-of-pearl articles are unlikely to have been used for anything other than display.

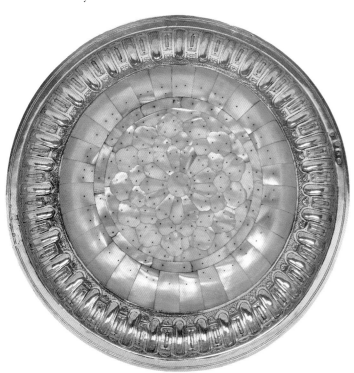

■ **Mother-of-pearl, with silver gilt mounts**

Gujarat, early 17th century; the mounts marked London 1621–22

Height: 8.5 cm Diameter: 24 cm

M. 17-1968

Bequeathed by Mrs Hannah Gubbay

Bowl and cover

This covered bowl is made of two layers of shell, the petal-shaped plaques of the exterior laid over longer strips of shell that constitute the interior. At present this is the only known example of this form. A bowl and cover of related rounded shape, but more squat and bulbous, and with a different, diaper arrangement of shell plaques, has been in the Medici collections since 1631 and is now in the Museo degli Argenti, Florence.[105] A number of bowls, with or without covers, are also known, but these are all composed of broad vertical strips of shell, rather than the petal-like arrangements of shaped plaques on this piece.[106] Of these the best documented is an example in the Kunsthistorisches Museum, Vienna, which descends from the Habsburg royal *Kunstkammer*.[107]

■ **Mother-of-pearl secured with brass pins, with silver gilt mounts**

Gujarat, early 17th century, the mounts English, mid-17th century or later

Height: 16 cm Width: 25 cm

M. 18 & a 1968

Bequest of Mrs Hannah Gubbay

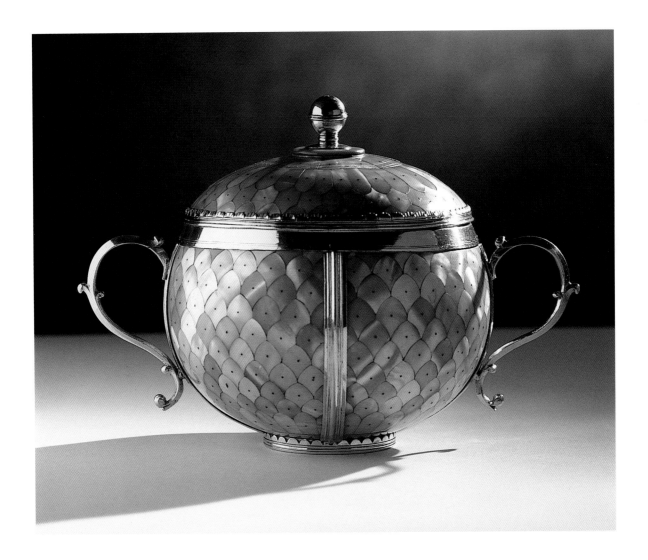

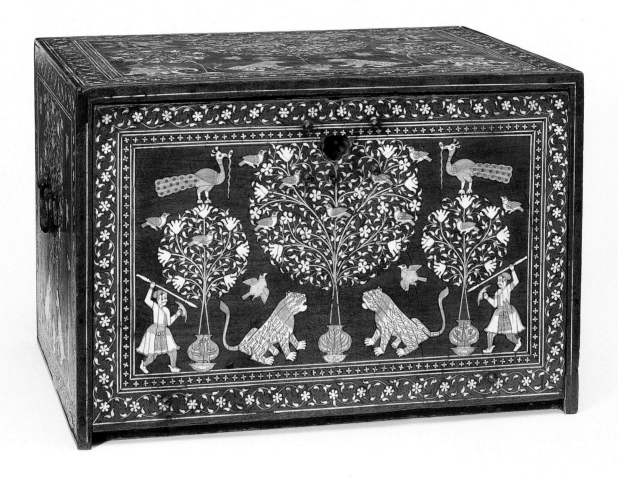

☐ **Shisham, veneered with rosewood and inlaid with various tropical woods, with brass and wrought iron mounts**

Gujarat or Sindh, early 17th century

Height: 32 cm Width: 48 cm Depth: 39 cm

122-1906

Fall-front cabinet; wood, inlaid with ivory; Gujarat or Sindh, 1625–50; private collection

Fall-front cabinet

Although clearly of the same school responsible for the cabinets and communion table also in this collection (see cat. 7, 8 and 9), this piece differs from those examples in the choice and handling of the ornament. Certain elements are familiar, such as the floral border, the pair of *simurghs* and elephants on the top, and the symmetrical placement of birds on the interior drawers. However, there are also appreciable differences: the trees are less profuse, and consist of a narrow trunk and a bulbous, circular spray of branches, sometimes nestled with groups of birds; and figures are better defined, and are laid out with greater symmetry against a less cluttered ground. New motifs are also evident, such as cypresses, shown in pairs on the sides, and figures wearing long sleeveless coats (*sadris*) over their *jamas*.[108] The human and animal figures are also more detailed, whether the hunters on the front,

who sport shields, spears and punch daggers; the peacocks, with their conspicuous tails; or the noblemen on the interior of the fall-front, with their richly detailed turbans and *jamas*. The precision of the inlay work and the stylized foliage foreshadow future developments in the decoration of furniture from this centre, which come more closely into line with fashions of the imperial Mughal court, particularly in the adoption of windswept plants of a type popularized by Shah Jahan (r.1628–58) (see p. 44, lower image).

This cabinet is of a type produced in some quantity; examples abound which are similarly decorated with pairs of tigers astride a central vase, flanked by hunters. On this example the inner face of the fall-front is inlaid upside down, so that when opened the inlay work faces the cabinet rather than the person using it.

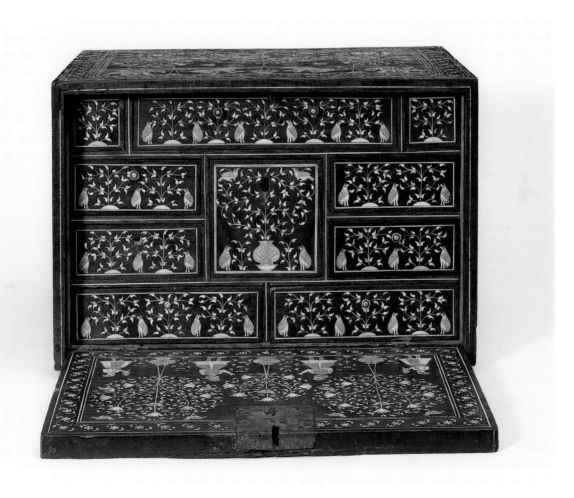

Side chair

No other group of Indo-European furniture has been as misunderstood as carved ebony furniture made in India, Ceylon and the Dutch East Indies in the second half of the seventeenth century. The furniture itself is of solid ebony, pierced or carved in various degrees of relief, with twist-turned components. Among the forms made were large suites of chairs and settees; and, less commonly, tables, cradles, beds, cabinets and boxes. The production of solid ebony furniture of this type seems to have first began along the Coromandel coast, a textile-producing region settled with European trading factories. Dutch traveller Georg Rumphius (1627–1702) recorded that the coast 'is exceptionally richly provided of this [ebony] as the natives make from it all kinds of curious work, as chairs, benches and small tables, carving them out with foliage, and sculpture'.[109]

Carved ebony chairs of this type have been recorded in English collections from as early as the mid-eighteenth century, and much of the confusion about their origin is due to the belief, current in the second half of the eighteenth and most of the nineteenth century, that they were surviving examples of early English furniture. This idea was supported by the rigid, rectilinear forms of the furniture, which looked antiquated to eighteenth-century eyes; the use of twist-turning, which was believed to be typical of Elizabethan furniture; the bizarre, intricate carving, which often included mythic beasts and figures that seemed to have been conceived before the vocabulary of classical ornament began to influence English design; and the colour, black, which was commonly associated with furniture of great antiquity.[110] For Horace Walpole (1717–97), who appears to have been responsible for this attribution, notions about the age of such furniture based on its physical attributes were confirmed by the existence of examples in houses with Tudor associations. In 1748 he saw carved ebony chairs at Esher Place, Surrey, and believed them to be the property of Cardinal Wolsey, who had lived there after 1519.[111] Buying chiefly at auction, Walpole acquired pieces of carved ebony furniture for his Gothic Revival house, Strawberry Hill. By 1759 he had furnished what was to become the Holbein Chamber with 'chairs & dressing table' of 'real carved ebony' (see above right).[112]

The decoration of Strawberry Hill was widely publicized, both by the numerous visitors to the house and through well-circulated published descriptions (1774; 1784).[113] By the early nineteenth century Walpole's view that carved ebony furniture of this type was both English

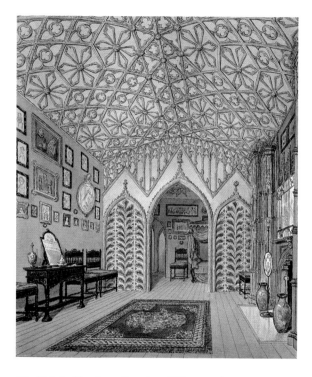

The Holbein Chamber at Strawberry Hill, watercolour on paper by John Carter, 1788; courtesy of The Lewis Walpole Library, Yale University Library

and of early date had become firmly established. In his drawings of 'Ancient Furniture' (1834) A.W.N. Pugin featured a carved ebony chair of the type at Strawberry Hill depicted beneath a portrait of Henry VIII,[114] and in *Specimens of Ancient Furniture* (published in monthly parts from 1832 to 1836 and then in a single volume in 1836) Henry Shaw included a carved ebony chair of the same type formerly in Walpole's collection.[115] Works such as these, which were used by antiquaries as reference texts, established the significance of carved ebony in houses with Gothic and Tudor style interiors, whether old or newly created.

■ **Ebony, carved and pierced, with caned seat**
Coromandel coast, 1660–80
Height: 97 cm (height of seat: 45.5 cm)
Width: 53.5 cm Depth: 46.5 cm
IS 6-2000
Gift of Robert Skelton

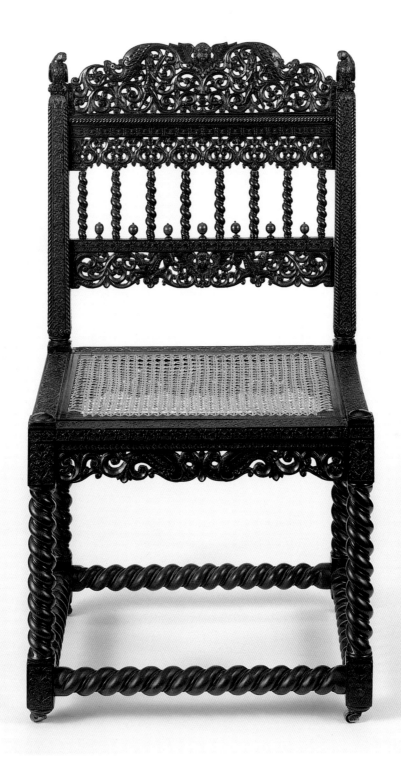

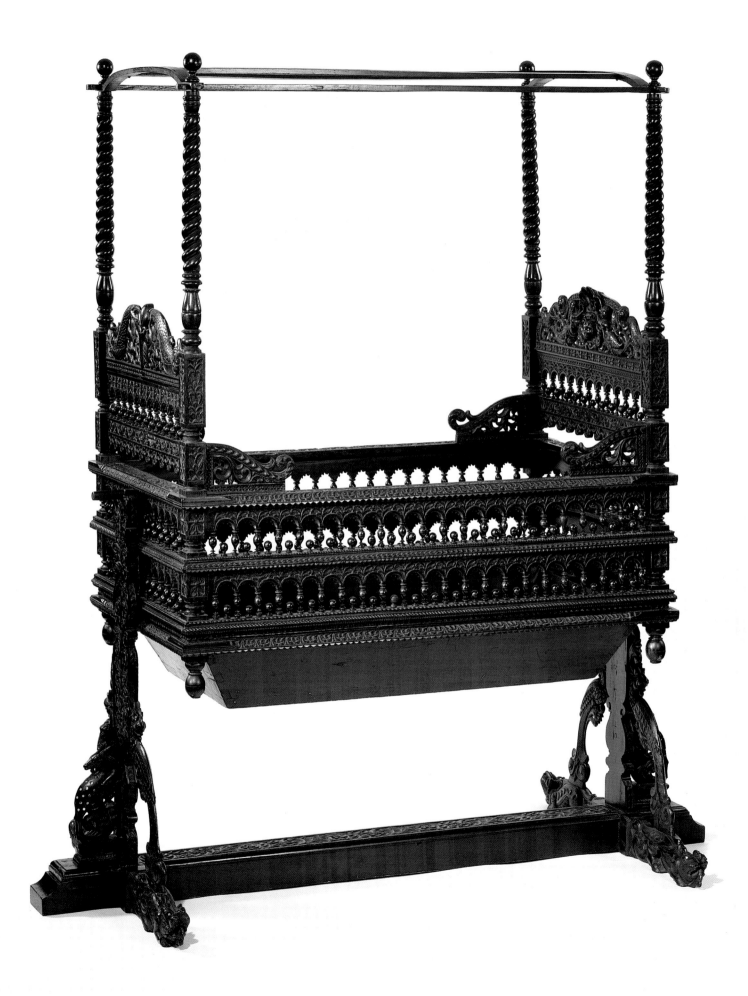

Cradle

The cradle is based on mid-seventeenth-century European prototypes but is richly decorated with a mixture of Christian and Hindu motifs in the manner of other Coromandel coast furniture.[116] The headboard is carved with a central winged female head – clearly based on contemporary Western representations of cherubs – supporting a scallop shell with a fleur-de-lis (a symbol of the Virgin Mary and the central motif in the royal arms of France). On either side is a mermaid, another Western element, but whose representation might have been inspired by a Hindu snake goddess with the head of a woman and the tail of a serpent (*nagini*). The tails of the mermaids terminate in a flourish relating to South Indian representations of mythic beasts with the head and torso of a human and the tail of a fantastic bird (*kinnaras*). As is commonly found on the top rails of chairs from the Coromandel coast, the headboard and footboard are defined by a pair of fantastic sea beasts with the head of an elephant or crocodile and the body of a fish (*makaras*).

In early British India, beds (as opposed to cradles) were of two types: those with posts and mosquito curtains, and Indian-style cots (*charpoy*), which consisted simply of a caned or strung frame on four turned legs. Bedsteads with posts were designed after the European fashion, but were built higher off the ground so as to deter vermin, which were a constant threat in India.[117] They were most often constructed in hardwoods, such as teak and black-wood, and fitted with mattresses usually stuffed with horsehair, coir or cotton, and supported on a frame of cane or wooden slats. Bedding was minimal and some-times consisted of little more than a sheet, a chintz bed cover (*palampore*), pillows and cases.[118] Whereas beds in Europe were swathed in rich textiles, much needed in the cold, beds in India were most often only fitted with mosquito curtains.[119] In the words of an American trav-eller in India, 'There would be no such thing as sleeping here, were it not for the *musquitoe curtains* which we use.'[120] Mosquito curtains were of locally-made or imported Chinese gauze that was always dyed green in order to diminish the need for frequent cleaning. Before entering the bed, curtains were beaten in order to ward off insects, and once in bed they were tucked in to the sides of the bed-frame.

■ **Ebony, carved and pierced**
Coromandel coast, 1660–80
Height: 155 cm Width: 142 cm Depth: 71 cm
IS 15-1983

Pipe case

Found in America by early Spanish explorers, tobacco – described by Ben Jonson (1572–1637) as 'the most sovereign and precious weed that ever the earth has tendered to the use of man' – quickly won favour in Europe and was by the late sixteenth century in use around the world. Native Americans savoured the intoxicating leaves of the tobacco plant in two ways. As Spanish explorer Fernandez de Oviedo y Valdez wrote in 1518, leaves were sometimes rolled into 'a little hollow tube, burning at one end, made in such a manner that after being lighted they burn themselves out without causing a flame', the progenitor of the cigar.[121] French explorer Jacques Cartier noted in 1535 that leaves were also pulverized and smoked in a 'hollow piece of stone or wood', the precursor of the Western-style pipe.[122] Both the cigar and pipe became popular in Europe, as did the powdered form of tobacco, which was scented and flavoured and taken by sniffing, and thus called snuff. Responses to tobacco have always varied. Jean Nicot de Villmain (after whom nicotine is named) presented a packet of it to Catherine de Medici as a cure for her headaches, and it is clear that other early users also believed the plant to have powerful medicinal qualities.[123] One of its vociferous opponents was James I, who attacked tobacco smoking in *A Counterblast to Tobacco* (1604), describing it as 'a custom loathsome to the eye, hateful to the nose, harmful to the brain, dangerous to the lungs, and in the black stinking fume thereof, nearest resembling the horrible Stigian smoke of the pit that is bottomless'.[124]

According to Bernhardt Laufer, tobacco was introduced to Asia by Portuguese vessels, which transported it from Lisbon, and by Spanish ones, which imported it to the Philippines, whence it spread throughout the East and South Asia.[125] The earliest reference to its use at an Indian court dates to 1604, at which time Asad Beg presented the Mughal emperor Akbar with tobacco that he found while in Bijapur. He recounts that,

> Never having seen the like in India, I brought some with me, and prepared a handsome pipe of jewel work . . . His Majesty was enjoying himself after receiving my presents, and asking me how I had collected so many strange things in so short a time, when his eye fell upon the tray with the pipe and its appurtenances: he expressed great surprise and examined the tobacco, which was made up in pipefuls; he inquired what it was, and where I had got it.

Asad Beg continues to say that,

> [as] I had brought a large supply of tobacco and pipes, I sent some to several of the nobles, while others sent to ask for some; indeed all, without exception, wanted some, and the practice was introduced. After that the merchants began to sell it, so the custom of smoking spread rapidly. His Majesty, however, did not adopt it.[126]

Detail of Dutchmen smoking pipes, from a depiction of the Dutch embassy to the Mughal court, headed by J.J. Ketelaar in 1711; painted textile; courtesy of KIT Tropenmuseum, Amsterdam

Akbar's successor, Jahangir, was also averse to smoking. In his memoirs he recalled that, 'Because of the evil effect tobacco has on most constitutions and natures, I ordered that no-one was to consume it.'[127] In spite of such measures, tobacco quickly won a following in India, where it continues to be smoked as a cigarette, through a water pipe (hookah), and chewed mixed with spices.

As at home, Europeans in Asia in the seventeenth century smoked tobacco principally through pipes, usually made of clay, for which Gouda, Holland, became an international centre of manufacture.[128] As clay pipes were fragile, they were stored and carried in purpose-made cases. Asian-made pipe cases are usually attributed to the Dutch, who were commonly identified with pipe-smoking and are sometimes depicted enjoying the pleasures of the pipe. Pipe cases made in Asia under Dutch patronage are usually configured to hold two pipes and are found in a range of materials, including lacquer, tortoiseshell, ebony and ivory. This example, of pierced ivory laid over a wooden carcass, is one of three such pipe cases, the other two being in the De Moriaan Museum, Gouda, and in a private Dutch collection.[129]

Wood, overlaid with pierced ivory, with brass pins and metal mounts

Ceylon, mid-17th century

Height: 6.5 cm Width: 47 cm Depth: 6 cm

W 147-1928

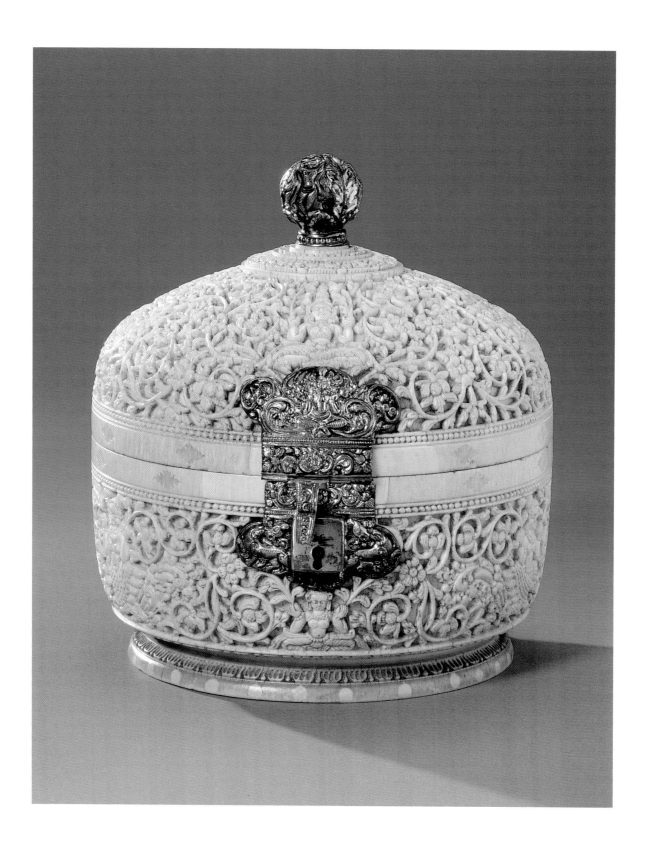

Round box

The lid and base of the box are each turned and carved from single pieces of ivory. Their design and decoration exemplify the melding of Dutch and Sinhalese decorative traditions in late seventeenth-century Ceylon. The shape of the box is indigenous, as is the complex pattern of scrolling vines worked with conventional representations of Sinhalese figures (*nari-lata-vela*).[130] However, the flowers they produce are of a type popularized in the East Indies by the Dutch and represented on furniture, textiles and silver from the Dutch East India Company's (Verenigde Oostindische Compagnie) Asian territories.[131] At front centre, on the lid, is a seated figure probably a tree spirit – wearing a triple-tiered headdress. Beneath him, on the base, and at other places on the box, are female figures, similarly seated. Also evident on the base are *kinnaras*, mythic creatures with the upper body of a woman and the lower body of a bird, with a voluminous, scrolling tail (below). *Kinnaras* may be likened to sirens, and according to legend lived in the upper reaches of the Himalayas, near the heavens. The *Rupavaliya*, a Sanskrit art treatise of undetermined age that formed the basis of Sinhalese art, explains that this creature 'hath a tuft of hair on the head, a garland around the neck, a human body, and singeth melodiously; hath a human face and hands, but the nether part like that of a bird, with wings; a face fair and radiant, a neck graceful as Brahma's'.[132]

For centuries Ceylon was influenced by the artistic and cultural traditions of South India.[133] The fact that South Indian craftsmen were working in the same style at home and in Ceylon has sometimes made it difficult to distinguish between articles made in the two places. However, the base and underside of the box are coloured with dye that is distinctive to Sinhalese Buddhist ritual ivory objects, suggesting that this box was made in Ceylon, which has a large Buddhist population, rather than South India, which is largely Hindu.

Related caskets exist in the Archaeology Museum, University of Peradeniya, Sri Lanka; at Brodick Castle, Isle of Arran; and the Museum für Indische Kunst, Berlin.

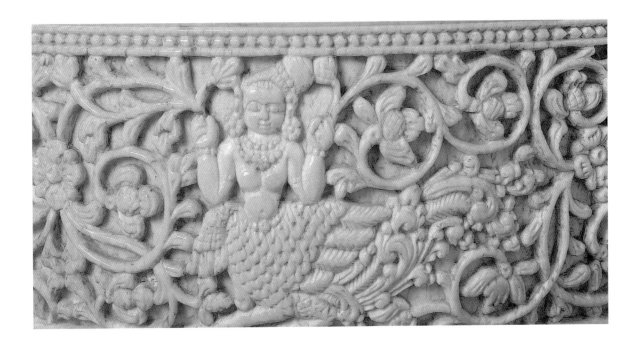

Ivory, carved, with silver mounts

Ceylon, mid-17th century

Height: 15 cm Diameter: 14.6 cm

13-1896

Ivory-veneered cabinet

The exterior and the inner face of the doors of this cabinet are all mounted with carved panels of ivory depicting Adam and Eve in the Garden of Eden. The couple stand beneath the 'tree of the knowledge of good and evil', Eve presenting Adam with a piece of fruit from the tree that God had explicitly forbidden them to eat (Genesis 3: 1–7). Adam recoils from the offering, with one hand on his breast signifying his determination to keep his promise to God and the other hand pointing to heaven to remind Eve of God's watchful eyes over them. The pair are surrounded by animals of creation.

The inhabitants of Ceylon first encountered Christian imagery after the arrival to the island in 1505 of the Portuguese, who used visual devices in their attempts to convert the local population. Sinhalese craftsmen and artisans were directly confronted with Christian iconography, which they interpreted in the building of churches on the island (by 1628 the Franciscans alone had fifty-four churches in Ceylon).[134] Many such craftsmen were prized for their ability to work the island's precious materials into devotional objects. Jan Huygen van Linschoten's account of the island (1598) explains that:

> My maister the Archbishop had a crucifixe of Ivorie of an elle long, presented unto him, by one of the inhabitants of the Ile, and made by him so cunningly and workmanly wrought, that in the hayre, beard, and face, it seemed to be alive, and in al [other parts] so neatly wrought and proportioned in limmes, that the like can not be done in [all] Europe: Whereupon my maister caused it to be put into a case, and sent unto the King of Spaine, as a thing to be wondered at, and worthy of so great a Lord, to be kept among his [costliest] Jewels.[135]

Although this depiction of Adam and Eve was probably inspired by a European engraving, it is difficult to establish a precise source. Woodcuts by northern European artists such as Albrecht Dürer and Thielman Kerver were certainly known to ivory carvers in Ceylon and may have been used (see cat. 1).[136] Jan Veenendaal suggests that engravings of Adam and Eve by Matthaus Merian (1593–1650) were a possible design source for this cabinet, since they include elephants.[137] The choice of this subject is likely to have been inspired by the presence in Ceylon of a mountain known as Adam's Peak. According to Linschoten, 'The Indians hold for certane that Paradice was in that place, and that Adam was created therein, saying that yet untill this daye.'[138]

Conservation work on this cabinet has revealed that, when it was being made, sheets of contemporary Italian paper were applied between the carcass and the ivory veneer, probably to help the adhesion of the ivory plates to the timber. Several related cabinets are known.[139]

Eave and Adem; oil on oak panel, anon, *c.*1600; English; V&A: W.39-1914

☐ **Wood, veneered with panels of carved ivory, with silver mounts**

Ceylon, 1650–75

Height: 24 cm Width: 27 cm Depth: 18 cm

1067-1855

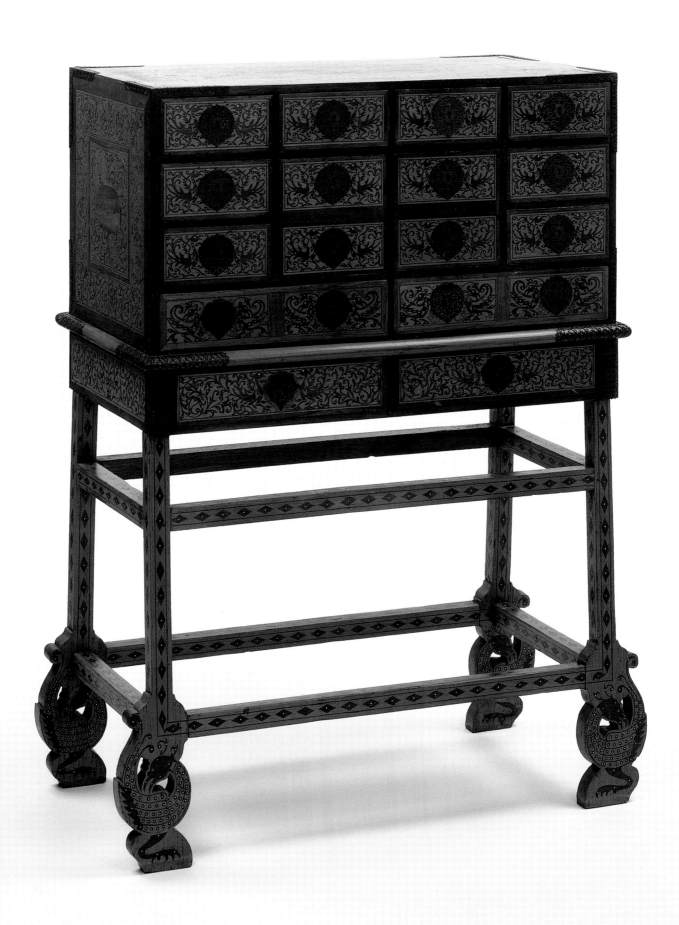

Cabinet on stand (*contador*)

The form and decoration of this cabinet are typical of a large group of furniture made in India under Portuguese patronage. Although pieces of this type were produced in quantity, there is little that can be firmly established about the workshops that made them. Some idea of date of manufacture is provided by parallels with European furniture: large multiple-drawer cabinets without doors or a fall-front, and mounted on stands, were very much in fashion in the second half of the seventeenth century.[140] High-style European furniture of that period is also characterized by intarsia of various types, including seaweed marquetry, named after the intricate interlacing designs and dense arabesques that were inlaid. Although these are possible influences, Indo-Portuguese cabinets of this type are also characterized by wholly distinctive elements, such as abstracted animal and geometric designs that have no precedent in any one European or Indian tradition. The scrolling legs, for instance, derive from seventeenth-century Iberian furniture, but are inlaid with bird forms that scholars have associated with *jatayu*, king of the vultures and a central character in the *Ramayana*.[141]

The materials, inlay and intricately pierced mounts on cabinets of this type bear an affinity with fitted chests of drawers and cabinets in the Sacristy of the Basilica of Bom Jesus, Old Goa (right). The church, which was consecrated in 1605, is the resting place for the body of St Francis Xavier (1506–52), who spent the last ten years of his life travelling and preaching in Asia. When he was canonized in 1622, the saint's body was moved into the basilica and temporarily placed in the north transept until a more fitting place was found. In 1637 the body was placed in a locally-made silver casket, which in 1698 was mounted on a grandiose catafalque of marble, precious stones and bronze, made by the Florentine sculptor Giovanni Foggini (1652–1725) and donated by Cosimo III, Grand Duke of Tuscany (r.1670–1723).[142] The catafalque was erected in a chapel formerly occupied by a small sacristy, which was rebuilt behind the church on a grander scale in 1654. The cabinets in the new, enlarged sacristy are likely to have been installed at some point

between its completion in 1654 and 1698, when the catafalque was erected.

The existence of purpose-built church furniture in a closely related style and identical materials suggests that cabinets of this type were made in or around Goa. In his description of Goa, Dutch clergyman Huygen van Linschoten explains that different craftsmen were concentrated on different streets: 'There is also a street full of gold and Silver Smithes [that are] Heathens, which make all kinde of workes, also divers other handicrafts men, as Coppersmithes, Carpenters, and such like [occupations], which are all heathens, and every one a street by themselves.'[143]

Cabinets in the sacristy, Basilica of Bom Jesus, Old Goa; second half 17th century; photograph in Fernanda Castro Freire, *50 dos Melhores Móveis Portugueses*, Chaves Ferreira – Publicações, S.A., Lisbon, 1995, p. 54

■ Teak and cedar (?), inlaid with rosewood and ivory, with pierced brass mounts
Goa (?), late 17th century
Height: 131 cm Width: 103 cm Depth: 49.5 cm
781-1865

Cabinet on stand (*contador*)

This cabinet is of a form that was much reproduced under Portuguese patronage in India. Examples exist in a host of different sizes and with various types of decoration ranging from abstracted scrolling inlay to repeating designs of triangles. The pattern of stars and intersecting circles that adorns this cabinet is perhaps the most commonly reproduced motif on such furniture and may be found on articles commissioned by the Portuguese in other parts of Asia.[144] The most distinctive feature of such furniture is the sculptural treatment of the legs, which are usually conceived as supporting figures. These assume a variety of human and animal forms. However, the most common are creatures with the upper body of a man or woman and a scaled lower body like a sea serpent. Past scholars have identified these with *nagas* and *naginis*, Hindu snake divinities that are considered auspicious and are believed to provide protection from dangers, including snake bites. The figures on this cabinet, although curiously represented, bear no real imprint of Hinduism. Rather, they continue the Western classical architectural tradition of employing atlantes (male versions of caryatids) as columns. Following the convention of treating furniture as an architectural form, on high-style European furniture of the later seventeenth century such figures were imaginatively conceived as supports for cabinets.[145] The posturing and articulation of the atlantes on this piece, however, suggests that they are modelled on architectural supports of some type, probably from the interior of a church.

The Western inspiration behind this piece of furniture is clearly a straightforward seventeenth-century cabinet on stand. However, the design of this piece departs from European examples in its inclusion of the lower register of four drawers, which give the piece a cumbersome appearance. Originally the supports were ornamented with decorative metal rivets, removed before this piece came to the Museum in 1865.

■ Cedar, inlaid with ebony and ivory, with gilt metal copper mounts

Goa (?), late 17th century

Height: 150 cm Width: 140 cm Depth: 69 cm

777-1865

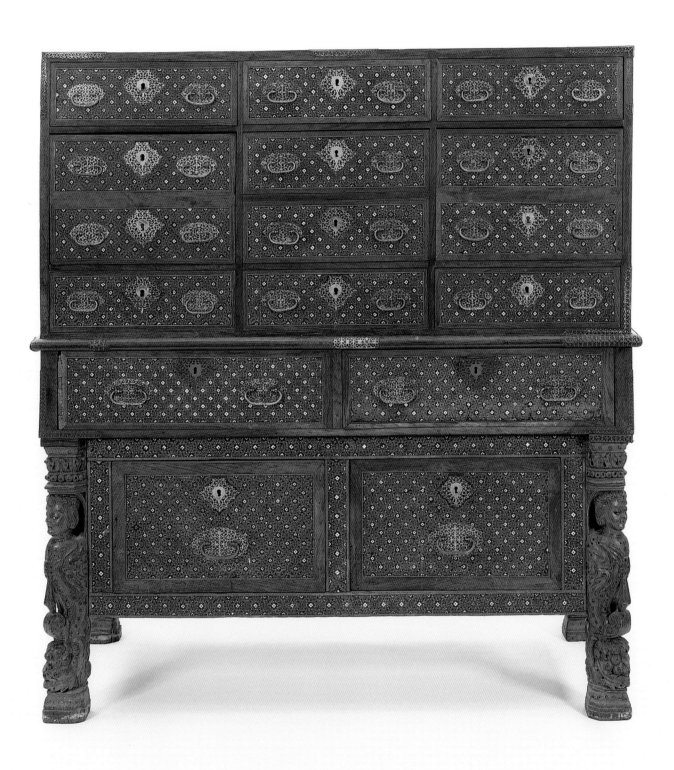

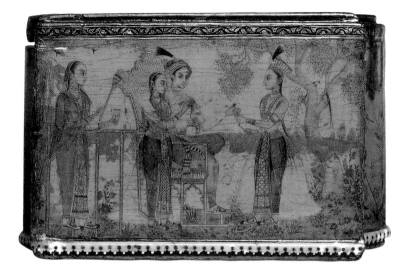
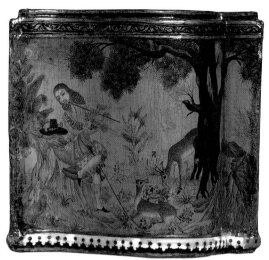
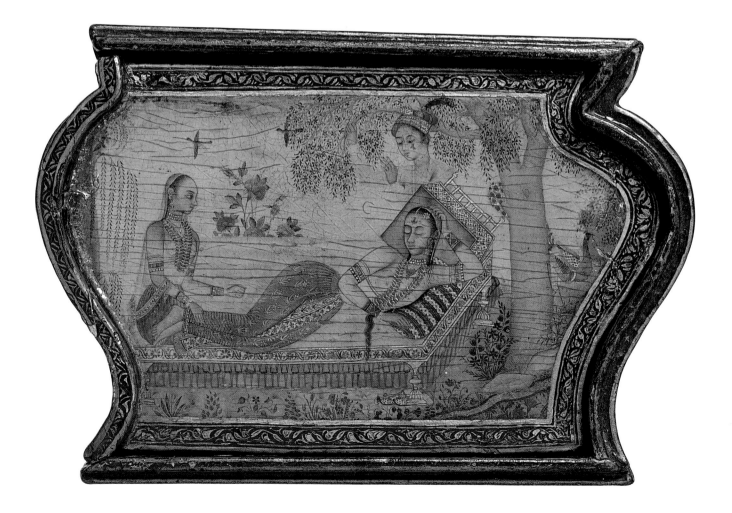

Painted box

This casket, probably originally used to hold precious belongings, is delicately painted with a *fête galante* in which courtiers are portrayed in a forest idyll. The singing birds and fragrant flowers lend a sweetness to the atmosphere in which the willowy figures are shown enjoying the pleasures of music, dance, drink and reverie. The feeling of insouciance resonates in the very shape of the casket, whose ends are surprisingly serpentine-shaped rather than straight. The principal scene is of an enthroned young prince wearing a turban with an egret's plume, embracing a girl who stands next to him (see opposite, top left). In front and behind the couple are two female figures presenting them with a drink. The lady in front of the couple wears a head-dress with an egret's plume, while the attendant behind them holds a fly-whisk (*chowrie*). On the reverse side there is a girl dancing to music played by two companions, one on the a vina and the other on the drum (*dholak*). The ends are each painted with a lone figure: on one end a girl clutching a tree in the Salabhan-jika pose and meditating on an egret; and on the other a youth in European clothes sitting on a rockery and charming deer with his flute (see opposite, top right). The sliding lid is painted with a woman, presumably the prince's mistress, reclining on a *charpoy* with an attendant at her feet (see opposite, below). Her expression and posture suggest that she is dreaming of the prince, and this is confirmed by an impression of his head depicted against the sky just above her.

The painting on the box belongs to a style practised in Golconda in the last quarter of the seventeenth century. Although not signed, it is very close in style and sentiment to a miniature painting in the Chester Beatty Library that bears the signature of Rahim Deccani and similarly depicts an enthroned prince surrounded by attendants.[146] The fact that in his signed works the artist specifies his Deccani origin suggests strongly that he was working away from home, possibly elsewhere in India or in Iran, where he might have fled following the Mughal subjugation of Golconda in 1687. Three pen-boxes (*qalamdans*) exist bearing his signature, one in the Khalili

Collection, a second in the Freer Gallery of Art, and a third that was on the Paris market in 1975.[147]

The European figure painted on the casket probably derives from Western representations of Orpheus, the legendary Thracian poet who charmed beasts with music played on his lyre. With the exception of the pleated sleeves, which belong to the early seventeenth century, his dress corresponds to European fashions of the 1670s and 1680s.[148] However, the Mughal-style flowers that decorate the lining of his coat and the patterned breeches suggest that these Western-style garments were made in India from textiles that were available locally. Indian tailors were renowned for their skill at copying Western fashions. Edward Terry (1614) marvelled that they could produce 'shooes, and boots, and cloathes, and linen, and bands, and cuffs of our English fashion',[149] and John Ovington (1689) likewise observed how 'The Tailers here fashion the cloaths for the *Europeans*, either Men or Women, according to every Mode that prevails.'[150] The highly stylized representation of the figure has led scholars to suggest that the image is based on a print. While this is possible, it is equally likely that Rahim Deccani's interpretation was to some degree based on Europeans that he himself encountered. On visiting Golconda in the 1670s, Thomas Bowrey found that 'Many Europeans, Especially of our English Nation, are here become inhabitants, Entertained here in the King's Service';[151] and J. de Thevenot (1696) similarly observed that 'There are many Franks also in the Kingdome.'[152] An impression of Europeans wearing their own fashions, but made of Indian textiles, may be seen in a painted and dyed wall-hanging made in the Madras–Pulicat region in the mid-seventeenth century in the Victoria and Albert Museum (687-1899).

The box was acquired in Iran by Jules Richard, a Frenchman who arrived in Tehran in 1844, initially teaching French and English at Dar al-Funun College, and later acting as interpreter to Mirza Ja'far Khan Mushir al-Dawla and Nasir al-Din Shah.[153] Richard's collection of Iranian art was unparalleled, being formed at a time when there were few Europeans in the country and little competition for the pieces that appeared on the market. In 1875 the South Kensington Museum acquired two thousand objects from the collection through Robert Murdoch Smith, who acted as the Museum's agent in Tehran from 1873 to 1885. Further pieces from Richard's collection – including this casket – were shown at the Exposition Universelle, Paris in 1889 and were purchased by the Museum through Murdoch Smith in that year.

Papier-mâché, painted and varnished, with pierced ivory base moulding

Painting attributed to Rahim Deccani

India or Iran, late 17th century

Height: 9.6 cm Width: 9.2 cm Length: 3.6 cm

851-1889

Fall-front cabinet

The ornament on ivory-inlaid furniture made in western India in the mid- to late seventeenth century reflects more closely the Mughal court style. This shift in design is matched by an improvement in the quality of the inlay itself. The round-headed trees and dense foliage of earlier work (see cat. 15) are replaced by full-blown flowering plants that begin to permeate Mughal painting, architecture, textiles, dress and metal-work from the second quarter of the seventeenth century onwards. As Daniel Walker observes, 'the flower style' commonly identified with the Mughal emperor Shah Jahan did not emerge suddenly or spontaneously, but followed in the train of a long-standing Mughal appreciation for flowers that since Akbar's day was manifested in courtly painting and decorative arts.[154] However, natura-listic flowers arranged in formal compositions seem very much to have been a product of the later reign of Jahangir. Robert Skelton demonstrates convincingly that the impetus for this new treatment of flowers was Jahangir's sojourn in Kashmir during the spring of 1620, at which time the emperor commissioned the court artist Mansur to depict flowers of the region.[155] Scholars are divided

over the degree of influence that European albums of flowers exercised over Mansur's works, but his treatment of floral subjects was probably directed to some extent by herbals that were known at the Mughal court.[156] Jahangir's successor, Shah Jahan, brought the use of the naturalistic single flowering plant to a new height, employing the motif in architecture, painting and the decorative arts (see below right).

In the decoration of the exterior of this cabinet we see how craftsmen attempted to reconcile long-standing motifs with newly introduced flowering plants. The pairs of confronting lions, and prancing gazelles and birds, for example, are vestiges of an earlier style that sit uneasily within the composition. The flowers, which themselves deserve a plain ground, appear hemmed in by the animals and are constrained by the borders, which further deprive them of space. The crowding of figures with foliage continues on the interior (see opposite), where the top drawers are inlaid with images of seated courtiers, and the lower ones with acrobats, musicians and dancing figures drawn from popular provincial Mughal painting of the later seventeenth century.

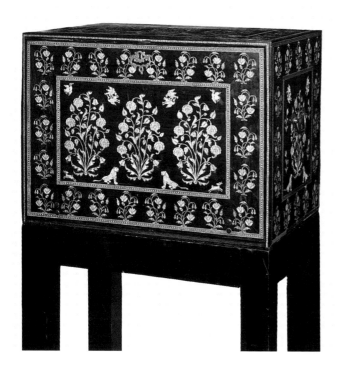

Wall hanging; cotton, embroidered with silk; Mughal, 1650–1700; V&A: IS 168-1950

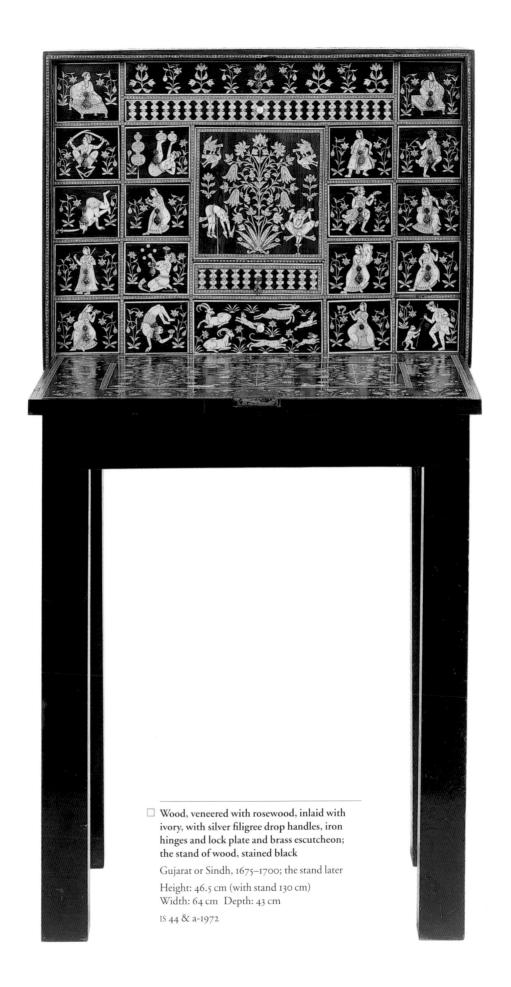

☐ Wood, veneered with rosewood, inlaid with
ivory, with silver filigree drop handles, iron
hinges and lock plate and brass escutcheon;
the stand of wood, stained black

Gujarat or Sindh, 1675–1700; the stand later

Height: 46.5 cm (with stand 130 cm)
Width: 64 cm Depth: 43 cm

IS 44 & a-1972

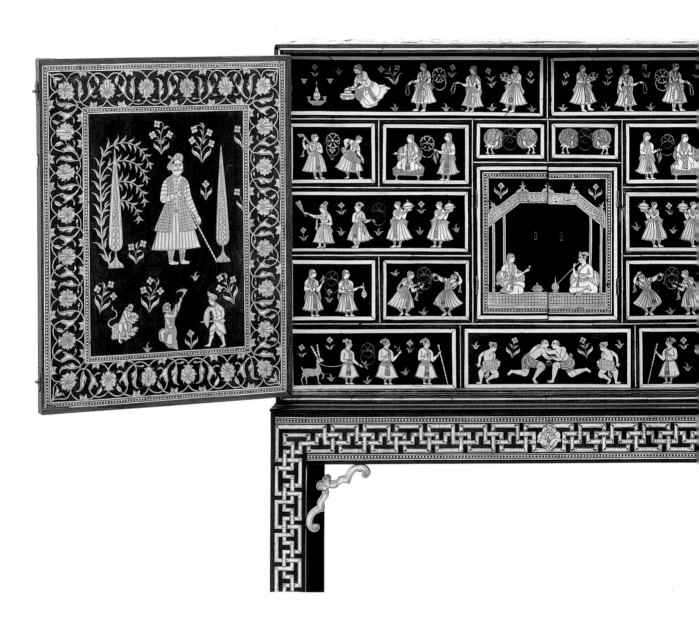

64

Cabinet on stand

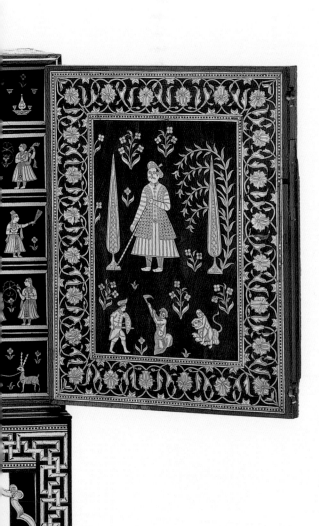

Towards the close of the seventeenth century, two-door cabinets of this type replaced portable fall-front cabinets as the leading form produced by furniture-making workshops in western India. Their configuration and dimensions reflect changes in Europe in the design and use of cabinets, which were increasingly devised as showpieces mounted on stands.[157] The decoration of the exterior of this cabinet reflects the high Mughal style of setting rows of flowering plants in alternating patterns against a plain ground (see below). This enchanting device is characteristic of the reign of Shah Jahan and may be found adorning buildings erected by the emperor, such as the Saman Burj, Agra Fort (c.1637).[158] The basic formula of employing rows of flowers as a principal form of decoration remained popular to the end of the eighteenth century, and throughout the period was applied to various media from carpets to album covers (see p. 66, below).

The figures inlaid on the interior are of a standard type found on cabinets of this stamp. They continue a

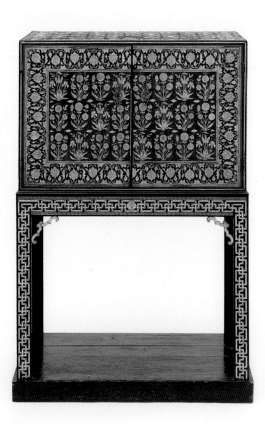

☐ **Wood, veneered with ivory, inlaid with ivory; the stand of wood, ebonized and inlaid with ivory**

Gujarat or Sindh, late 17th or early 18th century; the stand English, mid-18th century

Cabinet: Height: 51 cm Width: 79 cm Depth: 47 cm
Stand: Height: 70.5 cm Width: 83 cm Depth: 50 cm

Loan: Poteliakhoff
On loan from Dr and Mrs Poteliakhoff

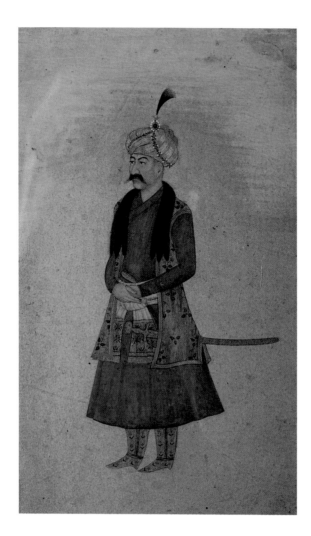

TOP *Portrait of Ali Mardan Khan*; gouache with gold on paper; Mughal, *c.*1640; photograph by Robert Skelton

ABOVE Detail of border from *Portrait of a Dervish*; gouache on paper by Farrokh Beg; Mughal, *c.*1630; V&A: IM 11-1925

theme evident on the earliest furniture made in western India for European consumption, that of a courtly couple seated in conversation surrounded by celebratory figures (see cat. 8 and 9). The couple are depicted at centre on a pair of doors, he to the right smoking a *hookah*, and she to the left holding a cup. The inlay on the drawers around them is symmetrically arranged, each side mirroring the other. Here again one finds attendants, serving women holding vessels, musicians, dancers, and at the bottom a pair of wrestlers fighting to the beat of drums. The handling of the figures is finer than on earlier work from this school, the detailing more attentive, and the poses more realistic, particularly in the case of the active figures. The composition of the inner face of the doors is less successful, with awkward positioning of plants and people. The figure wearing a sleeveless coat and the cypresses at the top are familiar from earlier paintings and woodworking traditions, while the images below all seem to derive form European engravings.

Although the figures depicted on cabinets of this type are drawn from the repertoire of images common to a number of schools of Indian painting and of different periods, scholars have recently linked them with the decorative traditions of the Deccan, particularly Golconda, suggesting that these cabinets were made there.[159] Some of the figures and the surrounding vegetation bear an affinity to motifs on Golconda textiles manufactured at Petaboli, near Masulipatam.[160] Contemporary accounts, however, fail to mention manufactures of this sort in the Deccan. Moreover, in light of the consistent techniques and methods of construction, and the tangible evolution of ornament from the earlier fall-front to the later two-door cabinets, it is certain that such cabinets evolved from the earlier cabinetwork from Gujarat and Sindh. Deccani textiles are likely to have been known at trading centres in Gujarat and Sindh, such as Cambay, Surat and Tatta, where ivory-inlaid cabinets of this type were probably made. Workshops engaged in the production of such wares produced a variety of goods for various foreign markets. The adoption of a wide range of motifs of diverse origin, sometimes indiscriminately applied, was not uncommon in the design of textiles and cabinetwork for European consumption, and the cosmopolitan nature of trade at the trading marts of western India would have been a natural place for the fusion of diverse decorative traditions.

Throne component

The tenon at the top of this figure suggests that it originally acted as some sort of support, possibly as one of a group of throne legs.[161] The bulging eyes, flame-like mane, fangs and distinctive rearing posture are all characteristic of contemporary interpretations of the *yali* (or *vyala*), a mythical beast with a leonine head whose attributes sometimes include an elephant's trunk and tusks, and foliage issuing from the mouth.[162] Although diminutive in size, this figure has been modelled on sculptural *yali* pillars, which attained prominence in South Indian temple architecture (see below right). Pillars carved with rearing animals of this type first make their appearance in the architecture of the Vijayanagara empire, specifically in temple complexes commissioned under the Tuluva dynasty in the sixteenth century. Mandapas erected at the Virupaksha shrine at Hampi (1510), the Chintala Venkataramana temple at Tadpatri (sixteenth century) and the Vidyashankara temple at Sringeri (sixteenth century) all bear examples of pillars treated sculpturally as rearing *yalis*.[163] Such columns became standard features in the extensive mandapas and monumental processional corridors erected by the Nayak governors of Gingee, Madurai and Tanjore, who were installed by the Tuluva dynasty and who proclaimed sovereignty from their overlords as the Vijayanagara empire disintegrated in the late sixteenth century.[164] This *yali* figure was probably made under Nayak patronage, and reflects both the prolific use of this mythic creature in the plastic arts of the period and the rise in that period of ivory carving at such centres as Madurai, Mysore and Tiruchirapalli.[165]

Solid ivory, carved

South India, 17th or 18th century

Height: 15.5 cm Width: 9 cm Depth: 3.5 cm

IS 146-1986

Jalakanteshvara temple, Vellore, Tamil Nadu, late 16th century; photograph by Clare Arni

Ivory-veneered cabinet

In his account of the products and manufactures of Ceylon, François Valentijn recalled 'entire cabinets covered with ivory and very ingeniously carved'.[166] Valentijn may well have been thinking of a piece of this type, which represents the high point of ivory carving in Ceylon under Dutch patronage. A number of cabinets of this form are known, all constructed in the same manner, with carved panels of ivory veneer secured to a wooden carcass.[167] On this example the ivory itself is profusely carved, each panel of the exterior with a vase full of flowers in bloom, surrounded by floral borders. The flowers themselves cannot be conclusively identified but appear to be tulips and sunflowers.

A precedent for embellishing furniture with this sort of decoration is found in Dutch cabinets of the mid- to late seventeenth century, which are ornamented with similar themes, but executed in marquetry. The mid-seventeenth century was a golden age for the Dutch Republic, largely due to profits from her far-flung maritime trade and the establishment of Amsterdam as Europe's leading centre of international finance. This period of prosperity witnessed not only the commissioning of fine works of art, but also a new appreciation of nature, and specifically of rare and exotic flowers.

The projection of blooms on to furniture seems to have occurred in the third quarter of the seventeenth century, led by Jan van Mekern (1658–1733), who produced cabinets that featured naturalistic depictions of flowers executed in marquetry of exotic woods.[168] The doors and side panels of these *bloemkasten* ('flower cupboards') were typically decorated with flowers in vases, while the cornice and mouldings bore trails of flowers.[169] Such designs were most probably drawn from engravings of flower paintings, which were widely circulated.

Whether it was an engraving or an actual piece of furniture decorated with blooms that provided the inspiration for this ivory-veneered cabinet is difficult to know. A taste for large blooms certainly existed among the Dutch in the East Indies and may be seen in locally produced furniture, silver, textiles and gravestones from the last decades of the seventeenth century and early decades of the eighteenth.[170] Vase-and-flower motifs in a similar style also featured in Mughal architectural decoration, specifically on the dados of the upper burial chamber of the mausoleum of the Taj Mahal (c.1632–36).[171] Although this motif has a precedent in Indian ornament, appearing, for example, on a minaret at the Mosque of Qutb Shah, Ahmedabad (1449), its use in the context of the Taj Mahal is likely to have been inspired by Dutch herbariums, which were known and admired at the Mughal court, and which influenced the course of Mughal flower painting.[172]

This cabinet was purchased at auction in 1959 with a provenance to the Pre-Raphaelite artist William Holman Hunt. Nothing further is known about where or when Holman Hunt acquired it. An ivory cabinet of similar shape and decoration appears in Holman Hunt's *The Shadow of Death* (1870–73; retouched 1888), which portrays the adult Jesus and the Virgin Mary in a carpenter's workshop (see left).

The cabinet is shown at the bottom of the canvas, on the ground, and supports gifts presented to the child Jesus by the three Magi. According to tradition these consisted of gold, frankincense and myrrh. Given the similarities between the cabinet in the painting and that owned by the artist, it is tempting to conclude that he used the latter as a studio prop. The painting was conceived and

The Shadow of Death; tempera and oil on canvas by William Holman Hunt, 1870–73; © Manchester Art Gallery

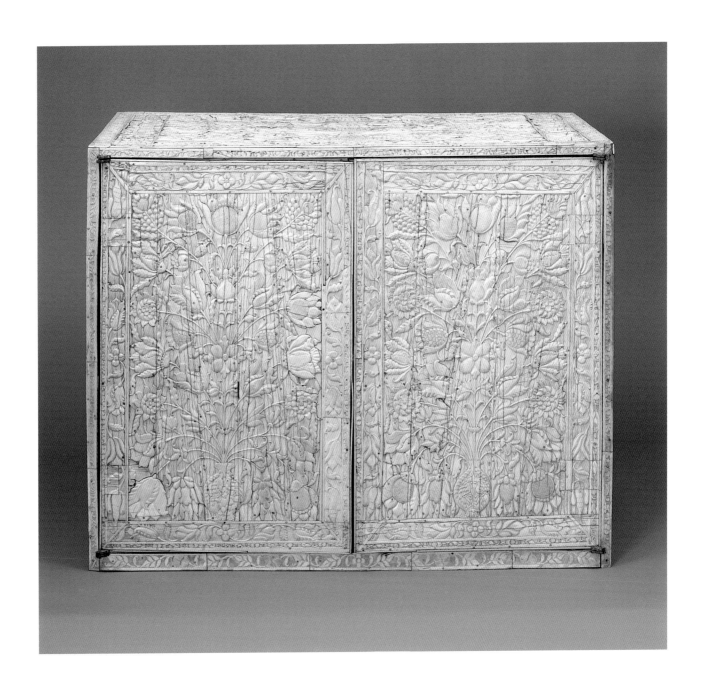

executed largely in Bethlehem and Jerusalem during Holman Hunt's stay there between 1869 and 1872. Whether the artist acquired and depicted the cabinet while in the Holy Land, or whether he purchased it in London and worked it in when he revised the painting after his return home, is at present impossible to establish.

Jackwood, veneered with carved ivory, with silvered brass mounts

Ceylon, c.1700

Height: 69 cm Width: 87.6 cm Depth: 52 cm

IS 70-195

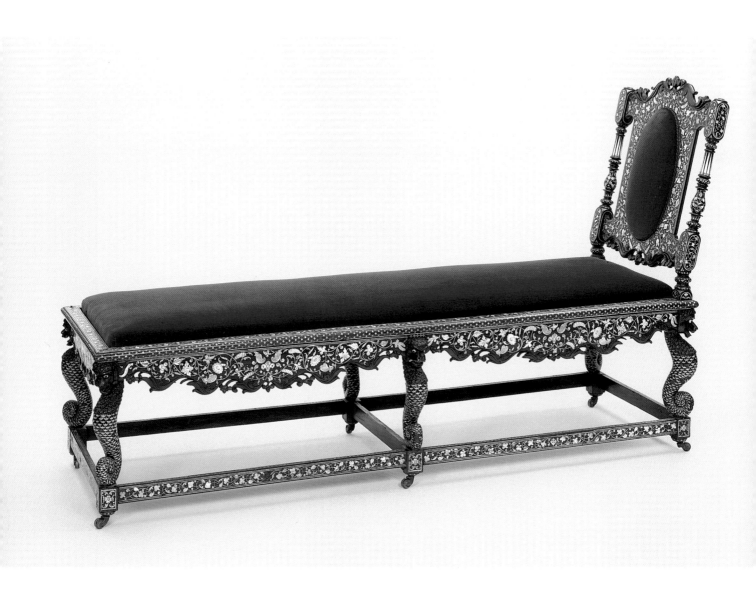

■ Ebony, inlaid with ivory, with later red velvet upholstery

Vizagapatam, 1700–20

Daybed (1024-1882)
Height: 117 cm Width: 66 cm Depth: 209 cm

Chairs (1023a 1882, 1023b 1882 and 1023c 1882)
Height: 119 cm (height of seat 44.5 cm)
Width: 46.5–46 cm Depth: 50–52 cm

Bequeathed by John Jones

Daybed and set of three chairs

This daybed and set of three chairs were made at Vizagapatam, a port situated on the east coast of India that possessed a fine harbour and a textile-producing hinterland, both of which attracted European settlement and introduced a demand locally for Western-style furniture. The timber required for the furniture was readily available from nearby forests, and, being the only natural harbour between Calcutta and Madras, Vizagapatam became a popular port of call where foreign woods and imported mounts and mirrors were all available.[173] The port was frequented both by European vessels travelling between Europe and the Far East, and smaller native craft trading along the coast, both of which provided a convenient and reliable method of exporting furniture to foreign markets.[174] The earliest Vizagapatam manufactures can be dated on stylistic grounds to the beginning of the eighteenth century, although the first references to the industry dates to the 1750s, when Major John Corneille wrote of Vizagapatam that its 'chintz is esteemed the best in India for the brightness of its colours', and that 'The place is likewise remarkable for its inlay work, and justly, for they do it to the greatest perfection.'[175]

Little is known about wood and ivory work at Vizagapatam preceding the arrival of Europeans to the area in the mid-seventeenth century. The practice of engraving ivory on furniture for royal use apparently existed in coastal Orissa, immediately north of Vizagapatam, and might have inspired the choice of the technique.[176] Writing boxes, rifles and gun boxes with marquetry decoration from Europe are likely to have been used by Europeans locally, and might have provided the inspiration for the initial production of inlaid furniture at Vizagapatam, which reflects the influence both of German ivory inlay and of designs on textiles produced locally for the European market.

The technique employed on this daybed and set of chairs is of inlaying wood – in this case ebony – with floral designs in ivory, the ivory itself being engraved and highlighted with the application of lac. The patterns required were drawn on a panel of ivory, filed out and sliced into veneers of between $\frac{3}{32}$" and $\frac{1}{8}$" thick. These were laid down in corresponding recesses in the carcass, the excess of mastic used filling any gaps and creating a black outline around the ivory. Once inlaid and engraved (the order for this procedure seems to have varied), the ivory was rubbed over with melted lac, the residue scraped off, and the surface polished.

This daybed and the accompanying chairs were formerly thought to be Italian or Indo-Portuguese. In fact, they are among the earliest surviving pieces of furniture made in India in an English style. Two related suites are known, one at Raynham Hall, Norfolk, and the other at Charlecote Park, Warwickshire.

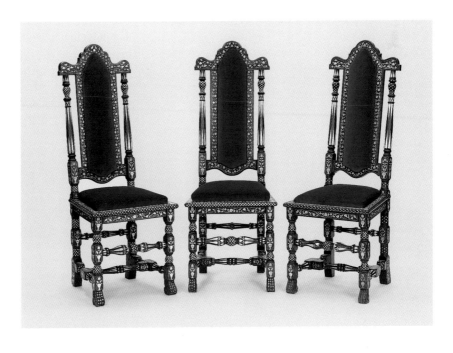

Cabinet on stand

This cabinet on stand is inspired by English prototypes of the second quarter of the eighteenth century, but its overall aspect reveals the maker's lack of understanding of Western notions of proportion. The broken pediment is too broad and high for the cabinet, and the uneasiness between the two is amplified by their marriage to the stand, which is itself unconventionally proportioned, with a narrow shaped apron and slender cabriole legs that protrude unusually far and terminate in cumbersome ball-and-claw feet. A distinctive feature of cabriole legs on Vizagapatam furniture is the manner in which their feet are carved, the elongated claws clutching a ball, the inner side of which is carved with a sprig – clearly a misinterpretation of a European ball-and-claw model. The conceit of inlaying ivory in the place of carving that would have been found on European furniture – such as on the legs, where acanthus is inlaid rather than carved, and on the cornice, where a dentilled effect is created by alternating ivory with wood – is also found on ivory-veneered furniture from Vizagapatam, where these effects are simulated with engraved decoration.

The face of the cabinet is worked with a combination of ivory inlay and ivory veneer, and belongs to the mid-eighteenth century, a period of transition between the two techniques. In terms of decoration, the use of ivory veneer permitted a greater degree of flexibility, since engraving on ivory permitted freer and easier expression than inlaying ivory into a wooden ground. A particularly prominent innovation in decoration is the introduction of figurative scenes and architectural vistas engraved on ivory, such as are evident on the central group of compart-

ments and the interior drawers of the cabinet. Although frequently fantastical, these images were originally inspired by European prints from illustrated volumes, which are prominently listed in contemporary inventories of the British in India and which were regularly advertised for sale in contemporary newspapers.[177] The designs on the upper two drawers of the central compartments and two of the inner drawers of the cabinet, for example, are views of Old Montagu House, London (see above). These appear on the same plate by J. Green after watercolours by Samuel Wale (*c.*1721–86), and are illustrated in R. and J. Dodsley, *London and Its Environs Described* (1761) (see below left).[178] The rest of the engraved images, which include a landscape capriccio with a bridge and ruin; a classical landscape with a temple; and a view of a seafront hilltop fort and castle flying a British flag, are possibly based on prints, but are more freely interpreted and executed. The various engraved panels are surrounded by an engraved floral border, which matches that inlaid around the cupboard doors and sides of the cabinet. This particular trail of stylized flowers was a much-reproduced pattern throughout the second half of the eighteenth century, and was both inlaid and engraved on ivory veneers.[179] A particularly striking feature is the distinctive flower with four leafy petals – perhaps originally based on a tulip or lily – which makes its appearance on earlier Vizagapatam work.

Old Montagu House, By J.G. Green, after watercolours by Samuel Wale, from *London and its Environs Described*, 1761; V&A Picture Library

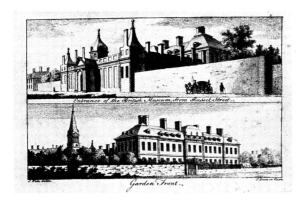

■ Rosewood, inlaid and partly veneered with ivory, with silver mounts

Vizagapatam, *c.*1765

Height: 174 cm Width: 103 cm Depth: 55 cm

IS 289 & a-1951

Gift of Mrs Muriel Bryant

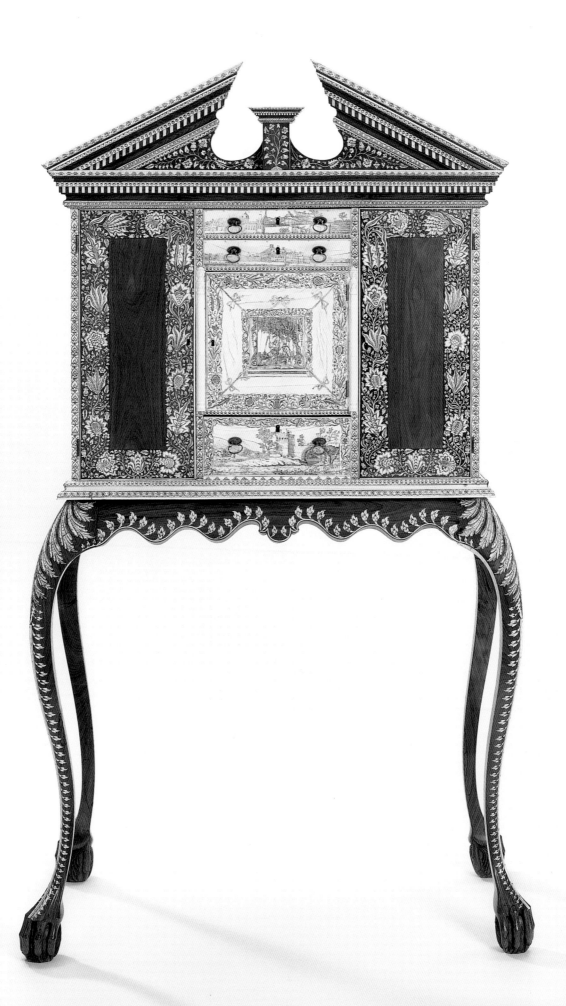

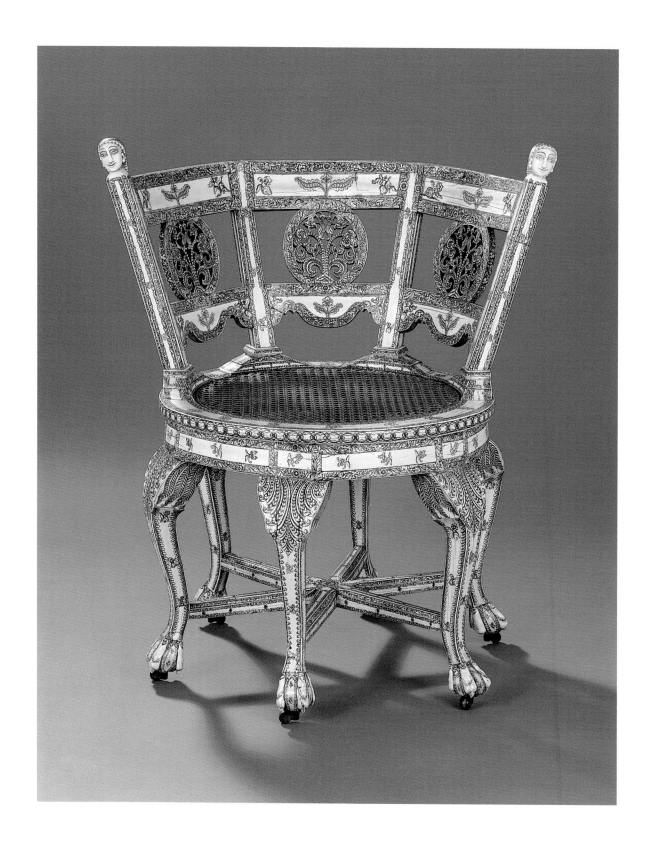

Revolving round chair

Chairs of this form were manufactured in the Indian subcontinent and the East Indies from the seventeenth century onwards and have been extensively copied in the last century.[180] The term currently used to describe them – 'burgomaster' – from the Dutch *burgemeester*, is of nineteenth-century origin, and suggests that chairs of this type were occupied by a person of rank. By contrast, in contemporary inventories from the Dutch East Indies and British India, chairs of this design are simply called 'round chairs', and are variously listed as single objects, in pairs and as sets of four and six, indicating that they served no particular hierarchic function.[181] The seat is always caned and usually rotates, as in this example, suggesting that this form was originally used as a barber's chair (*scheerstoel*).

The precise origin of the form of the chair is obscure, but traditionally it was thought to have been inspired by ancient Indian or South-East Asian seating furniture, in which a variety of round seats figure.[182] The form has no obvious precedent in the West, but the earliest surviving round chairs are constructed entirely out of turned components in the manner of seventeenth-century European furniture, suggesting that the translation of the Eastern shape into a Western piece of furniture occurred at the hands of European craftsmen, most likely working on the east coast of India or in the Dutch East Indies. Seventeenth-century round chairs are solid, in the manner of much European furniture of the period, with the bulbous turned components in most cases entirely undecorated, the legs joined with several rings of stretchers, and each splat bearing a simple caned lozenge at centre.[183] A chair of this type engraved '1640' on the top rail was formerly in the Victoria and Albert Museum (W 98-1891), and was sold in 1967. Museum records do not stipulate a timber for the chair; when acquired it was thought to be Dutch. In the absence of the object itself, it is difficult to establish anything about its origin, including whether it was authentic or a deliberate copy.[184] Round chairs from the first half of the eighteenth century are more decorative, with boldly carved cabriole legs, and

shaped stretchers and top rails, the caned splats substituted with pierced roundels typically featuring a plant or flowering tree, and the finials on the chair's two outer uprights, originally turned bulbs, sometimes carved as human heads.

With its cabriole legs and pierced lozenges, the design of this chair is typical of mid-eighteenth-century interpretations of the 'burgomaster' form. However, components such as the uprights and the stretchers, which on hardwood examples would be turned or carved, are here of square section and veneered.[185] The engraved design of repeating floral sprigs on the chair is found on the frame of a *charpoy* belonging to Ananda Ranga Pillai, and appears on the seat rails and frames of a variety of Vizagapatam chairs, including sets modelled on a prototype inspired by plate XVI of the third edition of Thomas Chippendale's *The Gentleman and Cabinet-Maker's Director* (1762).

The chair is one of several ivory chairs in the Victoria and Albert Museum that were traditionally believed to have belonged to Tipu Sultan, ruler of Mysore from 1782 to 1799. A silver plaque mounted on the inner face of the seat rail endorses this spurious provenance: 'Formerly the property of Tipoo Saib, taken after the storming of Seringapatam and presented to Queen Charlotte by Warren Hastings'. This myth has now been debunked.[186]

Deck of a Dutch East India Company Vessel Bound for Java; watercolour by Jan Brandes, 1778; © Rijksmuseum, Amsterdam

■ Haldu (*Adina cordifolia*), veneered with ivory, with caned seat

Vizagapatam, 1760–70

Height: 88 cm (height of seat: 47 cm) Width: 77 cm
Depth: 69 cm

IS 25-1970

Ceremonial staff or fencing stick

The design and decoration of this stick derive from diverse sources. The hilt, with its ball pommel and guard composed of two ears, is based on a variety of Rajput and central Indian sword (*khanda*), although the leaves on the ears are clearly inspired by European acanthus leaf motifs.[187] The pommel spike and ferrule are of blue and green enamel on silver, in style and colour typical of late eighteenth-century metalwork from Lucknow. A Lucknowi attribution is also supported by the painted decoration, which features cock and ram fights, both traditional pastimes of that city.[188] The painting on the stick is sketchy, with figures set against foliage and rockeries in a Chinese style. The figures themselves are of hybrid appearance; most often shown sitting cross-legged, they wear seventeenth-century Western dress and richly plumed hats, and sometimes have oriental facial characteristics. The imagery is possibly influenced by figures on Chinese and Japanese export porcelain and lacquer. However, the use of blues and greens against a cream ground is more typical of mid-eighteenth-century European imitations of Oriental lacquer (known as japanning) rather than Oriental lacquer itself, with its palette of black, red and gold.[189]

That Lucknow was responsible for its own particular brand of chinoiserie is hardly surprising; its rulers were themselves interested in China and her manufactures. Nawab Asaf-ud-daula (r.1775–97), for example, is recorded as filling his Aina Khana palace with, among other things, 'Chinese drawings and ornaments'.[190] Lacquered Chinese export furniture, or furniture decorated with Chinese ornament, was certainly available at Lucknow. A portrait of John Wombwell (*c.*1785), the East India Company's accountant there, depicts him on a corner armchair whose surface is clearly decorated in the Oriental style. Such chairs might well have been made locally, or at regional centres of painted and varnished furniture, such as Patna and Bareilly.[191]

Scholars are divided over the function of this object. The fact that it is richly decorated and mounted with enamel suggests that it was intended for display, raising the possibility that it was a ceremonial staff such as were carried by stick-bearers (*chobdars*). The role of a *chobdar* was to wait on a person of quality, to process before him and to announce visitors into his presence. In her *Journal of a Residence in India* (1813), Maria Graham described him as a 'servant who attends on person of consequence, runs before them with a silver stick, and keeps silence at the doors of their apartments'.[192] Contemporary accounts and illustrations specify that staffs carried by *chobdars* were usually silver.[193] Captain Thomas Williamson (1810) described them as 'about four feet and a half in length, tapering gradually from the metal ferule at its base, to the top, which may be about four inches in diameter, and is generally embossed with some figure, such as a tiger's head etc; while the rest, for the whole length is of some pattern, such as volutes, scales, flowers, etc'.[194]

That this stick is configured with a hilt also suggests that it might have been intended for *lakri*, a combat game played with wooden sticks.[195] Two types of *lakri* were taught and practised at Lucknow. *Ali mad*, which was the preserve of the ruling classes, derived from the Persian martial art of *phankainti*, in which the left foot of each player was fixed to one place. By contrast, in *Rustam khani*, the less formal Indian variation of the sport, players were allowed to change their positions. Given its delicate surface decoration, however, it is likely that this stick was for display rather than use.

Wood, covered with cloth, gessoed and painted, with pommel spike and ferrule of champlevé enamel on silver

Lucknow, 1750–80

Length: 135 cm

IS 10-1980

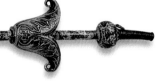

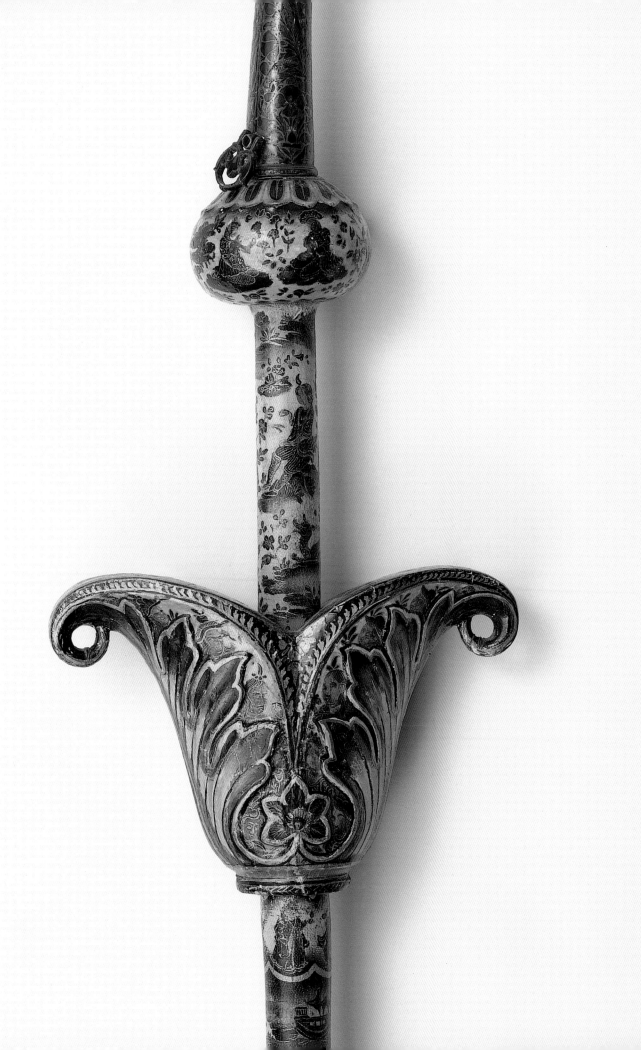

Rosewood, carved and turned, with later
velvet seats

Goa, 1760–70

Height: 82 cm (height of seat: 45 cm)
Width: 84 cm Depth: 67 cm

312& a-1879

Pair of Armchairs

These chairs present an interesting example of how the attribution of an object changes as knowledge of the field advances. When acquired by the Museum in 1879, they were identified as mahogany and thought to be of mid-eighteenth-century English manufacture, doubtless because in shape they conform so closely to corner chairs of that period. By the 1980s considerable research had been done on hardwood Chinese export furniture, and, given the pierced *ruyi*-head on the splats, it was felt that the chairs had been made in China for Western markets. They were accordingly transferred to the Museum's Far Eastern Department. In the following decade a number of chairs appeared on the market that resembled these, and a close study of their construction suggested that they were not Chinese, but possibly Indian. This was supported both by the appearance of similar corner armchairs in mid-eighteenth-century Company paintings from Bengal (see below left), and the fact that Chinese craftsmen were known to have been working in that region, thus explaining the presence of the *ruyi*-head ornament. Recent research has revealed that the chairs were, in fact, made in Goa and represent the vogue for English furniture forms there from the mid-eighteenth century onwards. They belong to a larger body of chairs of varying design made in the second and third quarters of the eighteenth century, all of which are characterized by the *ruyi*-head in more or less elaborate interpretations.[196] Examples may be seen at the Miranda House, Loutulim, and the Bragança House, Chandor.[197]

The inverted cloud motif on the splats derives from the head of a *ruyi* (literally 'what one wants'), a wand associated with good fortune and the realization of worldly aspirations (see below right).[198] *Ruyi* seem to have evolved as a fashionable accessory after the end of the Han dynasty (206 BC–AD 220) but were still current in the Qing dynasty (1644–1911), at which time they had heads in the shape of stylized clouds.[199] The motif is a standard design found on chair splats from the Yuan (1279–1368), Ming (1368–1644) and Qing periods.[200] That Chinese chairs were known in Portuguese India is highly likely. Furniture had featured among sixteenth- and seventeenth-century Portuguese imports from the Far East to India, and although it principally consisted of lacquered wares, there is evidence that domestic furniture forms, principally chairs, also travelled west.[201] The fact that the elevated furniture of China would have suited a Western lifestyle supports the idea that it played a practical role in Portugal's Chinese settlements, such as Macao, which was connected to Goa through the frequent passage of vessels. That Chinese domestic furniture was known on India's western coast is confirmed by the existence of Chinese chairs and furnishings in the early eighteenth-century Padmanabhapuram Palace, south of Trivandrum.

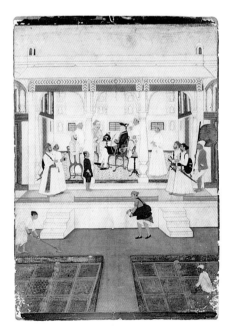

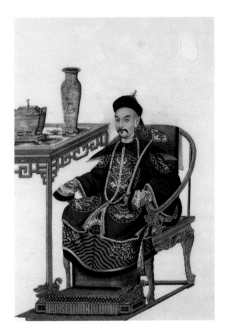

RIGHT *An English official in discussion with a nawab and his sons*; gouache with gold on paper; Patna or Murshidabad, 1760–65; courtesy of Sotheby's Picture Library

FAR RIGHT *A Mandarin*; watercolour on pith paper; Canton, c.1860; V&A: D. 38-1902

Miniature bureau-cabinet

This piece is a scaled-down version of an English bureau-cabinet, a type of furniture that would have been used for writing and storing documents and papers. It is difficult to know exactly why miniatures of such forms were made. Examples were certainly produced as commercial models or samples, and as dolls' furniture.[202] However, at Vizagapatam it is likely that miniatures were made because they were easy to transport and were thus more readily purchased by travellers who stopped at the port. Being highly decorative, a cabinet such as this would have been considered a showpiece, placed on a table and used for storing private effects.

By the 1760s, artisans at Vizagapatam were in the practice of engraving ivory veneers with architectural scenes based on European print sources (see cat. 29). Although in some cases these images were closely copied, in the main they were freely reproduced and reworked, sometimes with fantastic Chinese or Indian elements, and with elements drawn from local Western-style architecture.[203] The configuration and decoration of this miniature bureau-cabinet is typical, and the engraved motifs themselves are commonly found on other examples. Horizontal spaces are engraved with rows of fantastic buildings, pavilions and fences, while vertical areas, such as the sides of the cabinet, are engraved with two tiers of images, the upper of trees and the lower of buildings. These stylized interpretations of European-style buildings have no single or obvious design source but appear to be creations of the imagination. The floral borders that surround the architectural scenes are drawn from textiles that were made in the region of Vizagapatam for export to European markets.

A few related pieces are known, which are engraved with an image that can be directly traced to a print source. One such example belonged to J.W. Janssens, last Dutch Governor of the Cape Colony, and is engraved on its slope with a view of Lowther Castle taken from Colen Campbell's *Vitruvius Britannicus* (1715; reprinted 1717, 1737, 1767 and 1771), an image which appears to have been much reproduced at Vizagapatam.[204] On the frieze drawer of the bureau of the same piece are two scenes taken from engravings of views around Haarlem published on pages 91 and 94 of *Het Zegepralent Kennemerlant* by Matthaeus Brouërius van Niedek and illustrated by Hendrik de Leth (1703–66).[205] Another notable example is the miniature bureau-cabinet at Arundel Castle, which is engraved with an image of Old Montagu House drawn from a print published in 1761 (see cat. 29).

■ Sandalwood, veneered with ivory, with silver mounts
Vizagapatam, 1780–90
Height: 74 cm Width: 61.7 cm Depth: 27 cm
Loan: Mott

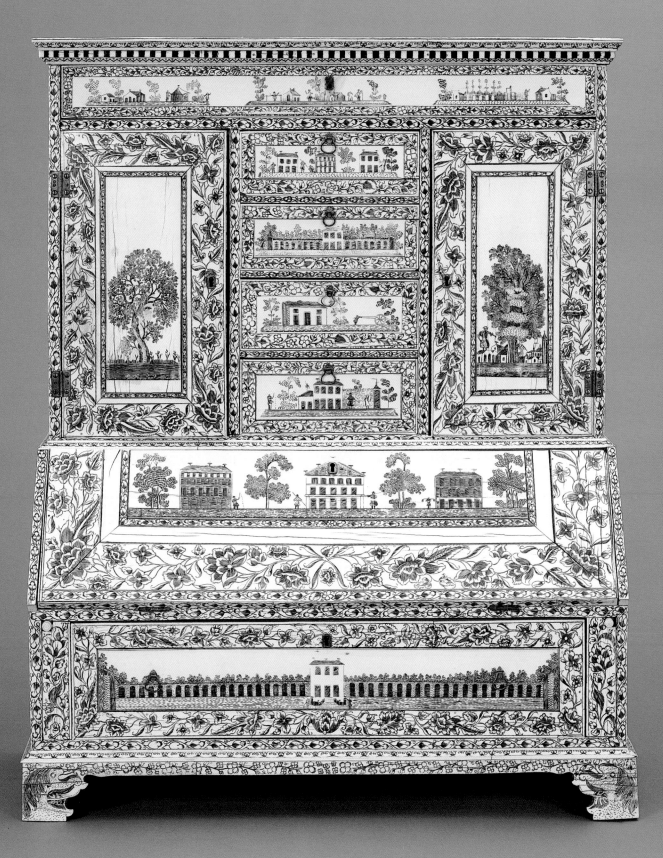

Pair of armchairs and table

This table and pair of armchairs were made in Murshidabad, the *nawabi* capital of Bengal and a celebrated centre of ivory carving that specialized in small-scale articles such as combs, fly-whisk handles, chessmen and caskets. Western-style furniture was made there in small quantities, possibly only on a commission basis. It was constructed principally of solid ivory with delicately carved decoration and gilding. Besides using it themselves to furnish reception rooms for the convenience of their European guests, the rulers of Murshidabad presented furniture to esteemed East India Company officials.[206] Warren Hastings (1732–1818), the first British Governor-General of India, was the recipient of a large suite of solid ivory furniture (the earliest documented furniture from Murshidabad) from Mani Begum, widow of Nawab Mir Jafar. This table and pair of chairs are almost certainly from that suite. Their design reflects the fusion of tastes evident at Indian courts at this time, with Western forms worked in an exotic manner. But merely to describe some of the pieces in the suite as Western in form is to oversimplify their design, which in fact does not belong to any one European decorative tradition, but which borrows elements from English, French and Chinese furniture, as well as from furniture made under European patronage in the East Indies.

The marketing of manufactures at Murshidabad and its environs does not appear to have been very sophisticated, but the quality of the carving assured it a good reputation. By 1811 the region was already known for its 'inimitable ivory work', which was simply sold by local vendors to European travellers in the region.[207] It is not known how many workshops operated at Murshidabad and the nearby towns of Cossimbazar and Berhampur, nor is the relationship between ivory carvers in each of these places presently understood. However, it is apparent that, with the decline of Murshidabad as a centre of courtly patronage in the early nineteenth century, ivory workers concentrated around Berhampur, where they found a ready market among European travellers journeying up the Bhagirathi towards the Ganges.[208] Arriving in Berhampur in 1836, Fanny Parks recalled that 'the budgerow [flat-bottomed barge] was instantly crowded with people, bringing carved ivory toys, chessmen, elephants etc. for sale.'[209] Isabella Fane was in Berhampur in the same year and also commented on 'beautiful things we saw there, such as chess men, boxes, palanquins, puzzles, paper-cutters'.[210] Also writing in the same period, Emma Roberts noted that, although a standard range of ivory works could be purchased locally, the makers worked principally to order. In spite of the proximity to Calcutta, their goods were not available there due to a lack of supply.[211]

Warren Hastings's ivory furniture was kept at Daylesford, his newly built country seat in Worcestershire (now Gloucestershire). The Revd F.E. Witts visited the house in 1827 and noted that the drawing-room was 'remarkable for its suite of ivory chairs and sofas' to which these pieces probably belonged.[212]

☐ Solid ivory, carved, pierced and partly gilded; the chairs with caned seats, the table with brass lock

Murshidabad, *c.*1785

Chairs (1075-1882 and 1075a-1882)
Height: 92.4 cm (height of seat: 49 cm)
Width: 71–72 cm Depth: 49 cm

Table (1085-1882)
Height: 71.5 cm Width: 77.5 cm Depth: 55 cm

Bequeathed by John Jones

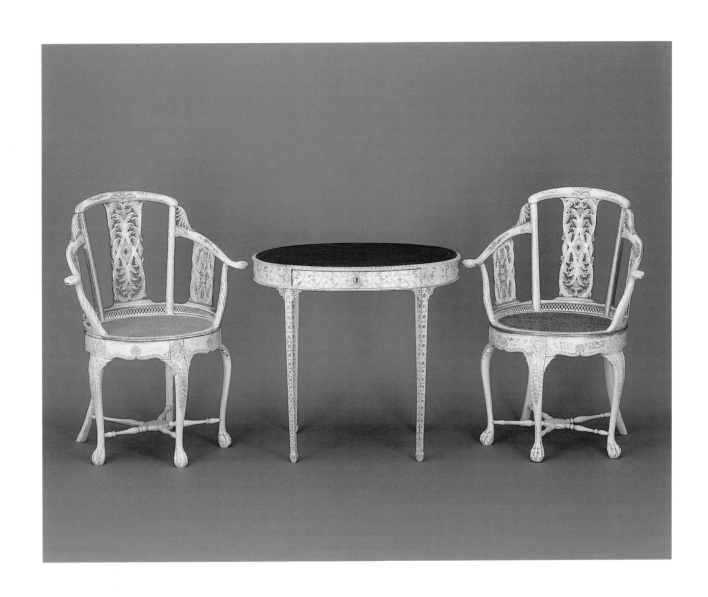

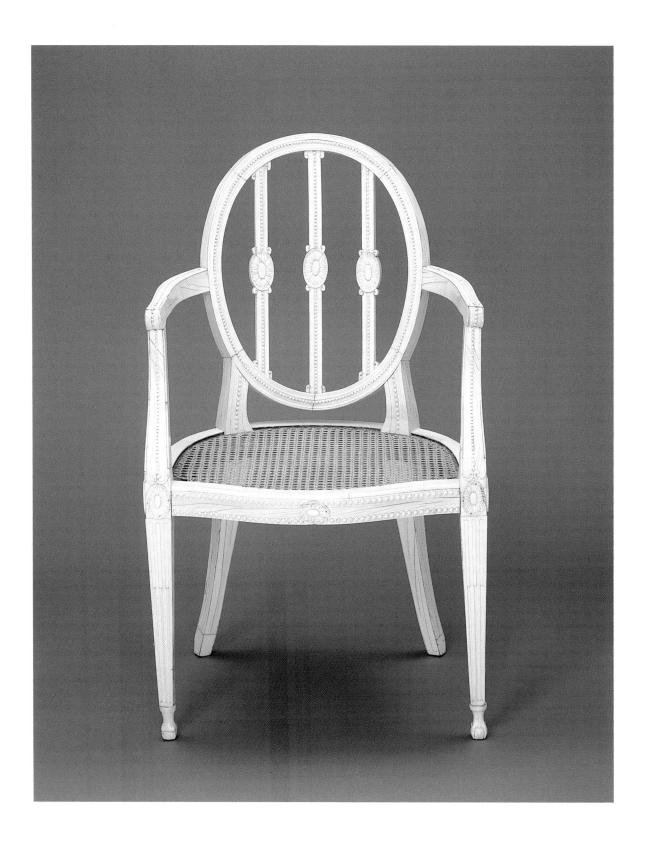

Set of four armchairs

While the overall shape of these chairs follows a familiar English design, they differ from English examples in the execution of the arms and arm supports, which would usually be shaped and moulded. The use of ivory veneer on these components has made this difficult to achieve, and, instead of being curvaceous and fluid in design, the arms on these chairs are stiff and awkwardly positioned. Elements of the chairs' design, such as the oval backs, fluted legs, beaded decoration, and oval rosette paterae, are commonly found in contemporary furniture patterns and surviving pieces of seating furniture from the 1780s.[213] Oval-backed chairs appear in the Gillow designs of that decade and in all three editions of Hepplewhite's *The Cabinet-Maker and Upholsterer's Guide* (1788, 1789 and 1794), where their backs are open and worked with intricate splats.[214] Chairs of closely related design were also being made in Canton for the export market. A pair of chairs of similar design to these, but with distinctive splats carved with a monogram, was bought there in 1795 by Dutch-American merchant Andreas Everardus van Braam Houckgeest.[215]

Other chairs of this design are not known. However, three pairs of chairs of related shape exist whose construction suggests that they were made in the same workshop. Each of the three pairs has oval backs and serpentine-shaped seats, but they are distinguished by solid ivory arms, arm supports and front legs. Of the three pairs, one was in the collection of the Earls of Lonsdale at Lowther Castle, and was sold in 1947, at which time it was described as 'A pair of Louis XVth style open arm fauteuils of ivory with oval backs on turned legs'.[216] Whereas on the front face of the V&A chairs the ivory veneer is secured with round-headed ivory rivets, which form a decorative beaded border, on the back the veneer is simply secured with regularly spaced ivory pegs. On the Lowther pair, ivory pegs are used to affix the veneer on both the front and back faces of the chair, although they are partly obscured beneath bold gilt borders defined by a black outline, a device found on other Murshidabad furniture. The second pair, identical to that from Lowther Castle, is at Kenwood House (IBK 1020 A & B). The pair is thought to have been part of Maharaja Duleep Singh's furnishings at Elveden Hall, Norfolk, purchased by the 1st Earl of Iveagh in 1894. However, it is equally likely to have been purchased by Iveagh under the recommendation of Caspar Purdon Clarke, Keeper of the Indian Section and subsequently Director of the South Kensington Museum, who was a constant adviser to Iveagh on the formation of his collection. The third pair, related in form to the preceding two, but without gilt borders, was on the London market in the 1950s and was purchased by Basil and Elise Goulandris. It is due to be displayed in the Museum of Contemporary Art in Athens, which is currently under construction.

☐ **Wood, veneered with ivory, with caned seat**

Murshidabad, 1780–90

Height: 92.5–93 cm (height of seat: 44–44.5 cm)
Width: 56–56.5 cm Depth: 57.5–58.5 cm

1064a to c-1882

Bequeathed by John Jones

Teapoy

In British India tripod tables – and small pillar tables in general – were known as 'teapoys' from the Hindi '*tin*' '*pai*', literally 'three leg' or tripod.[217] The teapoy's form was taken directly from the European candlestand, and although it was used principally for candles and their shades, contemporary illustrations indicate that it was sometimes also used as a hookah stand (right).[218] In Britain, the term teapoy was erroneously associated with tea and came to refer to a small pillar table incorporating a caddy or chest fitted for the storage and consumption of tea. This type of furniture evolved after the first quarter of the nineteenth century and figures in published sources of the day, such as Thomas King's *The Modern Style of Cabinet Work Exemplified*, first published in 1829.[219]

According to tradition, this teapoy belongs to a group of ivory furniture assembled in India by Francis, 1st Marquess of Hastings, who was Governor-General from 1813 to 1823.[220] It was acquired from him by his successor, William Pitt, 1st Earl Amherst of Arracan.[221] Precisely how the collection of ivory furniture passed from Hastings to Amherst is not known. When he left for England in January 1823, Hastings was heavily in debt, and his circumstances may have forced him to sell it. If transacted directly, the sale could only have occurred in England, since Amherst and Hastings never met in India.[222] This supposition is supported by the absence of any mention of ivory furniture in the correspondence and financial records dating to Amherst's stay in India from 1823 to 1828.[223] Alternatively, the furniture might have been acquired by Amherst on the market in Calcutta. What is certain is that the furniture was acquired by Amherst before 1830, as it features in an inventory of Montreal Park, Kent, of that year along with other Indian artefacts that Amherst brought back with him, such as arms, textiles and courtly articles used in *durbar* (an audience, court or levee).[224] This teapoy (described as an 'Ivory and Gold Pillar and Claw'd Stand') is listed in the drawing-room of Montreal Park alongside a pair of teapoys that is identically described and is now in a private collection.[225]

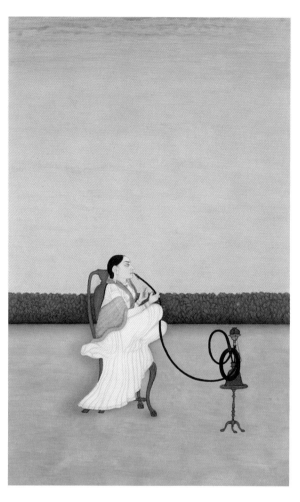

Woman smoking a hookah; gouache on paper; Murshidabad, 1760–63; V&A: D. 1181-1903

☐ **Solid ivory, turned, carved and partly gilt**
Murshidabad, *c.*1790
Height: 73 cm Diameter: 31.5 cm
IS 12-1991
Gift of the 5th Earl Amherst of Arracan

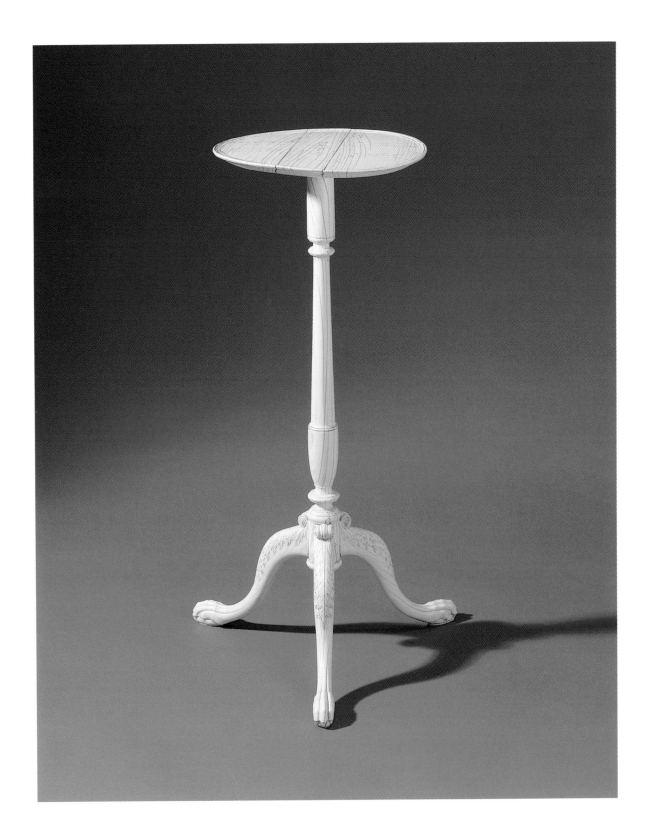

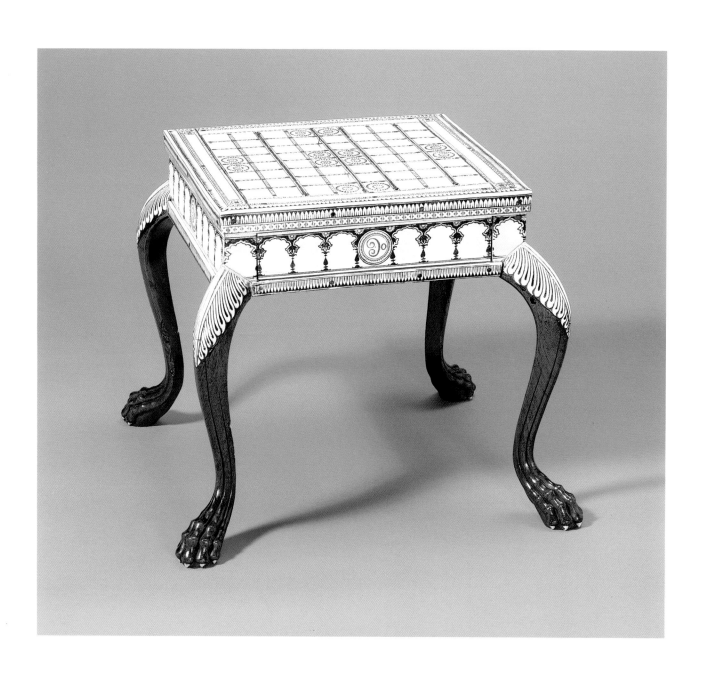

Teak, partly carved and partly veneered with ivory

Travancore or Coorg, late 18th century

Height: 36 cm Width: 45 cm Depth: 45 cm

335-1907

Gift of Mrs F. Halse

Games table

Incising ivory and highlighting it with lac is characteristic of southern India. The decoration of this table, however, is unusually restrained and differs vastly from other incised ivory work from the region, which is usually richly ornamented with designs of foliage and mythic beasts. Aspects of the table's design, such as the acanthus leaves on the legs, reveal the influence of Western furniture, but they are incised on ivory rather than carved, as would have been the European prototype. The construction of the drawer is also based on English examples: the sides and back are joined to each other with dovetails (the front dovetails are lapped), and the drawer bottom is secured in rebates along the base of the sides.

The table is an early example of courtly furniture made for indigenous consumption in a Western style. Its height suggests that it was used by people on low seats. According to tradition, the table was looted from the palace at Mercara (Madikeri), the capital of Coorg, a small princely state to the west of Mysore that was taken by British forces in 1834. The symbol on each side of the case belongs to the rulers of Coorg, and is found as the central device of Linga Raja's (r.1811–20) seal. Coorg had been a British ally in the wars against Tipu Sultan. However, the reigns of Linga Raja and his son Vira Raja (r.1820–34) were periods of unrest and strife, both among the people of Coorg and within the ruling family. In 1834 Governor-General William Bentinck ordered the invasion and subsequent annexation of the state by Company forces, allegedly acting in response to repeated complaints about the situation in Coorg. According to a letter from the table's donor, dated 11 April 1907, 'the Table was taken from the Palace at Coorg, or Coorge and sent to my late uncle Lieut-Colonel Maling, and has been in our Maling family since.'[226] According to a directory of the Indian Army, Lieut-Col. C.S. Maling (1808–60) was not involved in the Coorg campaign; in fact in 1834 he is recorded as captain in the Jodhpur Legion and on furlough.[227] It is possible that he acquired the table afterwards from somebody who had been at the taking of Coorg.

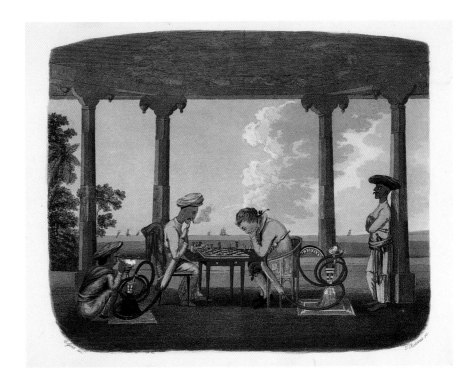

Smoking the Hookah; hand-coloured aquatint by T. Rickards after a drawing by Charles Gold, from his *Oriental Drawings*, London, 1806; by permission of The British Library

Toilet glass

The term 'toilet glass' refers to a small cabinet with an integral swinging mirror that usually sat on a lady's dressing table (below). Such furniture was often highly decorative and personalized; the owner of this example, for instance, had her initials, 'T.F.', engraved on the oval cresting. The oval mirror plate and restrained Neoclassical decoration of husks and urns on this toilet glass are based on late eighteenth-century English toilet glasses, such as those illustrated in plates 70 and 71 of Hepplewhite's *The Cabinet-Maker and Upholsterer's Guide* (1788).[228] The stepped and pagoda-shaped base does not have a precedent in English furniture, but may have been loosely inspired by two-tiered English toilet glass bases. Toilet glasses of related design – with crested oval mirrors on stepped cabinets – were stock products of Canton lacquer workshops during the late eighteenth century, and it is very likely that Canton prototypes inspired the manufacture of this particular form at Vizagapatam.[229]

The decoration of the toilet glass conforms to prevailing Neoclassical tastes and represents the shedding of exotic decorative elements in the engraving of Vizagapatam wares in favour of motifs that were in fashion in Europe. The introduction of restrained decoration featuring husks and urns probably occurred towards the end of the 1790s. Among the purchases of Lady Clive while at Vizagapatam in 1801 were two games boxes, the borders of one of which correspond to those on the toilet glass; the other is decorated with a Greek key design.[230] Richard Wellesley, Governor-General of India from 1798 to 1805, sent his wife Hyacinthe a travelling desk engraved with trails of flowers in the manner of the toilet glass, with her initials 'H.C.W.' engraved at the centre of the lid,[231] and games boxes with precisely this type of decoration abound.[232]

The Young Lady's Toilet, coloured lithograph by J. Bouvier after the drawing by William Tayler in *Sketches Illustrating the Manners and Customs of the Indians and Anglo-Indians*, 1842; by permission of The British Library

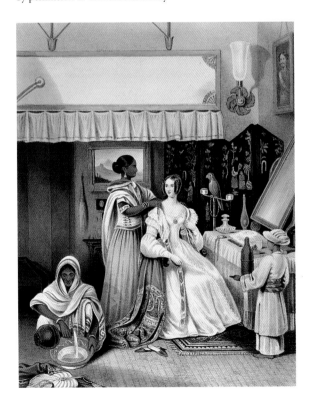

◼ Sandalwood, veneered with engraved ivory, with silver mounts

Vizagapatam, 1790–1800

Height: 104 cm Width: 58 cm Depth: 31.5 cm

IS 31-1975

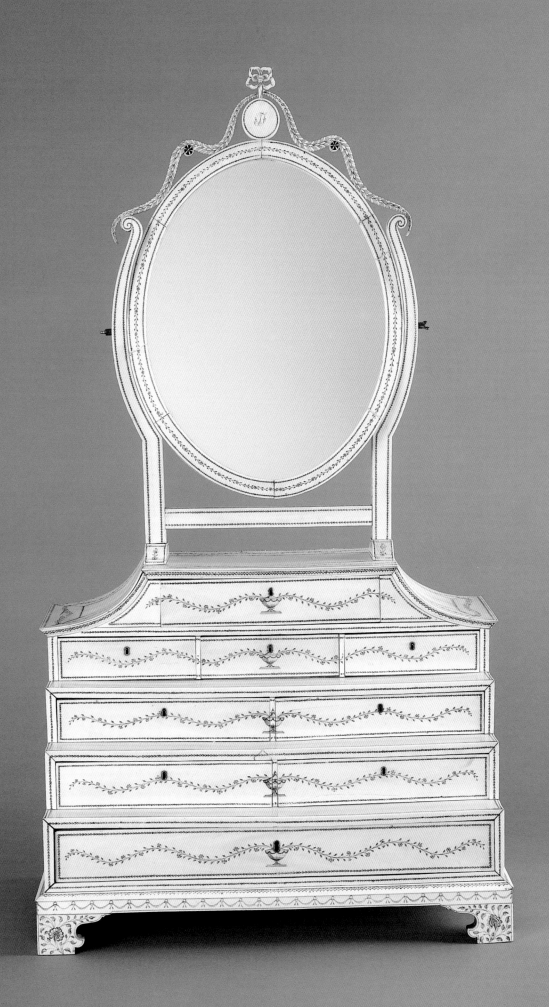

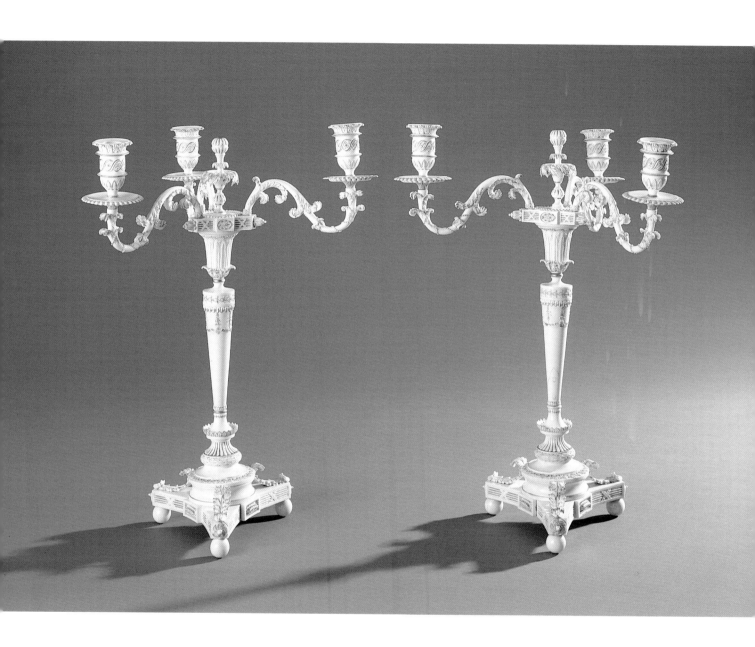

☐ **Solid ivory, carved and partly gilt**
Murshidabad, c.1800
Height: 57 cm Width: 42 cm
W. 17&a-1960

Pair of candelabra

In spite of their unusual appearance, when acquired by the Museum in 1960 these candelabra were thought to be late eighteenth-century English. Aspects of the candelabra's design, such as their triangular base, inverted tapering column, and branches with unfurling acanthus, are typical of English metalwork of this date.[233] However, other elements are distinctly out of character, including the finials of whirling acanthus; the section into which the three branches are joined; and the raised decoration on the tablets on the base, which have no parallel in the vocabulary of late eighteenth-century English ornament. H.D. Molesworth, Keeper of the Department of Furniture and Woodwork, argued that they were of such high quality that they might have been made as a type of 'exotica for a special commission – like Carlton House'.[234] Molesworth's attribution was partly supported by Charles Oman of the Metalwork Department, who agreed 'that there can be no doubt of the English silver design origins for these pieces.' Oman expressed uncertainty, however, as to 'whether they could have been done in Europe [or] in one of the countries influenced by English design (Scandinavia) or Russia'.

The idea that the candelabra were made in India was given credence only after 1964, when Museum curators learnt of a stylistically related solid ivory wall bracket that had just been given to the Metropolitan Museum of Art, New York, and which could be firmly attributed to late eighteenth-century British India (below). The wall bracket depicts a lion trampling a tiger, surmounted by a Persian inscription that translates as 'gift of God'. It was almost certainly made to commemorate the British victory in 1799 over Tipu Sultan of Mysore, whose defeat is represented symbolically in the subjugation of the tiger, his personal symbol, by the British lion. The motto, 'gift of God', was used by Tipu to refer to his kingdom and was adopted by the British to allude to their victory over him.[235]

The handling and overall style of both the wall bracket and the candelabra relate closely to documented Murshidabad furniture of the late eighteenth century. Motifs such as acanthus leaves, chains of pearls, pendant bell-flowers, festoons and reeded mouldings crossed with ribbons are characteristic of that school, and indicate that Murshidabad ivory carving workshops were familiar with the sort of ornament fashionable in late eighteenth-century design. The shape and decoration of the candelabra might have been inspired by imported European examples, or by designs supplied by locally based European tradesmen or patrons. Published designs from pattern books were certainly current among Murshidabad ivory carvers. An example of their use is found on a work table given around 1800 to Jeanette Sturt, wife of a judge and magistrate at Murshidabad, the legs of which are of solid ivory, carved according to a pattern in Thomas Sheraton's *The Cabinet-Maker and Upholsterer's Drawing Book*, published in 1793.[236]

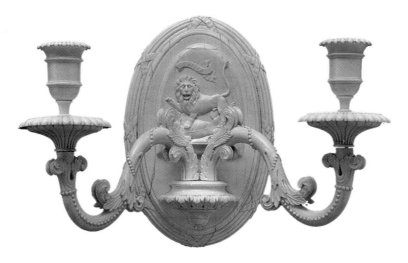

Wall bracket; ivory, carved; Murshidabad, *c.* 1800; courtesy of The Metropolitan Museum of Art, New York. Gift of Irwin Untermeyer, 1964 (64.101.1033)

Marble throne chair

According to tradition, this chair was presented by Bahadur Shah II, the last Mughal emperor (r.1837–57), to General Sir George Brooke, KCB (1801–82). By the 1820s it had become standard practice for Indian princes to present British officials with gifts of high-quality furniture. For example, among the gifts received by Lord Amherst during his journey up the Ganges was 'a magnificent ivory chair'.[237] Lord Auckland, Governor-General from 1836 to 1842, was honoured with similar presents. Near Patna he was presented with 'an ivory arm-chair',[238] and in the Punjab, Ranjit Singh gave him 'a bed with gold legs, completely encrusted with rubies and emeralds'.[239] Furniture was given by Indian rulers to lesser Europeans as well. Nina d'Aubigny, a visitor to Murshidabad in the early nineteenth century, received from the Nawab 'the most beautiful chair . . . inlaid with all coloured glasses'.[240]

At the Mughal court marble was one of a variety of precious materials used for thrones. Secure and impervious to the climate, platform thrones (*takhts*) of this type formed part of the architecture, and when in use were dressed with textiles and bolsters. At some seventeenth-century Rajput courts, marble platform thrones were rendered more comfortable with a back-rest and surrounded by railings. In early manifestations of this form the railings are found around the perimeter of the platform, such as may be seen on the throne of Rao Rata Singh (r.1607–41) at Bundi (see below), and on thrones in the Aina Mahal, Bhuj and Deogarh Mahal, Deogarh. Late eighteenth- and nineteenth-century examples, for example in the Shringar Chowk, Merangarh Fort, Jodhpur, are more obviously influenced by Western chairs, the platforms mounted with a back and sides of the size and shape of an armchair.

The transformation from marble platform thrones to Western-style chairs probably occurred in the late eighteenth or early nineteenth century, driven by the overall trend of westernization that affected the domestic life of Indian elites in that period. Marble was certainly being worked into a range of Western furniture forms from the early nineteenth century onwards. In her diary, Emily Metcalfe described the furniture in her father's Delhi house in the 1830s: 'Many of the tables were entirely of marble, the tops, pedestals and all, and very beautiful they were.'[241] In his catalogue written to accompany the Delhi Exhibition of 1902–3, Sir George Watt observed white marble 'chairs' and 'garden benches' among the exhibits from Jodhpur, which is the centre for the reproduction of such marble chairs today.[242] Much of the marble worked specifically for Britons in Delhi and Agra was inlaid with semi-precious stones (*pietra dura*), an effect visitors saw and admired on the the great Mughal monuments. Touring Delhi in 1838, Emily Eden, for example, couldn't resist admiring the Red Fort's 'beautiful inlaid floors, any square of which would have made an enviable table for a palace in London'.[243] The taste for Mughal *pietra dura* among tourists led to the copying of designs not only on portable articles such as boxes but also on furniture, principally table tops and chairs.[244]

Marble seat of Ratan Singh; Bundi, Rajasthan;
photograph © Antonio Martinelli

Marble, carved and pierced
Delhi, early 19th century
Height: 98 cm Width: 62.5 cm Depth: 53 cm
15-1899
Gift of Mrs Edith Johnson

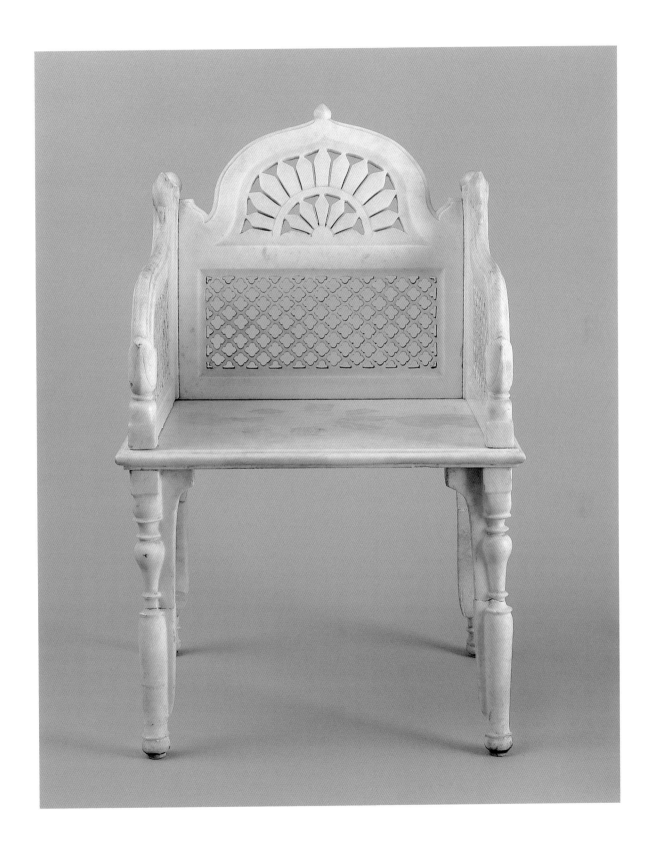

Travelling armchair and footstool

The chair represents various Anglo-Indian furniture traditions: it is based on an English prototype, but is made of precious materials; it is embellished with both conventional European effects, such as reeding and Indian enamel; and it collapses for ease of portability. The design of the chair was possibly influenced by George Smith's *A Collection of Designs for Household Furniture and Interior Decoration* (1808), in which are illustrated several chairs of this shape, with such features as swept legs, uprights that scroll backwards, scrolling arms and paw feet.[245] The metalwork points to Lucknow as a place of manufacture. Champlevé enamel (*minai*) was a speciality of the city, particularly using green, blue and yellow on a silver ground, as is found on reserves on this chair (see below).[246] Silver gilt and chased work on silver, the former on the feet of the chair and footstool, and the latter found on the top rail and along major components of the chair, are also both characteristic of Lucknowi metalwork.[247] Finally, the sophisticated execution of the chair, both technically as a piece of collapsible furniture and as an example of fine metalwork, points to Lucknow, a courtly centre of production where Indian craftsmen were capable of producing high-quality Western-style articles.[248]

Given its chief attribute of portability, it is likely that the chair was made specifically for use by a high-ranking East India Company official. Based on what is known about the production of enamels in Lucknowi workshops, the chair was probably made as a joint effort by a number of different hands: the frame would have been constructed by a furniture-maker; the sheet silver hammered over it by a goldsmith (*sunar* if Hindu, *sadakar* if Muslim); the surface design marked by a painter (*chitrakar* or *nakshiwalla*); the depressions to be enamelled created by an engraver (*chatera*); the enamel applied by an enameller (*minakar*); the surface finished by a polisher (*jilasaz*); and gilt by a gilder (*mulamasaz*).[249]

Rosewood, partly carved and covered in sheet silver, partly gilt, with enamel reserves

Lucknow, *c.*1820

Armchair (2519 [IS])
Height: 93 cm (height of seat: 51 cm) Width: 68 cm
Depth: 72 cm

Footstool (2520 [IS])
Height: 17.5 cm Width: 44.5 cm Depth: 33 cm

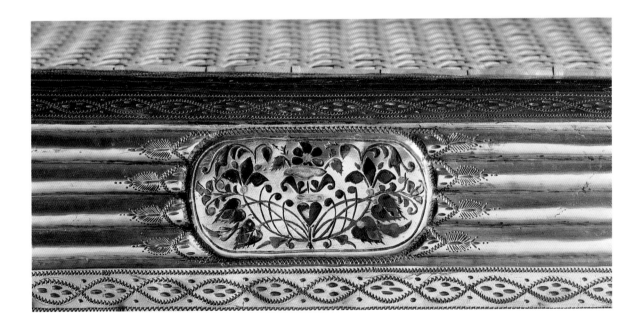

Giltwood throne chair

The chair is a rare surviving example of Lucknowi palace furniture and was probably given by Ghazi-ud-din Haidar, Nawab (r.1814–27) and (after 1819) King of Oudh, to Lord Amherst, Governor-General of India (1823–28) during his visit to Lucknow from 28 November to 5 December 1827.[250] The production of stylish Western-style furniture at Lucknow is hardly surprising. Following the defeat of Nawab Shuja-ud-daula (r.1754–75) by East India Company forces in 1764, Lucknow came under the sphere of British influence, and there developed a taste for Western-style architecture and goods among successive generations of its rulers.[251] Nawab Shuja-ud-daula employed Europeans at his court, such as the French mercenary Colonel Jean-Baptiste Gentil, who helped to reorder the nawab's army along European lines, and Colonel Antoine Polier, who acted as his engineer and architect. Artists were also appreciated, such as Tilly Kettle (1735–86), who painted a number of portraits of the nawab and his sons.[252] His successor Asaf-ud-daula (r.1775–97) spent vast sums on European manufactures, cultivated European manners, and employed European craftsmen and artists, among them Johann Zoffany (1733–1810).[253] In the words of his contemporary Lewis Ferdinand Smith, 'he is very fond of the English and English manners; he eats at table with them without the silly superstitious repugnance of other Mahomedans, and he relishes a good dish of tea and hot rolls.'[254] According to the nawab's chief minister Husain Reza Khan, Asaf-ud-daula's adoption of Western habits was motivated by his dependence on the East India Company, for which purpose his court 'endeavoured in all matters that they could with propriety to accommodate themselves to these [European] Manners'.[255] His successor, Saadat Ali Khan (r.1798–1814), sometimes wore European dress and was in the habit of entertaining Europeans to grand breakfasts, at which he lavished on them European delicacies (prepared by his French cook) in a room 'furnished with chairs, and every other article in the European style'.[256]

Lord Valentia visited one of the nawab's palaces, which was a 'very comfortable English gentleman's house, with suitable furniture, beds, prints and chairs'.[257] He went on to describe a dinner at Lucknow, which indicates that the nawab's manner of entertaining was undertaken in as European a style as possible:

> The room at dinner was very well lighted up, and a band of music (which the Nawaub had purchased from Colonel Morris) played English tunes the whole time. The scene was so singular, and so contrary to all my ideas of Asiatic manners, that I could hardly persuade myself that the whole was not a masquerade. An English apartment, a band in English regimentals, playing English tunes; a room lighted by magnificent English girandoles, English tables, chairs, and looking-glasses; an English service of plates; English knives, forks, spoons, wine glasses, decanters and cut glass vases – how could these convey any idea that we were seated in the court of an Asiatic prince?[258]

His successor, Ghazi-ud-din Haidar, carried on in the same vein. When Bishop Heber visited he found that the palace furniture 'was altogether English'.[259] An image of the nawab entertaining Lord and Lady Moira illustrates precisely what Heber must have seen: an interior complete with dining table, shades, mirrors and even prints of horses, presided over by an Indian prince wearing Western-style regalia (see p. 100).

The nawab's Western furniture was imported from Europe at vast expense via locally based agents in Madras.[260] However, articles were also fashioned in Lucknow in the latest European taste. A particularly important figure in terms of the production of nawabi courtly paraphernalia was Robert Home (1752–1834), a pupil of Angelica Kauffmann (1741–1807), who was invited to Lucknow by Saadat Ali Khan and was court painter during the reign of his successor Ghazi-ud-din Haidar from 1814 to 1827. When the nawab was installed as King of Oudh in 1819, Home was responsible for devising his regalia as well as such accessories as carriages, howdahs, barges and palace furnishings.[261] An album of

Wood, gilt, with gilt brass and gilt gesso mounts and later blue velvet upholstered seat

Probably designed by Robert Home

Lucknow, *c.*1820

Height: 89 cm (height of seat: 45 cm)
Width: 61 cm Depth: 65.5 cm

IS 6-1991

Gift of the 5th Earl Amherst of Arracan

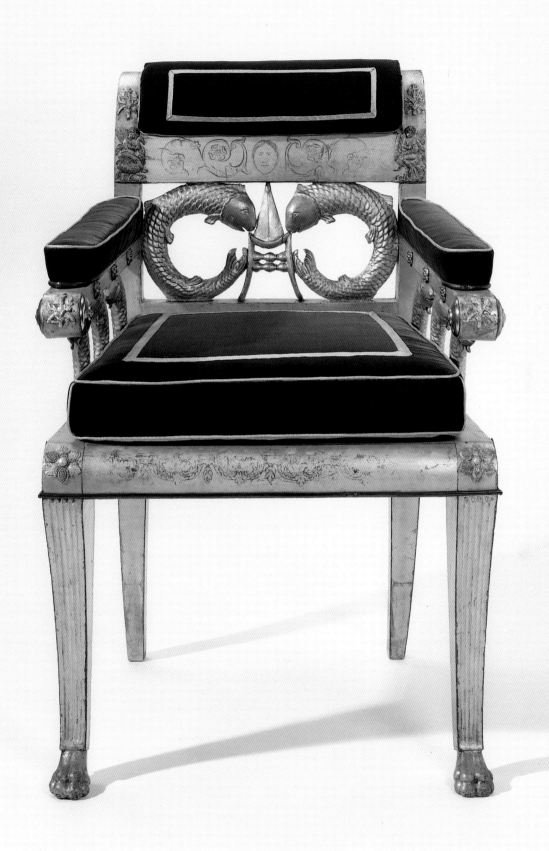

Ghazi-ud-din Haidar Entertaining Lord and Lady Moira; gouache on paper; Lucknow, *c.*1814; by permission of The British Library

his designs in the Victoria and Albert Museum includes numerous sketches based on Antique sources as well as his own quasi-Indian creations for his patron. Among these are both Western-style objects worked with twin fish – the badge of the nawabs of Lucknow – and Indian articles incorporating elements of classical ornament.[262] Typical designs include a carriage decorated with giant fish, a howdah worked with griffins, a barge supported on a crocodile and a Western-style order of merit worked with fish motifs.

This chair is typical of Home's designs and was probably executed under his direction. Plates in the Victoria and Albert Museum album indicate both that Home fashioned chairs of state for Ghazi-ud-din Haidar and that he was the author of the distinctive fish and punch dagger design.[263] Other elements of the chair's form, however, such as the flat arms and lightly reeded front sabre legs, were possibly inspired by fanciful Neoclassical and Egyptian revival furniture designs published in Thomas Sheraton's *The Cabinet-Maker, Upholsterer and General Artist's Encyclopaedia* (1804), Thomas Hope's *Household Furniture and Interior Decoration* (1807) and George Smith's *A Collection of Designs for Household Furniture and Interior Decoration* (1808).[264]

Maharaja Ranjit Singh's throne

Whereas in Europe royal furniture is most often simply gilded, thus creating the effect of gold without incurring the cost, in India the reverse is true, richly worked sheets of gold being abundantly used in the decoration of thrones. The use of precious metals in the decoration of royal seats is referred to in sacred Hindu texts and established a precedent for Hindu rulers, who would also have valued these materials for their attributes of purity in a social and religious context.[265] As well as indigenous works such as Abul Fazl's *Ain-i Akbari*, which reveals, for example, that at the Mughal court thrones were 'made of gold, silver, etc.', there exist numerous descriptions by European visitors to Indian palaces of silver and gold-covered state furniture.[266] These accounts indicate that furniture covered with precious metals has been current in courts throughout the subcontinent over at least the last five centuries. On visiting Calicut in the early sixteenth century, the Portuguese P.A. Cabral noticed that the Zamorin sat on a 'large silver chair, the arms and back of which were of gold and full of stones, that is, of jewels'.[267] In the late eighteenth century Lord Valentia observed at Lucknow that the nawab sat 'on his musnud, which was handsomely covered with silver plates, with ornaments of gold';[268] and, on his visit to Ceylon in the early nineteenth century, Charles Pridham found that the eighteenth-century throne of the Kings of Kandy was 'of wood, entirely covered with a thin gold sheeting (studded with precious stones)'.[269]

The throne provides tangible evidence of the splendour of Ranjit Singh's court that so impressed European visitors. Travelling there in 1837 as part of a diplomatic entourage, Henry Edward Fane noted that 'The dresses and jewels of the Rajah's court were the most superb that can be conceived'.[270] Emily Eden's observations, made in the following year, likewise ring with superlatives. On inspecting the jewel-encrusted attire of Ranjit Singh's horses, she admitted to herself that 'It reduces European magnificence to a very low pitch.'[271] Miniatures of Ranjit Singh's court frequently depict throne chairs and footstools of gold with precious stones, and the use of such richly worked furniture is confirmed by contemporary travellers' accounts. For instance, Emily Eden recorded that, among presents given by Ranjit Singh to her brother Lord Auckland, Governor-General of India, was 'a bed with gold legs, completely encrusted with rubies and emeralds'.[272]

The throne was made for Ranjit Singh by the goldsmith Hafez Muhammad Multani, probably in the second decade of the nineteenth century. The throne's distinctive cusped base composed of two tiers of petals derives from lotus thrones of Hindu deities. As a symbol of purity and creation, the lotus has traditionally been employed as a seat for gods, although most often they consist of a single lotus flower with petals open. The two-tiered cusped lotus shape that inspired Ranjit Singh's throne seems to have evolved in the post-Gupta period and was widely used thereafter.[273] Thrones composed of two tiers of lotus petals were certainly current in the Punjab in the early nineteenth century and appear, for example, in Basholi painting.[274] Although Hindu in concept, the throne's octagonal shape is based on polygonal courtly furniture of the Mughals, which provided prototypes for thrones, footstools and tables throughout northern India.[275]

Maharaja Sher Singh; oil on canvas by August Schoefft, *c.*1850; Vienna; courtesy of the Department of Archaeology and Museums, Government of Pakistan. Princess Bamba Collection

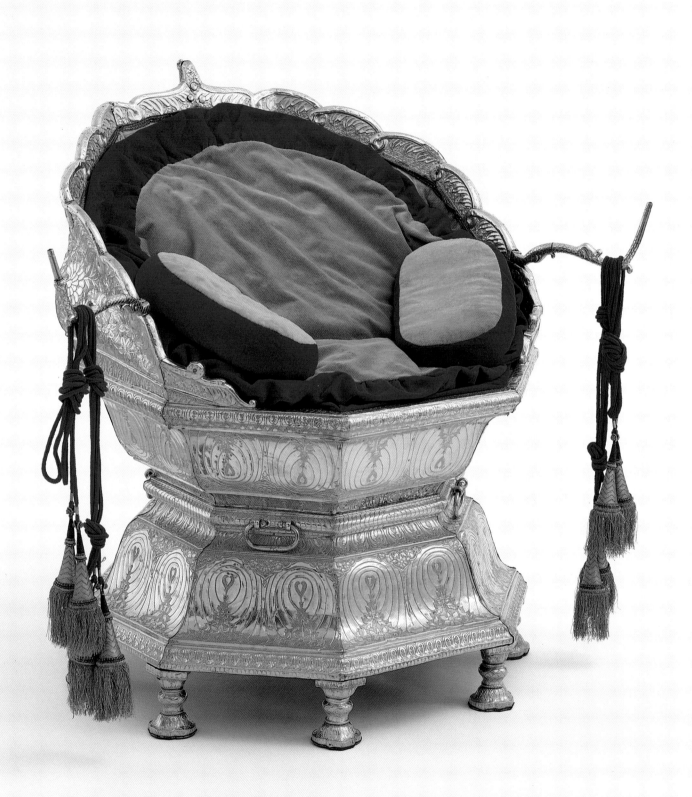

Portraits of Ranjit Singh depict him on various thrones of similar shape. However, the only portrait in which this throne is shown is in that of his son Maharaja Sher Singh (r.1841–43), painted by August Schoefft (1809–88) in Vienna c.1850, based on sketches made in the Punjab in the previous decade (see p. 101).[276] The Schoefft portrait reveals that the prongs protruding at either side of the seat originally supported gold orbs.

The throne is recorded in the inventory of the Sikh treasury made by Dr John Login after the British annexation of the Punjab in 1849. Initially it was unclear whether the East India Company wanted to preserve the throne or dismantle it and divide up the gold sheets as prize money, as had been done with the gold-covered throne of Tipu Sultan.[277] In 1853 it was brought to Calcutta, where Lord Dalhousie, Governor-General (1848–56), had it copied in mahogany by Shearwood and Company.[278] Thereafter it was sent to England for display in the East India Company's Indian Museum, and was transferred to the South Kensington Museum in 1879.

An almost identical giltwood throne exists in Government House, Calcutta. By the time Lord Curzon arrived there in 1899 it was being described as the 'Throne of Tipu Sultan', but it is in fact more likely to be a Dalhousie-period copy of Ranjit Singh's throne that has been wrongly attributed.[279] The confusion over its origin is most probably due to an early nineteenth-century description of Government House, in which there is a reference to a 'musnud of crimson and gold, formerly composing part of the ornaments of Tipoo Sultan's throne'.[280] The term *musnud* describes the bolster and surrounding textiles used by Indian princes in state, and a close reading of this particular text confirms that it is textiles (perhaps the textile dressing of Tipu's gold throne), rather than a wooden throne, that the observer has seen. However, the giltwood throne of oriental shape at Government House was somehow coupled with Valentia's reference to Tipu's *musnud*, thus adding one more object to the long list of furniture spuriously associated with the 'Tiger of Mysore'.

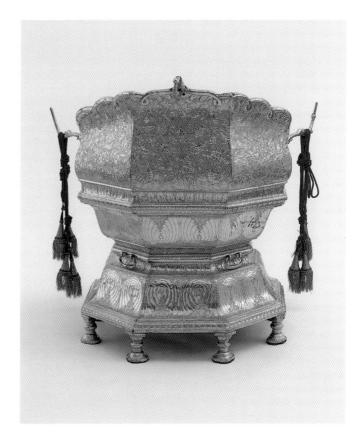

Wood, overlaid with repoussé, chased and engraved sheets of gold

Made by Hafez Muhammad Multani

Lahore, 1820–30

Height: 93 cm (height of seat: 51 cm)
Width: 90 cm Depth: 77 cm

2518 (IS)

Games box

There can be no doubt that this compendium of games originated at the court of the Maharaja Krishnaraja Wadiyar III, ruler of Mysore from 1794 to 1868.[281] The Maharaja was a skilful player, and his abiding interest in the board games of his own country prompted him to develop both variations of existing games and entirely new games. These labours bore fruit in an encyclopaedic Kannada work, which included a substantial section on chess entitled *Chadurangasarasarvasva*, and another on games and pastimes entitled *Kautukanidhi*. Various lengthy manuscript versions or extracts of these works exist in Mysore and elsewhere (see below). These contain illustrations of boards, together with rules and other interpretative material. While many concerned chess, or chess-type variants with astrological additions, much attention was also devoted to the far simpler indigenous folk games that have traditionally been played throughout India. Sundry illustrations and texts from these compositions were engraved on copper plates which, hinged together, formed a playing compendium of a different kind. Others, especially those concerned with chess, were printed on paper. The Maharaja's own collection of gaming materials in the form of boards, dice and pieces is still preserved in the Sri Jayachamajendra Art Gallery, Mysore. The collection includes a number of boards that are of the same materials, style and standard of workmanship as the gaming box under discussion, and comparison leaves no doubt of their common origin.[282]

The eleven games provided for in this games box vary from the most sophisticated to the most elementary. It is worth pointing out that the simpler of the games have almost invariably been traditionally played in improvised boards scratched on the ground or the like. Boards in the literal sense of the term are, for these games, seldom to be encountered. The top board is configured for four-sided chess. Games boards from the Maharaja's collection in Mysore share the characteristic, also evident on this compendium, that designs of the pieces used for each game are inlaid into the playing surface. Judging by the inlays, the box would appear to have been originally issued with the ornate pieces that were kept in the two storage drawers.

It is not known exactly when in the Maharaja's reign the games box was made. An examination of the box suggests that it has been used, and this is supported by the fact that some of the pieces are missing. The box was acquired at the Exposition Universelle, Paris, in 1867, and was probably the 'Inlaid chess box' from Mysore in Group IV, Class XIV.[283] In India Museum records it was simply described as a 'magic box for native games'.

Engraving of a numerical table invented by Maharaja Krishnaraja Wadiyar III, 1852

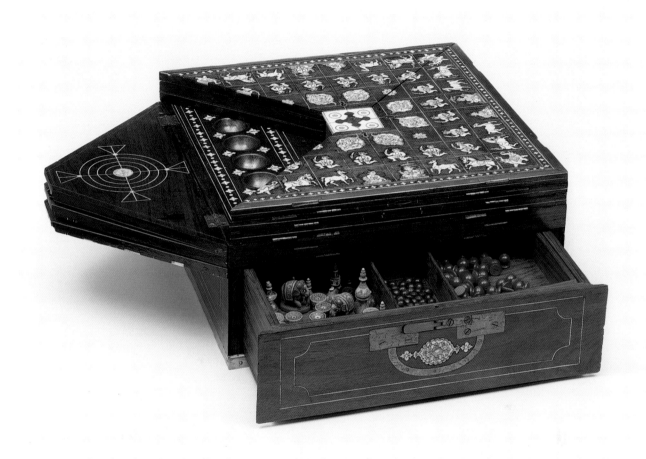

Blackwood, inlaid with ivory, with lacquered brass mounts

Mysore, 1825–50

Height: 17.5 cm Width: 36 cm Depth: 36 cm

06409 (IS)

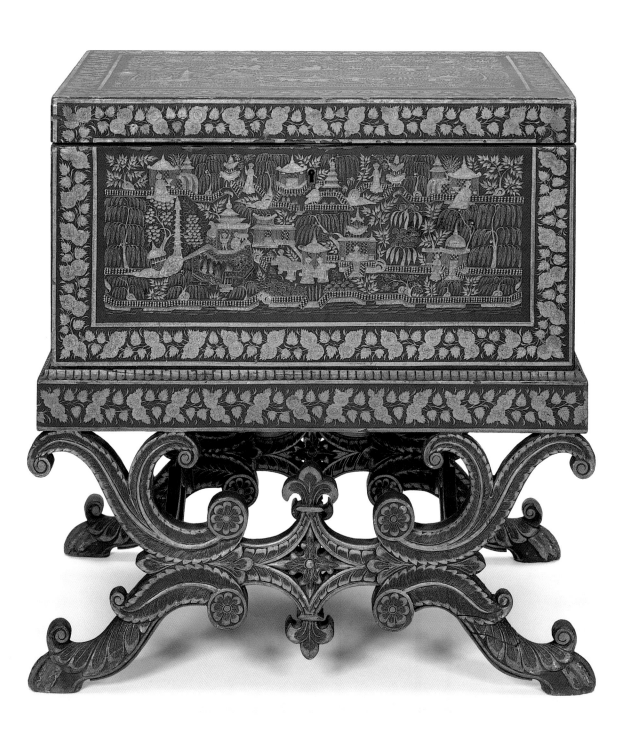

Chest on stand

By as early as the 1770s craftsmen at centres in north-eastern India who had traditionally been employed in painting and varnishing toys, bangles and *charpoys* came to apply their traditional decorative techniques to objects for Western consumption. The inspiration behind this was probably lacquered furniture from the Far East, which was already in evidence in Bengal in the Portuguese period and was widely imported into British India, where it was in favour for much of the eighteenth and early nineteenth century.[284] This chest was made at Bareilly, the former capital of Rohilkhand, which was ceded to the East India Company in 1801. Bareilly was a stopping point on the route between Calcutta and Delhi, and as early as the 1820s the place was renowned for the production of Western-style furniture, which was painted and varnished in black and gold. Captain Mundy remarked in 1828 that items of Bareilly furniture, 'though painted and gilded very handsomely, are remarkably cheap'.[285] Writing in the same period, Emma Roberts described Bareilly as 'famous for the beauty of its household furniture, which is painted and lackered with much taste'.[286]

Because of the willow trees, pagodas and oriental figures painted on chests of this type, they have been wrongly thought to have been made in Canton for export to Western markets. Museum documentation confirms that this piece was actually made in Bareilly, whose workshops were producing articles in a number of different finishes, including one directly inspired by lacquer designs on Chinese export furniture (described as being of 'Chinese pattern').[287]

Wood, painted and varnished, with silvered brass mounts
Bareilly, mid-19th century
Height: 66 cm Width: 66 cm Depth: 46.5 cm
02325 (IS)

Painted box

This box is painted with narrative scenes of Indian courtly life. However, it is difficult to know whether these record actual historic events or simply represent themes popular in contemporary Rajasthani and Gujarati painting. When acquired, the painting was believed to represent scenes from the life of a ruler of Tonk, a princely state south of Jaipur. However, the distinctive high turbans, curved Arab daggers (*jambiyas*) and apparent tie-dye textiles are all characteristic of Jamnagar, a princely state in Gujarat, suggesting that the box was made there.[288] Further support for this attribution is found in the similarity between the painting on the box and wall paintings at Lakhota Palace, Jamnagar.[289] The palace was built in Ranmal Lake by Jam Ranmalji (r.1820–42), a dynamic ruler known for his building projects and his passion for hunting. The wall paintings that Ranmalji commissioned include courtly scenes as well as portraits of his ancestors, some of whom wear turbans of the type depicted on the box.[290] A visitor to the palace in 1927 observed that one of the rooms,

> is covered with remarkable frescoes some of which depict the exploits of a former Jam. One of these shows the Jam on horseback firing at a lion which has one of his Sidi followers in its grip. A whole array of nobles with levelled muskets is riding behind him. This must have been Jam Ranmalji who died in 1852 . . . Another painting depicts the Jam and his ministers carousing . . .[291]

Parallel themes of hunting and carousing are depicted on this box. On the front is a *durbar* scene, with a richly jewelled prince sitting on chair surrounded by courtiers (see opposite). One of them kneels in front of him, touching his foot in what is probably an act of obeisance, while the rest all raise their wine cups. The scene on the top of the box is in the same vein. The prince sits with his courtiers watching dancing girls and musicians. Some of them have wine cups, and the ruler himself is being presented one by an attendant. On the back the prince and two courtiers are shown hunting on horseback, carrying muskets and firing at a tiger who sits at the edge of the composition (see below). The sides of the box are less specific. The subject of the left side, a girl pulling a thorn out of her foot with the help of an attendant, derives from Rajasthani folk legends, and may be found on local wall painting.[292] The right side depicts a girl walking with a *hookah*.

The attitudes of the figures suggest that the scenes represent a particular series of events. However, to date it has not been possible to identify the events or the figures beyond that of the prince, who is probably Ranmalji himself.

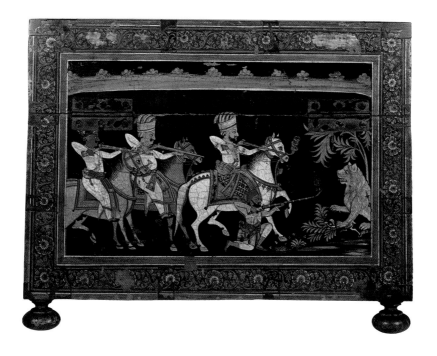

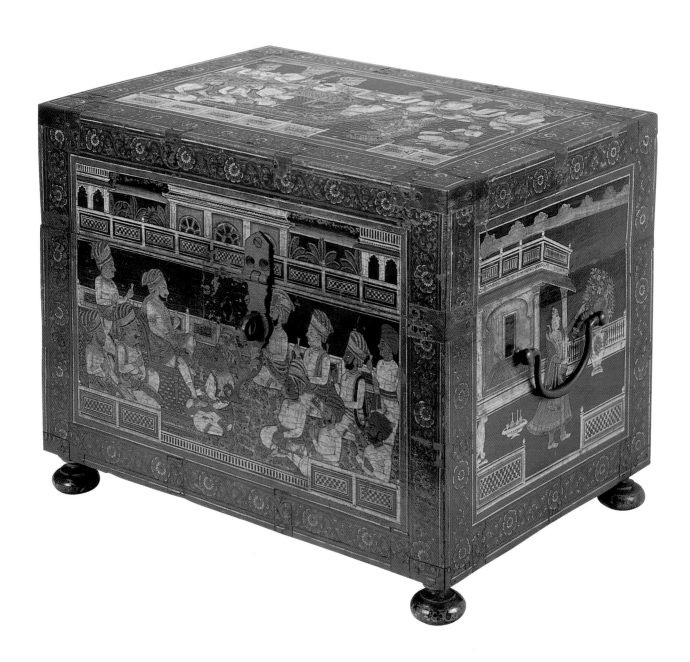

Sandalwood, painted with tempera and gold, with brass mounts

Jamnagar, mid-19th century

Height: 31.1 cm Width: 39.7 cm Depth: 27.9 cm

IM 6-1920

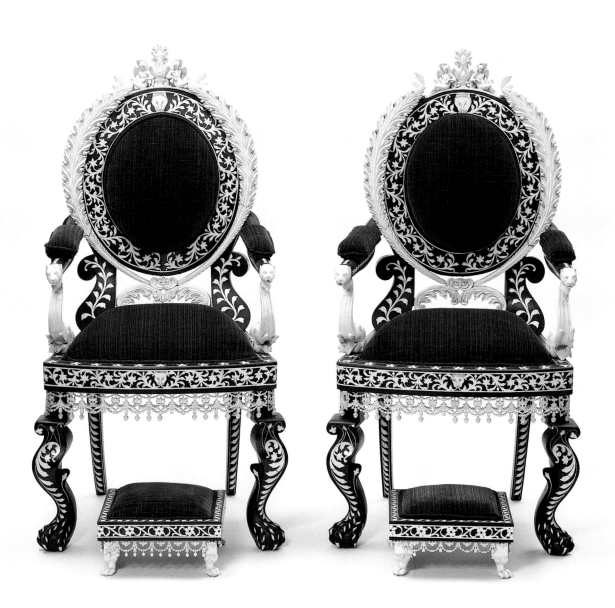

Ebony, inlaid and mounted with ivory, with red velvet upholstery

Berhampur, *c.*1855

Armchairs (01216 and 01217)
Height: 112 cm (height of seat: 44 cm)
Width: 59–60.5 cm Depth: 51–52 cm

Footstools (01219 and 01220)
Height: 12.5 cm (without upholstery)
Width: 29 cm Depth: 29 cm

Pair of armchairs and footstools

The chairs are based on Rococo revival models of the second quarter of the nineteenth century, with intricately carved ivory elements attesting to the virtuosity of Berhampur craftsmen of the *bhaskar* caste, who were renowned for their skill at carving ivory figures.[293] These chairs were originally accompanied by a matching chess table, and it was formerly thought that all three pieces had been exhibited at the Great Exhibition of 1851.[294] No reference to these pieces has been found in documentary material relating to the exhibition, however, and it is more likely that the suite was acquired at the Exposition Universelle held in Paris in 1855, at which a pair of chairs and a table of this description were shown.[295] In his

seminal work on ivories, W. Maskell cited this suite as an example of exceptionally poor design: 'If an attempt were purposely made to show to what depths of vulgarity and bad taste art could be made to descend, together with a waste of a valuable and beautiful material, it would be difficult to succeed better than has been done with these astounding specimens.'[296]

Two tables of the same style are known, and both are decorated with similar aprons of ivory simulating lace and groups of carved ivory animals, all delicately worked in the manner of the Murshidabad figures and deities featured at exhibitions of the period.[297]

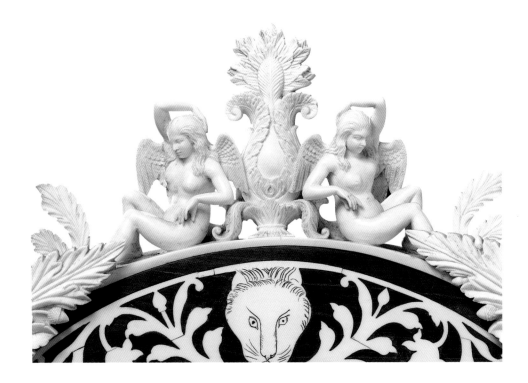

Armchair

The art of painting and varnishing surfaces was reputedly introduced into Kashmir by Sultan Zain-ul-Abdin (r.1420–70), who admired such work during his captivity in Samarkand and brought skilled artisans back with him on his return.[298] The technique was called *kar-i-qalamdani* (pen-case work) since it was principally pen-cases (*qalamdans*) that were first ornamented in this way, although the decoration of bookbinding was also central to the evolution of this work.[299] The production of painted and varnished wares was divided into two stages: making (*sakhtasazi*) and painting (*naqashi*), each the speciality of a different craftsman (see below). The pigments used were derived principally from minerals and vegetables, both of local origin and imported.[300] In the case of a gold or silver ground, thin sheets of these materials were laid down over areas applied with an adhesive (*dor*) composed of glue, sugar and yellow paint. Designs and highlights were painted in diverse colours, together with gold and silver paint, using brushes of varying fineness made of cat, goat or ass's hair.[301] On completion, the surface was burnished with jade or agate, and coated with a transparent varnish, originally made of linseed oil and gum resin but from the late nineteenth century made of amber or copal dissolved in methylated spirit.[302] Accounts indicate that painters worked from memory and specialized in depicting either arabesques and paisley designs (such as found on shawls), figurative scenes or flowers.[303] Stock designs from the last group included 'thousand flowers' (*hazara*), a dense grouping of diverse flowers; 'foreign flower' (*gul-i-wilayat*), a flowering tree populated with birds; and a 'shrubbery of flowers' (*gul-ander-gul*), clusters of receding bunches of flowers.[304]

Papier-mâché and painted wares were probably first made in Kashmir expressly for European consumption in the early nineteenth century, probably on the back of the shawl trade. Writing in the early 1820s, William Moorcroft described papier-mâché as a 'branch of manufacture for which Kashmir has long been celebrated'.[305] On her visit to the Punjab in the late 1830s, Emily Eden lamented over her failure to acquire some Kashmiri papier-mâché: 'I had a great miss this morning of some trays and cups japanned in Cashmere.'[306] Production of a whole range of Western goods was certainly underway by the 1860s, and included nesting tables, trays, salvers, chess-boards, hanging shelves and candlesticks.[307] At which date painted chairs were first produced in Kashmir is difficult to establish. However, it is possible that they were made for the indigenous elite from as early as the beginning of the nineteenth century. Richly decorated seating furniture based on Regency forms featured at the courts of the Sikhs (who controlled Kashmir from 1780 to 1846), and, while some examples were made in silver and gold encrusted with precious stones, others must have simulated these effects with lustrous, highly coloured painting embellished with varnish. The production of lacquered chairs was certainly underway by 1864, at which time the Maharaja of Kashmir submitted an example at the Punjab Exhibition held in that year.[308] By the 1870s chairs had become stock manufactures of Srinagar workshops, but were poorly received by art critics, who felt that on Western-style furniture this brand of painted work 'has a vulgar appearance, and soon gets worn and tawdry'.[309] Having never been used, this chair's *hazara* decoration is beautifully preserved.

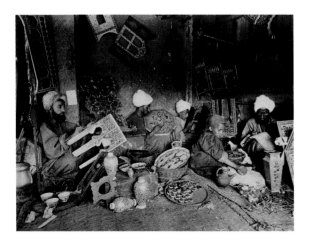

Papier-mâché painters; photograph from the 'Album of Indian Trades and Occupations', Earl of Elgin Collection, *c*.1890; by permission of The British Library

Wood, painted and varnished, with caned seat

Srinagar, *c*.1870

Height: 89 cm (height of seat: 47 cm)
Width: 61 cm Depth: 62 cm

1598-1871

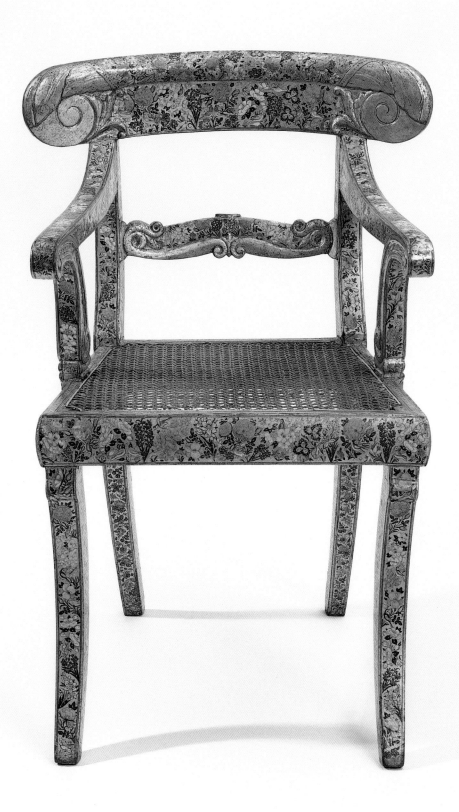

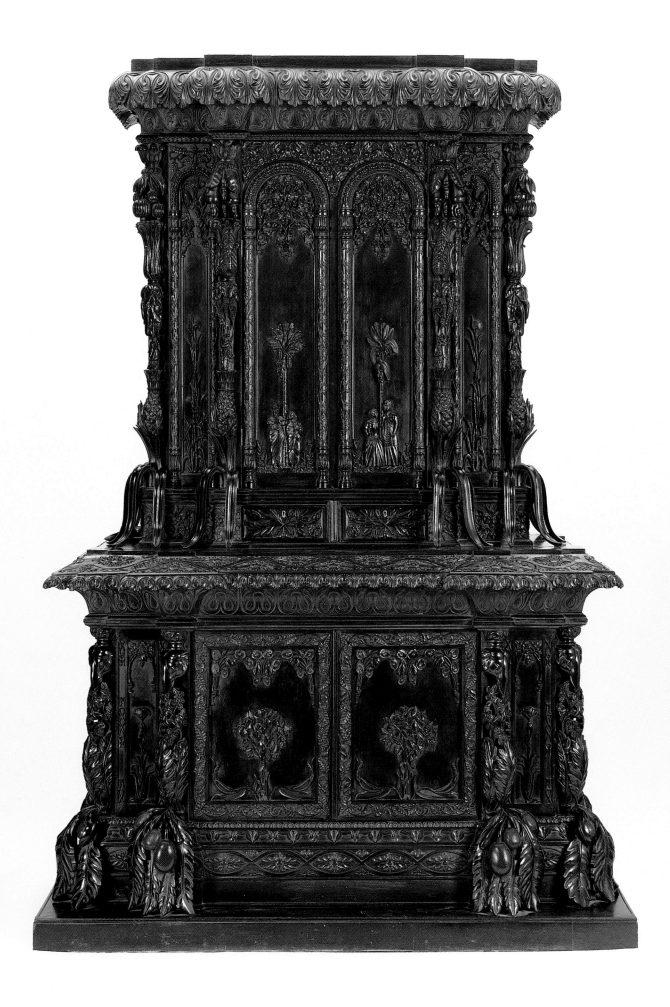

Ebony cabinet

This cabinet was designed to communicate the attributes of Ceylon at a number of different levels. The lavish use of ebony, a timber that has always been accorded a high value, illustrates the natural wealth of the island; the case construction and carving, executed in various degrees of relief, advertises the virtuosity of Ceylonese craftsmen; the vegetation depicted announces the range and abundance of fruits and vegetables on the island; and the pairs of figures from different regions provide an idea of the appearance and dress of island's inhabitants. They are, from the left to right sides: a Jaffna Tamil couple with a palmyra palm; a Sinhalese Kandyan couple with a toddy palm; a Galle or Matara Sinhalese couple with a coconut palm; and a Tamil Indian couple with a date palm.

The practice of depicting peoples of the island was by no means recent; from at least the late eighteenth century ivory figures of native peoples were being fashioned for Western consumption.[310] The use of furniture as a tableau for these purposes probably first occurred on objects specifically intended for the Great Exhibition in 1851. Craftsmen intending to submit articles for the Exhibition were informed that suitable articles must be 'ornamented with figures, flowers and fruit and c., strictly Ceylonese'.[311] Reputedly made for the Empire of India Exhibition held in London in 1895, this cabinet epitomizes the convention of producing furniture for exhibitions whose overriding purpose is to represent national attributes.

The form of the cabinet is copied from a Baroque revival walnut and ebony 'cabinet, secretary, and bookcase' exhibited at the Great Exhibition of 1851 by William and Charles Freeman of Norwich (see below right).[312] Based on a historic form and decorated with highly elaborate carving, the Freeman cabinet characterizes the tastes of the day. It was illustrated in both the Exhibition's *Official Descriptive and Illustrated Catalogue* and *The Art Journal Illustrated Catalogue*, in which it was lauded as a 'specimen of work that would do credit to the first house in London'.[313] It is most probable that the design itself was transmitted to Galle carvers through one of these sources; however, it is puzzling that such a long time lag existed between the presentation of this form in 1851 and its copying in Ceylon nearly fifty years later.

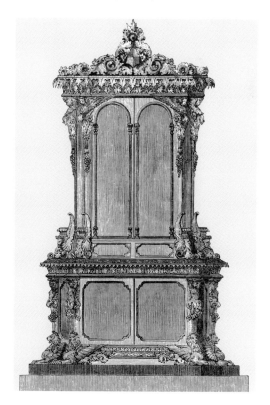

Walnut and ebony cabinet by Freeman of Norwich, from *The Art Journal Illustrated Catalogue*, The Industry of all Nations, London, 1851, plate 23, p. 230, NAL PP.6.B

Ebony, with brass and silvered brass mounts
Galle District, *c.*1895
Height: 231 cm Width: 156 cm Depth: 73 cm
IS 18-1986

Dowry chest (*patara*)

Metal-mounted storage chests of this type are a standard component of household furniture in Kathiawad, the peninsular part of the modern state of Gujarat. Although used across castes and commonplace throughout the region, *pataras* are particularly associated with the Kathi, the clan after whom Kathiawad was named. According to Kathi customs, a *patara* forms part of a bride's dowry and is used as a receptacle for textiles and other valuables that she brings with her to her new home.[314] In Kathiawadi houses *pataras* are typically placed against one of the walls in a living room, most often with other trunks, boxes and containers used for storage (see below).

Traditionally *pataras* were made by *gujjar suthars*, carpenters who are traditionally believed to descend from Vishvakarma, in Hindu mythology the divine world builder.[315] In the twentieth century, however, different castes working in related materials also began to manufacture them, including *luhar suthars* (blacksmiths) and *kumbhars* (potters).[316] Woods used in construction typically consist of mango and teak, which are mounted with iron, brass and aluminium.[317] In India the practice of covering wood with sheets of metal is an ancient one.[318] In the case of *pataras*, metals are used not only to enrich the surface and to add value to the object, but also to reinforce the carcass, which is secured entirely with nails.[319]

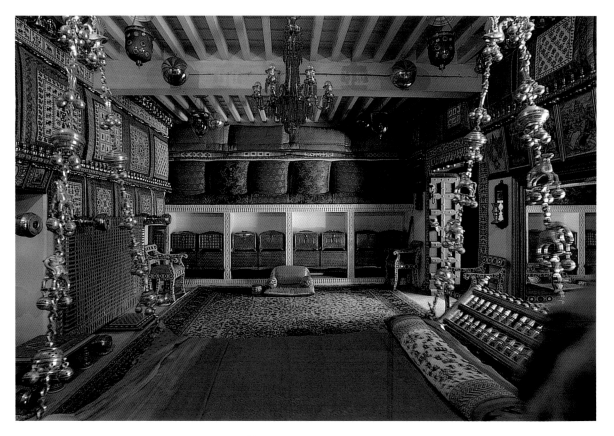

Sitting room, decorated in the late nineteenth century, with pataras stacked along the lower back wall, Jasdan Palace; Jasdan, Gujarat; photograph © Deidi von Schaewen

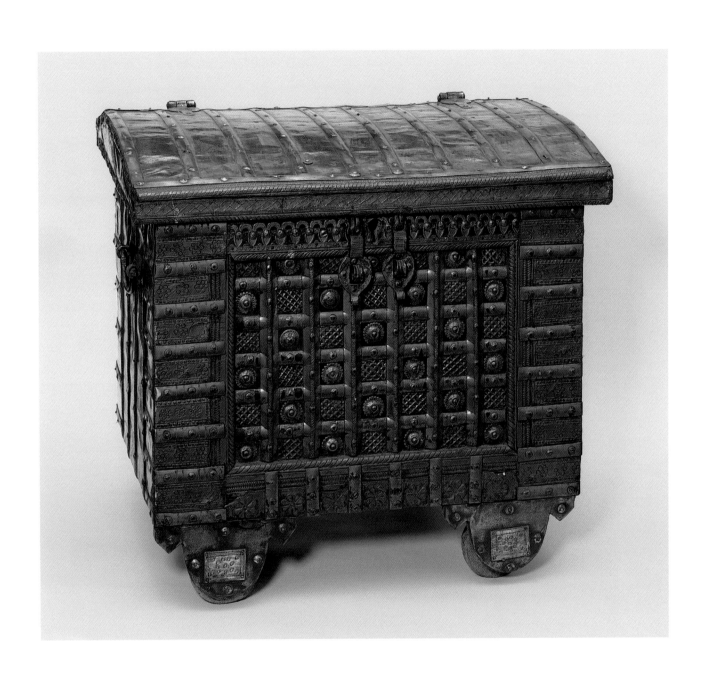

Wood, covered with steel and brass

Kathiawad, Gujarat, 19th century

Height: 73 cm Width: 80 cm Depth: 58 cm

IS 15-1982

Notes

Introduction

1 George C.M. Birdwood, *The Arts of India* (London, 1880), p. 199.

2 Edward Terry, *A Voyage to East India with a Description of the Large Territories under Subjection of the Great Mogol, in The Travels of Sig. Pietro della Valle, a Noble Roman into East-India and Arabia Deserta Whereunto is Added a Relation of Sir Thomas Roe's Voyage into the East Indies* (London, 1665; 2nd edn 1777), p. 185.

3 T. Bowrey, *A Geographical Account of the Countries Round the Bay of Bengal 1669 to 1679*, ed. R.C. Temple (Cambridge, 1905), p. 96.

4 Cited in V.P. Dwivedi, *Indian Ivories* (Delhi, 1976), pp. 18–19.

5 *The Voyage of Pedro Alvares Cabral to Brazil and India*, trans. W.B. Greenlee (London, 1938), p. 73.

6 *Jahangir's India: The Remonstrantie of Francisco Pelsaert*, trans. W.H. Moreland and P. Geyl (Cambridge, 1925), p. 67.

7 J. Ovington, *A Voyage to Surat in the Year 1689*, ed. H.C. Rawlinson (London, 1929), p. 233.

8 Annemarie Jordan Gschwend, 'The marvels of the East: renaissance curiosity collections in Portugal', *The Heritage of Raulunchantim*, ed. Nuno Vassallo e Silva (exh. cat., Lisbon, Museu de São Roque, 1996), pp. 82–127.

9 C.R. Boxer, *The Dutch Seaborne Empire 1600–1800* (London, 1965), pp. 213–14.

10 Sir Thomas Herbert, *Some Yeares Travels into Africa and Asia the Great: Especially Describing the Famous Empires of Persia and Industant . . .* (London, 2nd edn, 1638), p. 37.

11 Ovington, *A Voyage to Surat*, p. 131.

12 *The Embassy of Sir Thomas Roe to the Court of the Great Mogul, 1615–1619*, ed. William Foster (1899, repr. Weisbaden, 1967), Vol. II, p. 478.

13 Ovington, *A Voyage to Surat*, p. 106.

14 Edward Ives, *A Voyage from England to India* (London, 1754), p. 52.

15 Ibid.

16 Ibid.

17 For further information, see Louis Dumont, *Homo hierarchicus*, trans. Mark Sainsbury (London, 1970), p. 95; E. Fischer and H. Shah, *Rural Craftsmen and Their Work* (Ahmedabad, 1970), pp. 66–68.

18 Fischer and Shah, 1970, p. 67.

19 Ovington, *A Voyage to Surat*, p. 165.

1 Robinson casket

20 *Proceedings of the Society of Antiquaries of London* (London, 1888), p. 268.

21 For a full discussion of these caskets, see Amin Jaffer and Melanie Schwabe, 'A group of sixteenth century caskets from Ceylon', *Apollo*, vol. CXLIX, no. 445 (1999), pp. 3–14; *Exotica: Portugals Entdeckungen im Spiegel fürstlicher Kunst- und Wunderkammern der Renaissance*, ed. Wilfried Seipel (exh. cat., Vienna, Kunsthistorisches Museum, 2000), pp. 234–43 and supplement, pp. 2–5.

22 C.R. de Silva, *The Portuguese in Ceylon 1617–38* (Colombo, 1972), p. 4.

23 Ibid. pp. 4–5; P.E. Pieris and M.A.H. Fitzler, *Kings and Christians 1539–1552*, Part I of *Ceylon and Portugal* (Leipzig, 1928), p. 9.

24 Svami-pillai Nanaprakasar, *A History of the Catholic Church in Ceylon: Period of Beginings 1505–1602* (Colombo, 1924), p. 118.

25 C.R. Boxer, *The Portuguese Seaborne Empire 1415–1825* (London, 1969), p. 367.

26 T. Kerver, *Horae beatae Mariae Virginis* (1499).

27 E. Bassani and W.B. Fagg, *Africa and the Renaissance: Art in Ivory* (exh. cat., New York, The Center for African Art, 1988); J.F. Butler, *Christianity in Asia and America after AD 1500* (Leyden, 1979), p. 10.

2 Tortoiseshell casket

28 José Jordão Felgueiras, 'A family of precious Gujarati objects', *The Heritage of Raulunchantim*, pp. 146 and 192.

29 Ibid. p. 146.

30 Francisco Pyrard de Laval, *Viagem de . . .* (Porto, 1944), p. 178; quoted in Felgueiras, 'A family of precious Gujarati objects', pp. 131–32.

31 *De Goa a Lisboa: A Arte Indo Portuguesa dos Séculos XVI a XVII* (exh. cat., Coimbra, Museu Nacional de Machado de Castro, 1992), p. 42.

32 Felgueiras, 'A family of precious Gujarati objects', p. 137.

3 Fall-front cabinet

33 Balkrishna Govind Gokhale, *Surat in the Seventeenth Century* (London and Malmo: Curzon Press, 1979).

34 *The Remonstrantie of Francisco Pelsaert*, p. 32.

35 Captain Cope, *A New History of the East-Indies* (London, 1758), p. 225.

36 William Finch, *Early Travels in India 1583–1619*, ed. William Foster (London, 1921), p. 173.

37 Herbert, *Some Yeares Travels into Africa and Asia the Great*, p. 45.

38 Ovington, *A Voyage to Surat*, p. 131.

39 *Voyage de François Pyrard de Laval*, 3rd edn (Paris, 1619), Vol. II, Pt I, pp. 176–77.

40 Monique Riccardi-Cubitt, *The Art of the Cabinet* (London, 1994), p. 24.

4 Reversible games board

41 A closely related example in the Metropolitan Museum of Art, New York, is catalogued as Italian, 1500–1550 (Pfeiffer Fund, 1962; 62;14). For a related Italian example, see Victoria and Albert Museum (7849–1861).

42 D. Barbosa, *The Book of Duarte Barbosa*, trans. from Portuguese, ed. and annotated by M.L. Dames (London, 1918–21), Vol. I, pp. 141–42.

43 *The Voyage of John Huygen van Linschoten to the East Indies: from the Old English Translation of 1598*, Vol. I, ed. Arthur Coke Burnell (London, 1885), p. 61.

44 *The Remonstrantie of Francisco Pelsaert*, p. 32.

5 Casket

45 A monograph on this subject is presently being prepared by Simon Digby and Amin Jaffer.

46 Gaspar Correa, *Lendas da India* (Lisbon, 1858), Vol. I, p. 287; *The Three Voyages of Vasco da Gama* (London, 1869), quoted in Simon Digby, 'The mother-of-pearl overlaid furniture of Gujarat: the holdings of the Victoria and Albert Museum', *Facets of Indian Art*, ed. R. Skelton *et al.* (London, 1986), p. 215.

47 M. de Laborde, *Notice des émaux, bijoux et objets divers exposés dans les galeries du musée du Louvre* (Paris, 1853), p. 432.

48 *The Voyage of John Huygen van Linschoten to the East Indies,* Vol. II, ed. P.A. Tiele (London, 1885), p. 136.

49 Abu'l Fazl Allami, *Ain-i Akbari,* trans. H. Blochmann (Calcutta, 1872), Vol. I, pp. 485–86.

50 Ibid. p. 56.

51 S. Sangl, 'Von der Aneignung des Fremden: indische Perlmutt-Raritaten und ihre europäischen Adaptionen in München, *Weltkunst* (1996), p. 2940.

52 *Exotica,* p. 149.

53 Ibid. p. 149.

54 Ibid. p. 152.

55 Ibid. p. 157

6 Painted fall-front cabinet

56 Riccardi-Cubitt, *The Art of the Cabinet,* p. 35.

57 Jagdish Mittal, 'Indian painters as designers of decorative art in the Mughal period', *Facets of Indian Art,* pp. 243–44.

58 Terry, *A Voyage to East India* (1665 edn), p. 377.

59 Gauvin Alexander Bailey, *Art and the Jesuit Missions in Asia and Latin America, 1542–1773* (Toronto, 1999), pp. 114–27.

60 Amina Okada, *Indian Miniatures of the Mughal Court* (New York, 1992), pp. 87–89.

61 Divyabhanusinh, 'Hunting in Mughal painting', *Flora and Fauna in Mughal Art,* ed. Som Prakash Verma (Mumbai, 1999), pp. 94–108.

62 George Cameron Stone, *A Glossary of the Construction, Decoration and Use of Arms and Armor in All Countries and in All Times* (New York, 1934), pp. 623–24.

7 Fall-front cabinet

63 Simon Digby, 'The mother-of pearl furniture of Gujarat: an Indian handicraft of the 16th and 17th centuries', *Facets of Indian Art,* pp. 213–22.

8 Cabinet on table-stand

64 Rosemary Crill, *Marwar Painting: A History of the Jodhpur Style* (Mumbai, 1999), pp. 18–22.

65 Amin Jaffer, *Furniture from British India and Ceylon* (London, 2001), p. 313.

66 Rafael Doménech and Luis Pérez Bueno, *Antique Spanish Furniture* (New York, 1965), pp. 50, 52 and 56; see for example an Italian chest (*cassone*), c.1500, in the Victoria and Albert Museum (7224–1860).

67 B.N. Goswamy, *Indian Costumes in the Collection of the Calico Museum of Textiles,* Vol. V (Ahmedabad, 1993), pp. 32–33.

68 See for example 'Jahangir receives an artist in camp', gouache, Mughal, c.1605, India Office Library, Johnson Album 27, 10, reproduced in *The Indian Heritage: Court Life and Arts under Mughal Rule* (exh. cat., London, Victoria and Albert Museum, 1982), p. 37.

69 Goswamy, *Indian Costumes,* p. 35.

70 John Guy and Deborah Swallow, eds, *Arts of India: 1550–1900* (London, 1990), p. 84; Daniel Walker, *Flowers Underfoot: Indian Carpets of the Mughal Era* (exh. cat., New York, Metropolitan Museum of Art, 1998), pp. 39, 45 and 55.

71 Riccardi-Cubitt, *The Art of the Cabinet,* pp. 77–83.

72 *Catalogue of Furniture in the Exhibition of Embroidered Quilts from the Museu Nacional de Arte Antiga Lisboa* (exh. cat., London, Kensington Palace, 1978).

73 Francisco Hipólito Raposo, 'O encanto dos contadores indo-portugueses', *Oceanos,* No. 19/20 (Sept–Dec 1994), p. 26.

9 Communion table

74 A wood panel also from Sindh/Gujarat inlaid with the same phrase is in the Museum of the New Julfa, Isfahan (Pedro de Moura Carvalho, 'A Safavid cope for the Augustinians? Their

role as political ambassadors and the diffusion of Western art models in Persia', *Oriental Art,* Vol. XLVII, No. 5, 2001, p. 20). This phrase is also found on the flag of a Japanese Christian army, c.1637: *Via Orientalis* (exh. cat., Lisbon, 1993), pp. 200–01.

75 James Hall, *Hall's Dictionary of Subjects and Symbols in Art* (London, 1974), pp. 212–13.

76 On this subject see Bailey, *Art and the Jesuit Missions.*

77 For an early seventeenth-century Mughal gouache of a *simurgh,* see Victoria and Albert Museum (IM 155-1914).

78 Richard Ettinghausen, 'New pictorial evidence of Catholic missionary activity in Mughal India (early XIIth century)', *Perennitas: P. Thomas Michels O.S.B. zum 70 Geburtstag,* ed. H. Rahner (Münster, 1963), fig. 11.

79 The existence of the documentary evidence has been confirmed in a letter from Dr Gauvin Alexander Bailey.

10 Ceremonial mace (*chob*)

80 See for example, 'The presentation of Prince Dara-Shikoh's wedding gifts', 'Europeans bringing gifts to Shah-Jahan', 'Jahangir receiving Prince Khurram' and 'Jahangir presents Prince Khurram with a turban ornament', in Milo Cleveland Beach and Ebba Koch, *King of the World: The Padshanamah, An Imperial Mughal Manuscript from the Royal Library, Windsor Castle* (exh. cat., London, Queen's Gallery, Buckingham Palace, 1997), p. 47.

81 *The Tuzuk-I-Jahangir, or, Memoirs of Jahangir,* trans. Alexander Rogers, ed. Henry Beveridge (London, 1909), Vol. I, p. 311.

82 *The Embassy of Sir Thomas Roe to the Court of the Great Mogul,* Vol. II, pp. 325–26.

83 Ibid., Vol. I, p. 143.

84 The marble facing on the dome is later (G.H.R. Tillotson, *Mughal India* [London, 1990], pp. 122–23).

85 Finch, *Early Travels in India,* pp. 149–50.

11 Pair of ewers and basins

86 *Inventory of the Objects in the Art Division of the Museum at South Kensington* (London, 1868), pp. 3, 19 and 31.

87 Sangl, 'Von der Aneignung des Fremden', pp. 2939–41.

88 *Exotica,* p. 160.

89 Ibid. pp. 163–64.

90 Ibid. p. 160.

91 Sotheby's, European Sculpture and Works of Art, 8 July 1998 (lot 282).

92 Gervase Jackson-Stops, *The Treasure Houses of Britain: Five Hundred Years of Private Patronage and Art Collecting* (exh. cat., Washington, DC, National Gallery of Art, 1985), p. 169.

93 Glanville, *Silver in Tudor and Early Stuart England,* p. 319.

94 Ibid. p. 320.

95 Ibid. p. 321.

12 Powder flask (*barud-dan*)

96 Ray Riling, *The Powder Flask Book* (New Hope, Pennsylvania, 1953), pp. 62–63.

97 Ibid. p. 229; *Splendeur des armes orientales* (exh. cat., Paris, ACTE-EXPO, 1988), p. 144.

98 *Masterpieces from the National Museum Collection,* ed. S.P. Gupta (Delhi, 1985), p. 165.

13 Basin

99 Philippa Glanville, *Silver in Tudor and Early Stuart England* (London, 1990), p. 448.

100 Pedro D. de Moura Carvalho, 'The possible influence of Chinese ceramics on Gujarati mother-of-pearl goods', MA dissertation, SOAS, London, pls XIV, XVI and XVIII.

101 *Exotica,* p. 160.

102 A basin of very similar form in a private Portuguese collection has '1568' engraved on the shell, at centre (Felgueiras, 'A family of

precious Gujarati objects', p. 133); and another, larger basin, was recorded in the probate inventory of Habsburg emperor Mathew in 1619 and is now in the Kunsthistorisches Museum, Vienna (*Exotica*, p. 164). An example of the same form, but with mastic inset, rather than overlaid, mother-of-pearl, bears mounts by Elias Geyer, Leipzig, 1611–13 and is now in the Green Vaults, Dresden (Felgueiras, 'A family of precious Gujarati objects', p. 135).

103 Sir Charles Jackson, *English Goldsmiths and Their Marks*, 2nd edn (New York, 1921), p. 116.

104 S. Bury, 'An early seventeenth-century master goldsmith', *Victoria and Albert Museum Yearbook* (London, 1969), pp. 64–66.

14 Bowl and cover

105 *Treasures of Florence: The Medici Collection 1400–1700*, ed. Cristina Acidini Luchinat (Munich and New York, 1997), p. 151.

106 Glanville, *Silver in Tudor and Early Stuart England*, p. 451.

107 *Exotica*, p. 164.

15 Fall-front cabinet

108 Goswamy, *Indian Costumes*, Vol. V, p. 119.

16 Side chair

109 G.E. Rumphius, *Herbarium amboinense* (Amsterdam/ The Hague, 1741–50), Vol. III, p. 5.

110 C. Wainwright, *The Romantic Interior* (London and New Haven, 1989), pp. 58–59.

111 C. Wainwright, 'Only the true black blood', *Furniture History Society*, Vol. XXI (1985), p. 251. The chairs may have been introduced into the interior at Esher by William Kent, who made alterations to the house in the 'Gothick' style.

112 From a letter of 1759 by Thomas Gray to Thomas Wharton, quoted in Wainwright, 'Only the true black blood', p. 251.

113 Wainwright, *The Romantic Interior*, pp. 71, 78 and 79.

114 Wainwright, 'Only the true black blood', p. 254 (fig. 4).

115 H. Shaw, *Specimens of Ancient Furniture Drawn from Existing Authorities* (London, 1836), pl. XII.

17 Cradle

116 See, for instance, the designs of Friedrich Unteutsch (*c.*1640–50) published in S. Jervis, *Printed Furniture Designs before 1650* (Leeds, 1974), pls 415–16.

117 R. Heber, *Narrative of a Journey through the Upper Provinces of India*, 3rd edn (London, 1828), Vol. I, pp. 19–20.

118 Sir Charles D'Oyly, *The European in India* (London, 1813), n.p.; C. Grant, *Anglo-Indian Domestic Life* (Calcutta, 1862), p. 13; Mrs Kindersley, *Letters from the East Indies* (London, 1777), p. 280.

119 Heber, *Narrative of a Journey*, Vol. II, p. 298.

120 'Original Letters, from an American Gentleman at Calcutta, to a friend of Pennsylvania', *Analetic Magazine* (Philadelphia, 1819), pp. 387–400.

18 Pipe case

121 Jerome E. Brooks, *The Mighty Leaf: Tobacco through the Centuries* (London, 1953), p. 17.

122 Ibid. p. 19.

123 Jordan Goodman, *Tobacco in History* (London and New York, 1993), pp. 47–48.

124 James I, *A Counterblast to Tobacco*, in *Tracts on Tobacco etc. 1650–1797* (London, n.d.), p. 12.

125 Berthold Laufer, *Tobacco and its Use in Asia* (Chicago, 1924), p. 73.

126 Ibid. pp. 68–69.

127 *The Jahangirnama: Memoirs of Jahangir, Emperor of India*, trans., ed. and annotated by Wheeler M. Thackston (New York, 1999), p. 217.

128 J.H.J. Leeuwrick, 'Koloniale pijpfoudralen', *Antiek* (May 1993), Vol. XXVII, No. 10, pp. 481–92.

129 Ibid. pp. 481–92.

19 Round box

130 Ananda K. Coomaraswamy, *Mediaeval Sinhalese Art* (New York, 1956), p. 92.

131 Jaffer, *Furniture from British India and Ceylon*, pp. 130–42.

132 Coomaraswamy, *Mediaeval Sinhalese Art*, pp. 67, 83 and 111–13.

133 Ibid. p. 61.

20 Ivory-veneered cabinet

134 Chandra Richard de Silva, *The Portuguese in Ceylon 1617–1638* (Colombo, 1972), p. 238.

135 *The Voyage of John Huygen van Linschoten*, Vol. I, p. 81.

136 Amin Jaffer and Melanie Schwabe, 'A group of sixteenth-century ivory caskets from Ceylon', *Apollo*, Vol. CXLIX, No. 445 (1999), pp. 3–4.

137 Jan Veneendaal, *Furniture from Indonesia, Sri Lanka and India during the Dutch period* (Delft, 1985), p. 43.

138 *The Voyage of John Huygen van Linschoten*, Vol. I, pp. 78–79.

139 Several cabinets are known that are also mounted with panels depicting this theme. Examples of almost identical size, and with similar scrolling borders, are in the Louvre (MRR 89) and in the Archaeological Museum, University of Colombo, Sri Lanka. A third related cabinet was sold by Palacio do Correio-Velho, Lisbon, in April 1993 (lot 116), and a fourth related cabinet was with Spinks in 1997. A cabinet with Adam and Eve doors positioned above two external drawers is in the Vatican Museum collection. Two single-door cabinets exist that are also mounted with these panels, the first in the Gemeentemuseum, The Hague (O12-1978), and the second in the Hermitage (E-7583), which was acquired by Peter the Great in 1716 from the Dutch collector Albertus Seba (*V.O.C. – zilver: Zilver uit de periode van de Verenigde Oostindische Compagnie, 17de en 18de eeuw* [exh. cat., The Hague, Gemeentemuseum, 1983], p. 55; R. Kistemaker, N. Kopaneva and A. Overbeek, *Peter de Grote en Holland* [exh. cat., Amsterdam, Amsterdams Historisch Museum, 1996], p. 167). Carved Adam and Even panels also exist in the Dutch Period Museum, Colombo; the Liverpool Museum; and the British Museum, but without any traces of the cabinets to which they originally belonged (O.M. Dalton, *Catalogue of the Ivory Carvings of the Christian Era with Examples of Mohammedan Art and Carvings in Bone in the Department of British and Mediaeval Antiquities and Ethnography of the British Museum* [London, 1910], p. 171).

21 Cabinet on stand (*contador*)

140 Riccardi-Cubitt, *The Art of the Cabinet*, pls 51–52, p. 85.

141 Sali Barnett Katz, *Hispanic Furniture: An American Collection from the Southwest* (Stamford, Connecticut, 1986), pp. 187–88; Raposo, 'O encanto dos contadores indo-portugueses', p. 32.

142 Maurice Hall, *Window on Goa: A History and Guide* (London, 1992), pp. 87–91.

143 *The Voyage of John Huygen van Linschoten*, Vol. I, p. 229.

22 Cabinet on stand (*contador*)

144 See for example *namban* lacquer (Maria Helena Mendes Pinto, *Namban Lacquerware in Portugal* [Lisbon, 1990], p. 112).

145 Riccardi-Cubitt, *The Art of the Cabinet*, pls 34 and 45.

23 Painted box

146 Mark Zebrowski, *Deccani Painting* (London, 1983), p. 204.

147 Stuart Cary Welch, *India: Art and Culture 1300–1900* (exh. cat., New York, Metropolitan Museum of Art, 1985), cat. no. 215; Jagdish Mittal, 'Indian painters as designers', p. 244; Zebrowski, *Deccani Painting*, p. 201.

148 I would like to thank Susan North for this information.
149 Terry, *A Voyage to East India* (1665 edn), p. 378.
150 Ovington, *A Voyage to Surat*, p. 166.
151 Bowrey, *A Geographical Account*, p. 111.
152 Jean de Thevenot, *The Travels of Monsieur de Thevenot into the Levant* (London, 1687), Part III, p. 97.
153 Stephen Vernoit, ed., *Discovering Islamic Art: Scholars, Collectors and Collections, 1850–1950* (New York, Metropolitan Museum of Art, 1997–98), pp. 11–13.

24 Fall-front cabinet
154 Walker, *Flowers Underfoot*, p. 86.
155 R. Skelton, 'A decorative motif in Mughal art', *Aspects of Indian Art*, ed. Pratapaditya Pal (Leiden, 1972), p. 151.
156 Walker, *Flowers Underfoot*, p. 86.

25 Cabinet on stand
157 Riccardi-Cubitt, *The Art of the Cabinet*, pp. 196–97.
158 Walker, *Flowers Underfoot*, p. 86.
159 *The Indian Heritage*, p. 163.
160 Ibid. pp. 92–93.

26 Throne component
161 George Michell, *Architecture and Art of Southern India: Vijayanagara and the Successor States*, Vol. I/6 of *The New Cambridge History of India* (Cambridge, 1995), p. 215.
162 A pair of related *yali* supports is in the Los Angeles County Museum of Art (M.80.232.7 and M.80.232.7b).
163 Ibid. p. 41.
164 J.C. Harle, *The Art and Architecture of the Indian Subcontinent* (Harmondsworth, 1986), pp. 332–35.
165 Michell, *Architecture and Art of Southern India*, pp. 207–15.

27 Ivory-veneered cabinet
166 Sinnappah Arasaratnam, trans. and ed., *François Valentijn's Description of Ceylon* (London, 1978), p. 166.
167 See for instance J.C. Harle and Andrew Topsfield, *Indian Art in the Ashmolean Museum* (Oxford, 1987), p. 92.
168 Christopher Wilk, ed., *Western Furniture, 1350 to the Present Day* (London, 1996), pp. 76–77.
169 *The Dictionary of Art* (London, 1996), Vol. XXII, p. 872.
170 Jaffer, *Furniture from British India and Ceylon*, pp. 130–42; S.M. Voskuil-Groenewegen, J.H.J. Leeuwrik and Titus Eliens, *Zilver uit de tijd van de Verenigde Oostindische Compagnie* (exh. cat., The Hague, Gemeentemuseum, 1998), p. 54.
171 Catherine B. Asher, *Architecture of Mughal India*, Vol. I/4 of *The New Cambridge History of India* (Cambridge, 1992), p. 212; Amina Okada and M.C. Joshi, photos by Jean-Louis Nou, *Taj Mahal* (New York, London and Paris, 1993), pp. 78–79.
172 R. Nath, 'Flora and fauna in Mughal architecture', *Flora and Fauna in Mughal Art*, pp. 157–58; Okada, *Taj Mahal*, pp. 25–26.

28 Daybed and set of three chairs
173 S. Arasaratnam, *Merchants, Companies and Commerce on the Coromandel Coast, 1650–1740* (Delhi, 1986), p. 104, 110 and 122.
174 W. Hamilton, *A Geographical, Statistical, and Historical Description of Hindostan and the Adjacent Countries* (London, n.d. [c.1820]), Vol. II, p. 62.
175 Major J. Corneille, *Journal of My Service in India*, ed. Michael Edwardes (London, 1966), pp. 100–01.
176 D.N. Varma, 'Visakhapatnam ivory carving', *Decorative Arts of India*, ed. M.L. Nigam (Hyderbad, 1987), pp. 226–27.

29 Cabinet on stand
177 British Library OIOC, P/328/60, Inventory of Samuel Greenhaugh, 11 June 1755. P/328/61, Inventory of John Palmer, 5 January 1762. OIOC, P/328/61, Inventory of William Roberts, 29 February 1760; Calcutta Gazette, 1 April 1784; *Calcutta Gazette*, 7 September 1786; *Madras Courier*, 6 June 1804.
178 This was identified by E. Croft-Murray of the British Museum in 1963.
179 A tea caddy inlaid with similar borders and bearing silver canisters by John Swift in 1764 was on the London market in 1992 (*Country Life*, 24 September 1992, pp. 76–77). Similar borders are inlaid on a serpentine-fronted commode, sold Sotheby's, 16 July 1982 (lot 113), whose form corresponds to the ivory-veneered example in the Lady Lever Art Gallery (LL 4235), which is similarly engraved, but with bolder and freer designs (L. Wood, *Catalogue of Commodes* [London, 1994], p. 275).

30 Revolving round chair
180 Sotheby's, 21–22 May 1990 (lot 75).
181 OIOC, P/328/62, Inventory of Robert Sloper, 20 January 1764; V.I. Van der Wall, *Het Hollandsche Koloniale Barokmeubel* (Antwerp, 1939), p. 79.
182 I. Gobert, 'Le Mobilier', *La Vie publique et privée dans l'Inde ancienne*, Part II (Paris, 1976), pp. 89–91 and pl. 20; R. Van der Vloodt, 'The mysterious origins of the burgomaster chair', *Antique Collector* (November 1982), pp. 60–62; Van der Wall, *Het Hollandsche Koloniale Barokmeubel*, p. 78.
183 Examples of this type are illustrated in M.G. Atmore, *Cape Furniture* (Cape Town, 1965), pl. 2; J. Veenendaal, *Furniture from Indonesia, Sri Lanka and India during the Dutch Period* (Delft, 1985), p. 73; Van der Wall, *Het Hollandsche Koloniale Barokmeubel*, p. 76.
184 Some scholars thought the form of this type of chair originated in Wales, a notion apparently supported by the existence of several examples in local timbers (H. Cescinsky and E.R. Gribble, *Early English Furniture and Woodwork* [London, 1922], Vol. I, pp. 195 and 198–99; E. Foley, *The Book of Decorative Furniture* [London, n.d.], p. 214; Van der Vloodt, 'The mysterious origins of the burgomaster chair', p. 60).
185 Examples of this type are illustrated in Veenendaal, *Furniture from Indonesia, Sri Lanka and India*, pp. 109–10; Van der Vloodt, 'The mysterious origins of the burgomaster chair', pp. 62–63; Van der Wall, *Het Hollandsche Koloniale Barokmeubel*, p. 77.
186 For information on the evolution of this spurious provenance see Amin Jaffer, 'Tipu Sultan, Warren Hastings and Queen Charlotte: the mythology and typology of Anglo-Indian ivory furniture', *Burlington Magazine*, Vol. CXLI, No. 1154 (1999), pp. 271–81.

31 Ceremonial staff or fencing stick
187 *The Indian Heritage*, pp. 162–63; P.S. Rawson, *The Indian Sword* (Copenhagen, 1967), pp. 52–55.
188 Abdul Halim Sharar, *Lucknow: The Last Phase of and Oriental Culture*, trans. E.S. Harcourt and Fakhir Hussain (Delhi, 1989), pp. 121–24.
189 Jonathan Bourne, Anthony Christie *et al.*, *Lacquer: An International History and Collectors Guide* (London, 1984), pp. 194 and 198–99; Wilk, ed., *Western Furniture*, pp. 120–21.
190 George, Viscount Valentia, *Voyages and Travels to India, Ceylon, the Red Sea, Abyssinia, and Egypt: In the Years 1802, 1803, 1804, 1805, and 1806* (London, 1809), Vol. I, p. 140; Rosie Llewellyn-Jones, *A Fatal Friendship* (Delhi, 1992), p. 181. An appreciation of Chinese works of art was not limited to the rulers of Lucknow. While visiting the palace at Tanjore in 1774, George Paterson observed apartments hung with Chinese pictures (OIOC, Mss. Eur. E.379/9, p. 39).
191 Jaffer, *Furniture from British India and Ceylon*, pp. 267–71.
192 Maria Graham, *Journal of a Residence in India* (London, 1813), p. 67.

193 Col. Henry Yule and A.C. Burnell, *Hobson-Jobson* (London, 1886), p. 204.

194 Capt. Thomas Williamson, *East India Vade-Mecum: Or, Complete Guide to Gentlemen Intended for the Civil, Military, or Naval Service of the Hon. East India Company* (London, 1810), Vol. I, pp. 195–96.

195 Sharar, *Lucknow*, pp. 109–10.

32 Pair of armchairs

196 Maria Helena Mendes Pinto, 'Sentando-se em Goa', *Oceanos*, No. 19/20 (Sept–Dec 1994), pp. 52–55.

197 Helder Carita, *Palàcios de Goa* (Lisbon, 1995), pp. 87 and 146.

198 Wolfram Eberhard, *A Dictionary of Chinese Symbols*, trans. G.L. Campbell (London, 1986), p. 258.

199 Craig Clunas, *Chinese Export Watercolours* (London, 1984), p. 68.

200 Nancy Berliner, *Beyond the Screen* (exh. cat., Boston, Museum of Fine Arts, 1996), p. 11. Wang Shixiang, *Classic Chinese Furniture: Ming and Early Qing Dynasties*, trans. Sarah Handler and the author (Hong Kong, 1986), cats. 46, 53 and 57.

201 Jaffer, *Furniture from British India and Ceylon*, p. 89; Nick Pearce, 'The Chinese folding chair: Mortimer Menpes and an Aesthetic interior', *Apollo*, Vol. CXLIX, No. 445 (1999), p. 51.

33 Miniature bureau-cabinet

202 *Miniature English Furniture* (exh. cat., London, Neil Willbroe and Natasha MacIlwaine Gallery, 2000), p. 29.

203 Christie's New York, 25 October 1986 (lot 134); Oger-Dumont, Druout Paris, 21–22 June 1999 (lot 122); Christie's 12 November 1998 (lot 157).

204 The bureau-cabinet was bequeathed to the Rijksmuseum by Janssen's daughter-in-law, Mrs W.M. Janssens-Arriëns. Rijksmuseum (11907). A miniature bureau-cabinet whose slope is identically engraved was sold at Sotheby's, 6 June 1990 (lot 12).

205 I am grateful to Jan Veenendaal and Pauline Scheurleer for this information.

34 Pair of armchairs and table

206 P.C. Majumdar, *The Musnud of Murshidabad (1704–1904)* (Murshidabad, 1905), p. 78; L.S.S. O'Malley, *Murshidabad* (Calcutta, 1914), p. 186.

207 O'Malley, *Murshidabad*, p. 142.

208 *Arts of Bengal: The Heritage of Bangladesh and Eastern India* (exh. cat., London, Whitechapel Art Gallery, 1979), p. 71; *Descriptive Catalogue of Articles Exhibited at the Calcutta Exhibition of Indian Art-Manufactures, 1882, Held at the Indian Museum in January 1882* (Calcutta, 1883), p. 267.

209 Fanny Parks, *Wanderings of a Pilgrim in Search of the Picturesque* (London, 1850), Vol. II, p. 99.

210 *Miss Fane in India*, ed. John Pemble (Wolfeboro, New Hampshire, 1989), p. 118.

211 Emma Roberts, *Scenes and Characteristics of Hindostan*, 2nd edn (London, 1837), Vol. I, pp. 88–89.

212 F.E. Witts, *The Diary of a Cotswold Parson* (Gloucester, 1978), p. 74. I am grateful to Raymond Head for this reference.

35 Set of four armchairs

213 For example, see *Gillow Furniture Designs*, ed. L. Boynton, (Royston, 1995), figs 264 and 271; A. Hepplewhite, *The Cabinet-Maker and Upholsterer's Guide* (London, 1788), plates 4 and 6; H. Cescinsky, *English Furniture of the Eighteenth Century* (London, 1911), Vol. III, p. 197; R. Edwards, *The Shorter Dictionary of English Furniture* (London, 1964), fig. 161, p. 158; M. Tomlin, *Catalogue of Adam Period Furniture* (London, 1982), pp. 131 and 135.

214 *Gillow Furniture Designs*, figs. 270 and 271; Hepplewhite, *The Cabinet-Maker and Upholsterer's Guide*, pls 6 and 8.

215 Jean Gordon Lee, *Philadelphians and the China Trade, 1784–1844*

(exh. cat., Philadelphia, Philadelphia Museum of Art, 1984), p. 85.

216 Maple & Co. Ltd and Thomas Wyatt, *Lowther Castle*, 15 April 1947, p. 29 (lot 308). At some point before 1947 the Lowther chairs were painted with cream-coloured floral designs.

36 Teapoy

217 Yule and Burnell, *Hobson-Jobson*, p. 910.

218 See, for instance, Mildred Archer, *Company Paintings* (London, 1992), p. 75; Toby Falk and Mildred Archer, *Indian Miniatures in the India Office Library* (London, 1981), p. 496; Sotheby's, 26 April 1995 (lot 133).

219 Reproduced in *Pictorial Dictionary of British 19th Century Furniture Design*, compiled by Edward Joy (Woodbridge, 1994), pp. 535–37.

220 V&A Registered Papers, 26/2566 and 90/2381.

221 Veronica Murphy, 'Art and the East India trade: some little-known ivory furniture (1500–1857)', *Connoisseur*, Vol. CLXXI, No. 706 (1970), pp. 233–34.

222 Hastings departed for England on 1 January 1823, at which time it is unlikely that he knew who his successor was to be, as Amherst was appointed on 23 October 1822, and the news could not have reached India before Hastings left. Amherst arrived in India on 1 August 1823. I am grateful to R.J. Bingle, formerly of the India Office Library, for information on the relationship between Hastings and Amherst.

223 OIOC, Mss. Eur. F. 140.

224 Kent Record Office, U1350 E14/2.

225 Ibid.

37 Games table

226 V&A Registered Papers, 1637/07.

227 *Bengal Directory and Annual Register* (1836), p. 212; *List of Officers of the Bengal Army 1758–1834* (1946), Part III, pp. 214–15.

38 Toilet glass

228 Hepplewhite, *The Cabinet-Maker and Upholsterer's Guide*, pls 70 and 71.

229 Carl Crossman, *The Decorative Arts of the China Trade* (Woodbridge, 1992), pp. 284–86.

230 *Treasures from India: The Clive Collection at Powis Castle*, ed. Mildred Archer *et al.* (exh. cat., Welshpool, Powis Castle, 1987), pp. 83–84.

231 V&A, ISEAD Archive.

232 For an example of a full-scale ivory-veneered cabinet on stand engraved in a similar style, see Sotheby's New York, 24 October 1992 (lot 351).

39 Pair of candelabra

233 Jonathan Bourne and Vanessa Brett, *Lighting in the Domestic Interior: Renaissance to Art Nouveau* (London, 1991), p. 152; Hilary Young, 'Neo-classical silversmiths' drawings at the Victoria and Albert Museum', *Apollo*, Vol. CXXIX, No. 328 (1989), p. 385.

234 V&A Registered Papers 60/2761.

235 Amin Jaffer, 'The Anglo-Indian ivory furniture', *Masterpieces of English Furniture: The Gerstenfeld Collection*, ed. Edward Lennox-Boyd (London, 1998), p. 140.

236 Jaffer, *Furniture from British India and Ceylon*, p. 256.

40 Marble throne chair

237 British Library OIOC, Mss. Eur. D/786/1, p. 129.

238 Emily Eden, *Up the Country* (London, 1930), p. 14.

239 Ibid. p. 203.

240 British Library OIOC, Photo Eur. 323, p. 8.

241 M.M. Kaye, ed., *The Golden Calm* (London, 1980), p. 126.

242 George Watt, *Indian Art at Delhi 1903 (Being the Official Catalogue of the Delhi Exhibition, 1902–1903)* (Calcutta and London, 1904), p. 71.

243 Eden, *Up the Country*, p. 97.

244 See also Pratapaditya Pal, Janice Leoshko *et al.*, *Romance of the Taj Mahal* (exh. cat., Los Angeles County Museum of Art, 1989), p. 241.

41 Travelling armchair and footstool

245 Reproduced in *Pictorial Dictionary of British 19th Century Furniture Design*, pp. 176 and 190.

246 *Official Report of the Calcutta International Exhibition, 1883–84* (Calcutta, 1885), p. 189; Watt, *Indian Art at Delhi*, p. 164.

247 H.H. Cole, *Catalogue of the Objects of Indian Art Exhibited in the South Kensington Museum* (London, 1874), p. 115.

248 Lewellyn-Jones, *A Fatal Friendship*, pp. 220–21.

249 Christianne Terlinden, ed., *Mughal Silver Magnificence* (exh. cat., Brussels, 1987), p. 39. Names of craftsmen are sometimes ambiguous and variable. *Chatera* or *chitera*, for example, is used variously to refer to a painter, artist and engraver (J. Platts, *A Dictionary of Urdu, Classical Hindi, and English*, 5th edn [Oxford, 1930], pp. 423–24).

42 Giltwood throne chair

250 OIOC, Mss. Eur. D/786/1, pp. 102–118. A parcel gilt, silver-covered sofa possibly from Lucknow was sold at Sotheby's, 17 November 1996 (lot 162).

251 R. Lewellyn-Jones, *A Fatal Friendship: The Nawabs, the British, and the City of Lucknow* (Delhi, 1992), pp. 58–59.

252 M. Archer, *India and British Portraiture, 1770–1825* (London, 1979), pp. 72–84.

253 Ibid. pp. 145–49; Llewellyn-Jones, *A Fatal Friendship*, p. 34.

254 From a letter of 1 March 1795, quoted in Archer, *India and British Portraiture*, p. 145.

255 Llewellyn-Jones, *A Fatal Friendship*, p. 59.

256 Valentia, *Voyages and Travels*, Vol. I, pp. 103–04.

257 Ibid. pp. 108–12.

258 Ibid. pp. 108–09.

259 Heber, *Narrative of a Journey*, Vol. I, p. 216.

260 Llewellyn-Jones, *A Fatal Friendship*, pp. 20, 59 and 61.

261 OIOC, Mss. Eur. Photo 331, unpublished biography of Robert Home by E.B. Day (*c*.1920), p. 273.

262 Sharar, *Lucknow*, p. 37. See also G.H.R. Tillotson, *The Tradition of Indian Architecture* (New Haven and London, 1989), pp. 10–11.

263 V&A, E. 694/1414/1595/1600/1615-1943.

264 Reproduced in *Pictorial Dictionary of British 19th Century Furniture Design*, pp. xvii, 147, 156, 176, 177, 190 and 212.

43 Maharaja Ranjit Singh's throne

265 Terlinden, ed., *Mughal Silver Magnificence*, p. 60; Oppi Untracht, *Traditional Jewelry of India* (London, 1997), p. 278.

266 Abu'l Fazl Allami, *Ain-i Akbari*, trans. H. Blochman, 3rd edn, rev. and ed. D.C. Phillott (New Delhi, 1977), Vol. I, p. 52.

267 *The Voyage of Pedro Alvares Cabral*, p. 73.

268 Valentia, *Voyages and Travels*, Vol. I, p. 116.

269 Charles Pridham, *An Historical, Political and Statistical Account of Ceylon and its Dependencies* (London, 1849), cited in W.G.M. Beumer and R.K. de Silva, *Illustrations and Views of Dutch Ceylon, 1602–1796* (London, 1988), p. 474.

270 H.E. Fane, *Five Years in India* (London, 1842), Vol. I, p. 120.

271 Eden, *Up the Country*, p. 227.

272 Ibid. p. 203.

273 Harle, *The Art and Architecture of the Indian Subcontinent*, figs 101, 146, 148, 159 and 160. For examples in South Indian sculpture see, Michell, *Architecture and Art of Southern India*, figs 144, 150 and 155.

274 W.G. Archer, *Indian Paintings from the Punjab Hills* (Delhi, 1973), Vol. II, pl. 28.

275 These are abundantly illustrated in miniatures, see for instance the throne of Timur in Guy and Swallow, eds, *Arts of India*, fig. 40.

276 See, for instance, W.G. Archer, *Paintings of the Sikhs* (London, 1966), pl. 28; Sue Stronge, ed., *The Arts of the Sikh Kingdoms* (exh. cat., London, Victoria and Albert Museum, 1999), fig. 176.

277 Stronge, ed., *The Arts of the Sikh Kingdoms*, p. 219. On Tipu Sultan's throne, Mildred Archer *et al.*, *Treasures from India*, p. 75.

278 A note by Dalhousie (*c*.1856) suggests that he originally intended for his copy of the throne to be gilt. For details, and a reproduction of Shearwood's invoice, see Sotheby's *Colstoun*, 21–22 May 1990 (lot 95).

279 The Marquis Curzon of Kedleston, *British Government in India* (London, 1925), Vol. I, p. 104.

280 Valentia, *Voyages and Travels*, Vol. I, p. 37.

44 Games box

281 Information from Dr R. Vasantha, Aanantapur: a joint publication concerned with this collection by Dr Vasanta and Dr Irving Finkel is in the course of preparation.

282 Sundry other boards deriving from the same background have also been recorded in private possession in London and Paris.

283 *Paris Universal Exhibition of 1867: Catalogue of the British Section* (London, 1867), p. 290.

45 Chest on stand

284 *Courier*, 1 January 1795; *Madras Courier*, 12 December 1815; *Government Gazette*, 27 January 1814.

285 Capt. Mundy, *Journal of a Tour in India* (London, 1833), Vol. II, p. 14.

286 Roberts, *Scenes and Characteristics of Hindostan* (London, 1835), Vol. III, p. 14.

287 *Paris Universal Exhibition of 1867*, p. 276.

46 Painted box

288 I am grateful to Rosemary Crill for this information.

289 Jutta Jain-Neubauer, 'Of kings, Krishna, malwa girls and opium: wall paintings in the palace of Jamnagar, India', *Indian Painting: Essays in Honour of Karl J. Khandalavala*, ed. B.N. Goswamy (New Delhi, 1995), pp. 187–206.

290 Ibid. p. 196.

291 Ibid. pp. 192–93.

292 Y.K. Shukla, *Wall Paintings of Rajasthan* (Ahmedabad, 1980), p. 8.

47 Pair of armchairs and footstools

293 Published designs for which are reproduced in *Pictorial Dictionary of British 19th Century Furniture Design*, pp. 194–97.

294 A. Maskell, *Ivories*, repr. (Rutland Vermont and Tokyo, 1966), p. 428. The chairs and table do not appear in the exhibition catalogue, nor do they feature in the list of objects sent to the Great Exhibition from the Bengal Presidency. Objects are known that do not appear in any of the literature but which are known to have been at the Great Exhibition, and these pieces might well fall into that category. Maskell, who argues that the pieces were on display there, did in fact attend. The chess table (V&A: 01218) was damaged and disposed of in 1950 (V&A Registered Papers, 50/1493).

295 *Paris Universal Exhibition, 1855: Catalogue of the Works Exhibited in the British Section of the Exhibition* (London, 1855), p. 159.

296 Maskell, *Ivories*, p. 429

297 *Arts of Bengal*, p. 75.

48 Armchair

298 G.M.D. Sufi, *Kashir* (Lahore, 1949), Vol. II, p. 577. For information on Persian antecedents of Kashmiri painted and varnished

wares, see N.D. Khalini, B.W Robinson and T. Stanley, *Lacquer of the Islamic Lands*, Vol. XXIII, Part I (London, 1996); Part II (London, 1997); M. Zebrowski, 'Indian lacquerwork and the antecedents of the Qajar style', *Lacquerwork in Asia and Beyond*, ed. W. Watson (London, 1982), pp. 333–45. Although painted Indian and Islamic woodwork covered with lac-based varnish is frequently described as lacquer, this term (or the term 'true lacquer') is technically reserved for the sap (*urushi*) of the Chinese and South East Asian *Rhus* genius of the tree. *Urushi*, which is the basis of Chinese, Japanese and Korean lacquerwork, can be built up in layers into an impervious material with a high gloss. Western attempts to simulate the effects of lacquer are generally decribed as japanning.

299 The technique also came to be known as *kar-i-munakash* or painted ware (P.N Kachuru, 'Papier-mâché', *Crafts of Jammu, Kashmir and Ladakh*, ed. Jaya Jaitly [Ahmedabad, 1990], p. 123).

300 G. Moorcroft and G. Trebeck, *Travels in the Himalayan Provinces of Hindustan and the Panjab, in Ladakh and Kashmir, in Pashawar, Kabul, Kunduz, and Bokhara ... from 1819 to 1825* (London, 1841), Vol. II, pp. 215–16.

301 R. Sharma, *Papier-mâché Crafts of Kashmir* (Ahmedabad, 1992), p. 37.

302 M.H. Kamili, *Jamu and Kashmir*, Vol. VI of *Census of India 1961*, Part VII-A(I) (n.d. [1966]), p. 7; Sharma, *Papier-mâché*, pp. 39–40.

303 Sharma, *Papier-mâché*, p. 53.

304 Kamili, *Jamu and Kashmir*, p. vii; Sharma, *Papier-mâché*, pp. 41–43.

305 Moorcroft and Trebeck, *Travels in the Himalayan Provinces*, Vol. II, p. 217.

306 Eden, *Up the Country*, p. 228.

307 B.H. Baden Powell, *Handbook of the Manufactures and Arts of the Punjab* (Lahore, 1872), p. 219.

308 Ibid. p. 219.

309 *Fifty-one Photographic Illustrations Taken by Order of the Government of India of Some Selected Objects Shown at the Third Exhibition of Native Fine and Industrial Art* (London, 1881), p. 17.

49 Ebony cabinet

310 *Ceylon Government Gazette*, 24 May 1814. A set of late eighteenth-century/early nineteenth-century figures exists in the British Museum (OA 1985.15).

311 *Ceylon Times*, 2 April 1850, p. 203.

312 *Official Descriptive and Illustrated Catalogue of the Great Exhibition of the Works of Industry of All Nations* (London, 1851), Vol. II, p. 732, pl. 98.

313 *Art Journal Illustrated Catalogue* (1851), p. 230.

50 Dowry chest (*patara*)

314 Jyotindra Jain, *Folk Art and Culture of Gujarat: Guide to the Collectors of the Shreyas Folk Museum of Gujarat* (Ahmedabad, 1980), p. 5. For princely *pataras*, see photographs of a reception room of Jasdan Palace, reproduced in Sunil Sethi and Deidi von Schawen, *Indian Interiors* (Cologne, 1999), pp. 210–11.

315 R.K. Trivedi, *Gujarat: Patara Making at Bhavnagar*, Vol. V of *Census of India, 1961* (Ahmedabad, n.d. [1966]), Part VII-A(3), p. 5.

316 Ibid.

317 Ibid. pp. 16 and 17.

318 Edgar Thurston, 'Wood carving in Southern India', *Journal of Indian Art and Industry*, Vol. X, No. 96 (1904), p. 49.

319 Trivedi, *Patara Making at Bhavnagar*, p. 22.

Glossary

Charpoy/charpai A low cot, most often consisting of a wooden frame supported on four turned legs with a plaited network of coarse string, cane or webbing.

Coast Abbreviation for the Coromandel Coast, current in the late seventeenth and eighteenth century.

Hookah Smoking pipe with a long tube that passes through a bowl (*chillum*) containing water, thus cooling the smoke as it is drawn through.

Ivory Term for the teeth or tusks of elephants and other mammals, including the Arctic walrus, Asiatic and African boar, hippopotamus, warthog and whale. In the context of the Indian subcontinent, it refers principally to the upper front tusks of elephants, which are found from the foothills of the Himalayas to the southern tip of Ceylon. Ivory is extremely dense, with a close texture, and may be carved, engraved, turned, pierced and painted. It is sufficiently strong and elastic to permit its use as a solid material as well as a veneer. Due to its high cost and scarcity, ivory has often been substituted with animal bone, from which it cannot be chemically distinguished, but which lacks its dense grain, elasticity and lustrous surface.

Lac A dark red, transparent, resinous incrustation secreted by females of certain homopteran insect species parasitic on various Indian and South-East Asian trees. It is principally available in three forms: stick-lac, seed-lac and shellac. The first describes the substance as found on twigs and branches. For seed-lac, stick-lac is melted and purified by separating it from wooden particles. Shellac, by contrast, refers to seed-lac that is further purified and dissolved in spirits, creating a transparent varnish that can be painted over surfaces to form a lustrous protective coating.

Mandapa A columned hall preceding the sanctuary in a Hindu temple.

Mother-of-pearl Material composed of calcium carbonate plaques found in thin layers on the inside of certain molluscs and marine invertebrates, principally the salt-water pearl oyster. Mother-of-pearl varies in colour and has traditionally been prized for its lustre, iridescence and reflective qualities.

Musnud A throne or royal seat, consisting of a bolster or cushion on a mat or carpet.

Muster A model or pattern.

Palanquin A litter carried on the shoulders of four or six men.

Sadeli A type of micro-mosaic inlay composed of faceted strips of diverse materials, such as tine, horn, ivory, sapan wood and ebony, which are cut transversely to reveal geometric designs. The technique is related to Persian *hatam-bandi*.

Takht A throne or chair of state consisting of a dais covered with textiles; a raised platform for sitting or sleeping.

Index